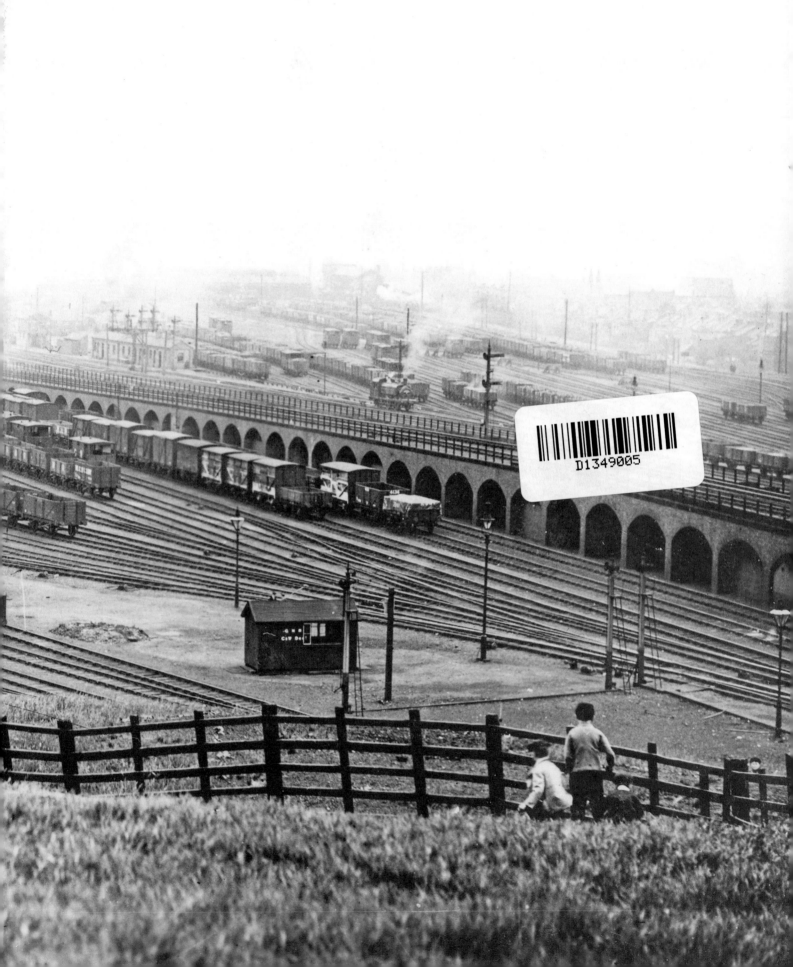

BRITAIN'S LOST RAILWAYS

THE TWENTIETH-CENTURY DESTRUCTION OF OUR FINEST RAILWAY ARCHITECTURE

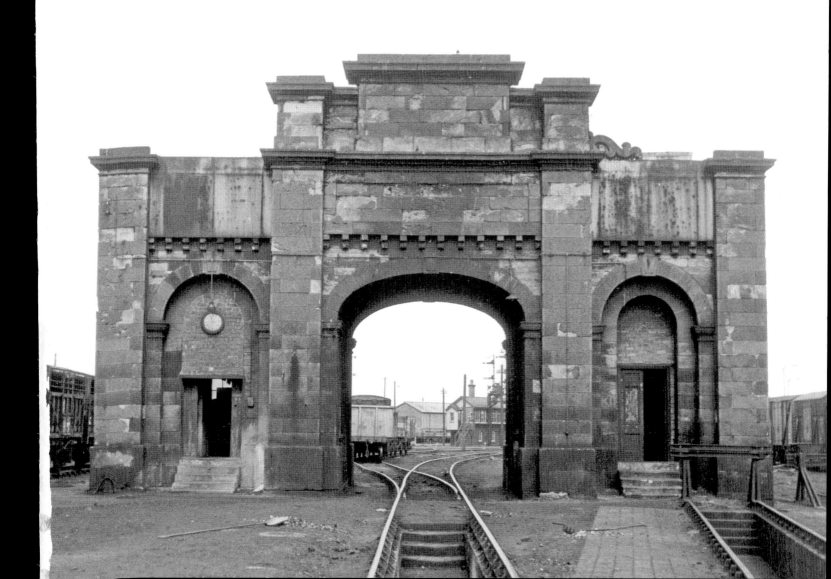

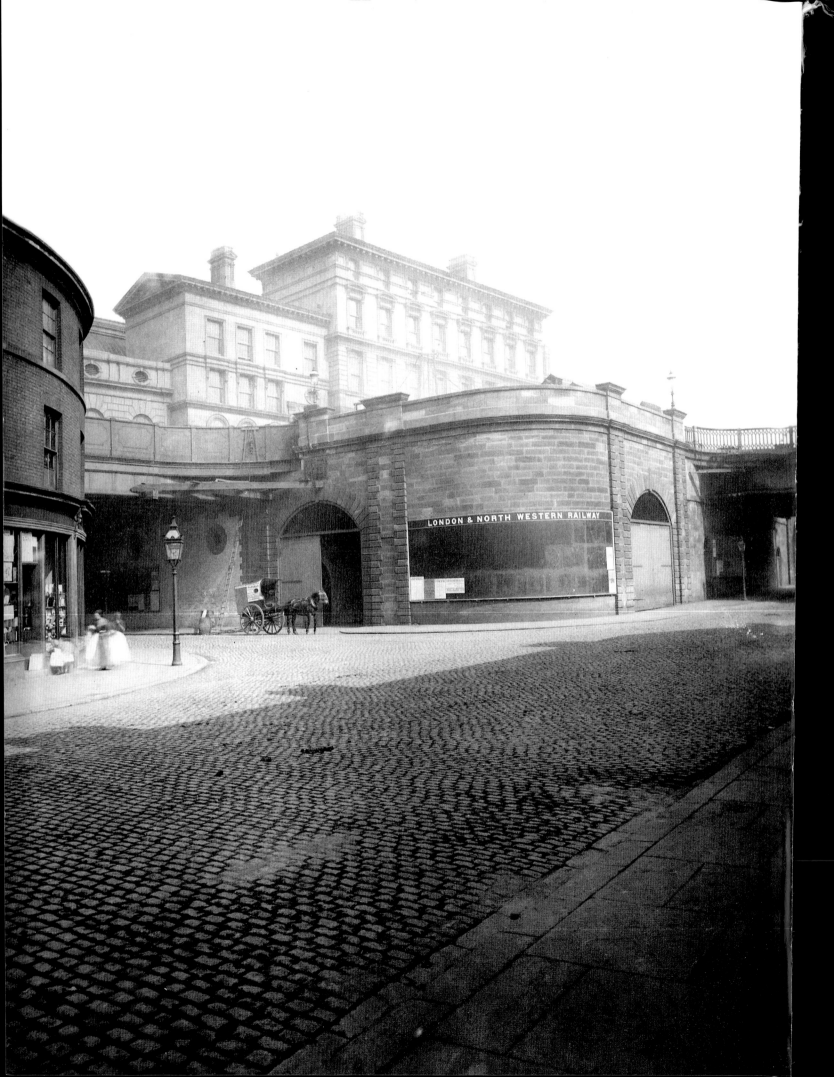

BRITAIN'S LOST RAILWAYS

THE TWENTIETH-CENTURY DESTRUCTION
OF OUR FINEST RAILWAY ARCHITECTURE

JOHN MINNIS

Aurum
history

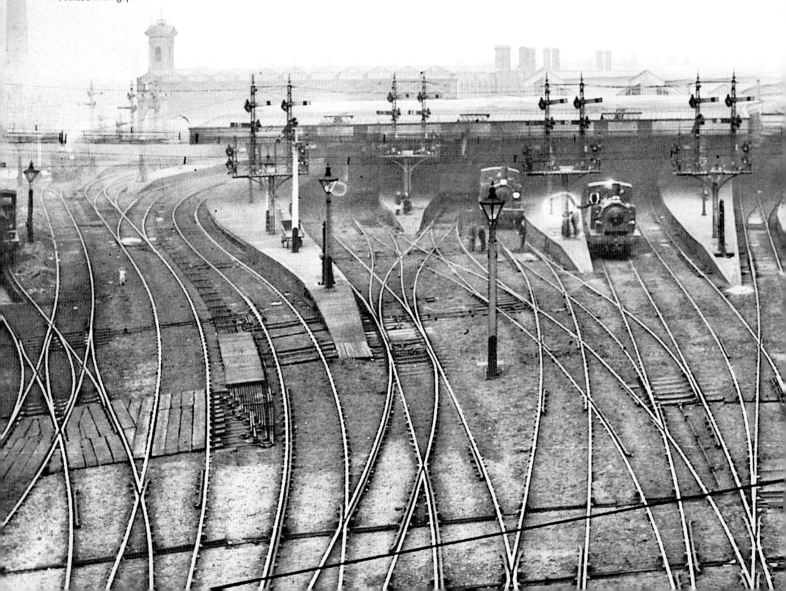

CONTENTS

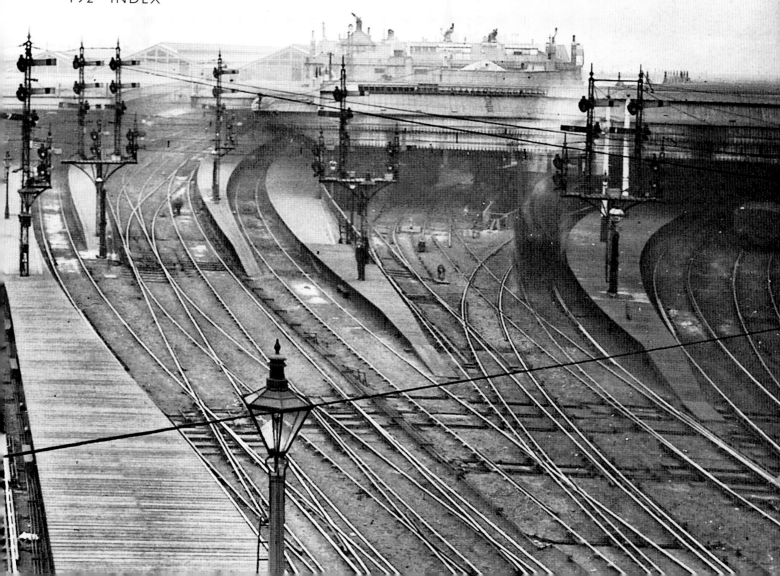

INTRODUCTION

A REMINISCENCE

Exactly 50 years ago, an unusually enlightened prep school teacher (she must have been a paid-up member of the Victorian Society) set her eight-year-old charges some unusual homework – to research, visit and draw some of London's threatened buildings. The first week, it was J. B. Bunning's superb Coal Exchange, demolished the following year. The following week's task was, in the event, even more opportune. My mother, by this time, was becoming a little put out with this slightly strange approach to learning, asking why she had to spend her weekends taking me up to town, but she acquiesced. We walked down a rather narrow street, hemmed in by tall buildings and, on the left, loomed the unmistakable shape of the Euston arch. I knew it from photographs but, to an eight-year-old, its scale seemed immense and the thing that struck me most about it was its blackness – 150 years of soot gave it an unmatched sublimity – not that I would have known the word at the time. The first delivery of scaffolding poles was lying alongside it and I was just in time – the scaffolding went up in mid October and Drummond Street, along which we had walked, was closed to traffic. Hoardings sprang up and the Euston arch was lost to view for ever. A couple of weeks further on in the year and it would have been too late. It was my one and only visit to it and I have that rather poor, if still recognisable, sketch *drawn from life* still.

The demolition of the Euston arch, which was, with St Pancras, arguably the finest example of railway architecture to have been built in Britain in the nineteenth century, caused anguish amongst all those who loved Victorian architecture. It was a "monument of elemental creativity" in a style that "stands in everyone's mind associatively for the greatest human achievements, the style of the Age of Pericles"[1] in the words of Sir Nikolaus Pevsner. *The Architectural Review* described it as the Euston Murder. It was the first great test of the newly formed Victorian Society and

Liverpool Street is one of the great conservation success stories, the present station combining the best of the 1874–5 station, with its soaring iron roof, with all the convenience that passengers and staff expect of a station today. Inevitably, in the process of reconstruction, there were losses: the roof of the east side extension of 1894 and the charming Edwardian tea rooms that used to run off the footbridge linking the disparate parts of the old station. But what has also gone is something much harder to define, the extraordinary atmosphere of the place. Deep gloomy patches, suddenly lit up by a shaft of light like this one shining on a railway policewoman, were to be found all over the station, especially around the cab road and the booking office, brilliantly captured in a Fox photograph of 27 March 1952. It was this combination of light and shade, adding an element of the sublime, that made Liverpool Street special. *Fox Photos/Getty Images*

the test case for Victorian architecture as a whole. With hindsight, the failure of the fight to save the Euston arch marked a turning point in conservation. The battle was carried on at the highest level with a letter to *The Times* arguing for the retention of the arch, signed by Sir Charles Wheeler, the President of the Royal Academy, and the presidents or chairmen of the Georgian Group, the Victorian Society, the SPAB and the London Society. A deputation of the signatories met the Prime Minister, Harold Macmillan, and the Minister of Transport, Ernest Marples, on 24 October 1961 but Macmillan's reply on 2 November failed to address the arguments put forward.[2] The government stuck to the view that the arch was only listed Grade II and was therefore expendable and that the cost of moving it, which they set at £190,000, was unacceptable. Demolition commenced and was completed by April 1962.

Britain's Lost Railways is not an exercise in nostalgia. There is more than enough nostalgia about railways, as a glance through any bookseller's catalogue will prove. Some of what is pictured here had to go, and with good riddance – it was simply not worth keeping. But much lost railway architecture was so good that, by its destruction, we are all the losers. And not all the losses are tangible. Today, romance is the last thing that comes to mind when waiting for a train at one of the great London termini. They are clean and efficient (certainly compared with fifty years ago) but extremely busy and, above all, incredibly noisy with constant warnings and advice, some necessary, some profoundly irritating, every few minutes.

But it wasn't always like this.

Railway stations were once intensely romantic places. There was a sense of *otherness* to them, as though they were in some way detached from the outside world. True, there were kiosks of W. H. Smith's, Wymans or John Menzies selling little but newspapers, books and magazines, the stalls of the Empire Fruit Co. and the sweet shops of Maynards. But these were merely a prelude to travel; one did not go to stations for a retail experience – to buy *stuff*. They were not extensions of high streets or Oxford Street. No, they were a point of departure for far-off places, a process accompanied by arcane ritual – even into the 1960s, the stationmasters of the great London stations wore silk hats.

It was at the great London termini and provincial stations that one encountered this romance, this sense of possibility, to the full. The names of the trains helped – the *Royal Scot*, the *Queen of Scots*, the *Cornish Riviera Limited*, the *Cathedrals Express*, the *Red Dragon*, the *Golden Arrow*, the *Atlantic Coast Express* – as did the names of the steam locomotives themselves – *Wolf of Badenoch*, *Hyperion*, *Quicksilver*, *Lord of the Isles*.

The architecture added to that sense of anticipation. Today, we have bright, even lighting seemingly everywhere on the station, certainly around the concourse, if not on the further extremities of the platform. What we have lost, above all, is *chiaroscuro*, the bright gleams of sunlight shining through patches of utter darkness that gave the great termini in the 1950s and '60s so much of their mystique. The soaring roofs were often half obscured in a sepulchral gloom, an intoxicating if unhealthy mix of locomotive exhausts and fog. Colours, too, were generally muted and layers of soot covered most of the surfaces.

G. K. Chesterton wrote in 1909 that:

> . . . you will find in a railway station much of the quietude and consolation of a cathedral. It has many of the characteristics of a great ecclesiastical building; it has vast arches, void

spaces, coloured lights, and above all, it has recurrence of ritual. It is dedicated to the celebration of fire and water, the prime elements of all human ceremonial.[3]

Along with *chiaroscuro*, it is this quietude that has largely vanished but along with it, so have many of the stations themselves, either wholly or in part.

The old Euston may have been an awkward place to operate but it had an almost palpable grandeur that came partly from age but more from the magnificence of its architecture. Coming by foot from Euston Road, one walked through what might almost have been a series of stage sets – past the two outer lodges (still there) where the view was blocked by the bulk of the Euston Hotel. Passing under this, the arch (I will call it that although, strictly, it is a propylaeum) stood before one in all its sublime splendour in what was almost a square. Passing through it, one entered an inner courtyard, covered with an awning, before walking through into the architectural climax of it all, the Great Hall, one of the most magnificent Victorian interiors in London, presided over by the large statue of George Stephenson. From here one would walk to the impressive, if grimy, train shed. In passing from one enclosed space to another, with views blocked, one experienced classic townscape of the type advocated by Gordon Cullen.

It was demolished between 1961 and 1964.

Nottingham Victoria was a much later addition to the railway network, one of the great provincial stations. Built in 1900, it represented all that was most up to date in station design with two wide island platforms reached by a broad footbridge from a spacious booking hall. Even suffering neglect, as it was in its final years, the quality of its construction still shone through. As the platforms were located deep in a cutting, buff glazed tiles were used to face the buildings on them, which, with the excellence of the brickwork, gave the station a hard-edged feel to it, mitigated by the Northern Renaissance treatment of the principal station building. This, with its extensive use of Darley Dale stone for decoration, would have passed muster for a town hall in some Flemish port. It was a glorious affair, beautifully proportioned in its slight asymmetry and its façade given tremendous vigour by the heavy blocking of the paired attached columns at first floor level and the rhythm set up by the repetition of elegant pedimented gables. But my abiding, if faint, memory of it, on the one return trip to Sheffield that I made on the Great Central line in 1959, was of steam rising amidst the gloom under the cavernous glass roof.

It was demolished, save for the clock tower, in 1967.

Country stations had character of a quite different sort. Some were just quaint, like the miscellaneous sheds and old carriage bodies that sufficed on the more out-of-the-way branch lines; others had a charm and a quality that enabled them to fit perfectly into the towns and villages they served. Take the station at Midhurst, built in the Domestic Revival style so popular in the home counties in the 1880s. Warm red brick, half timbering and tile hanging were in perfect harmony with the building materials of that most attractive of West Sussex towns. The detailing was exquisite, a porch with turned posts, coved eaves, turned brackets everywhere and the company's initials and the date of building on two stone panels. And that was just part of it. Neat valancing around the canopy, stained glass in the upper lights of the windows, doors with circular lights, ridge tiles, sunflowers incised into plaster and cut into the timber of the porch. And even a miniature signal box on the platform in matching style boasting a tiled roof with the same ridge tiles. When I saw it, the place was

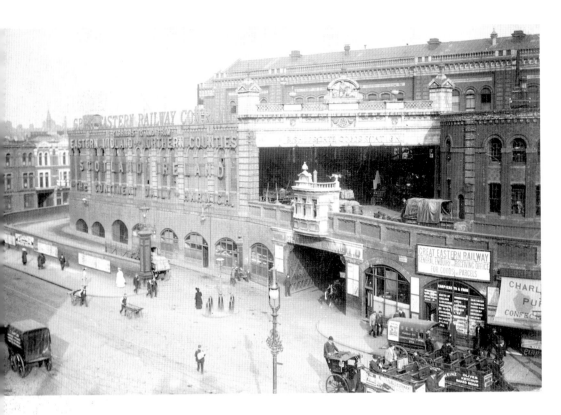

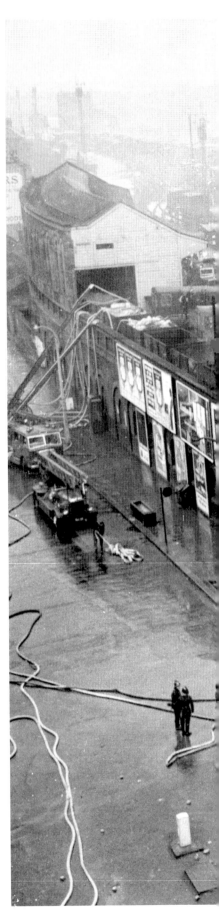

The former Bishopsgate terminus of the Eastern Counties Railway became the Great Eastern Railway's principal London goods depot when the line was extended to its new terminus at Liverpool Street in 1874–5. The station buildings of 1848–9 by Sancton Wood were replaced by purpose-built warehouses erected in 1881 on the raised land. The complex is seen in a postcard view of c. 1905. *Lens of Sutton Collection*

A devastating fire on 5 December 1964 saw the closure of the goods depot and the area was used for storage and car parking for almost forty years, with redevelopment commencing only after years of plans and public inquiries. This view was taken in the immediate aftermath of the fire with fire crews still present, damping down the smouldering ruins. *Robert Humm Collection*

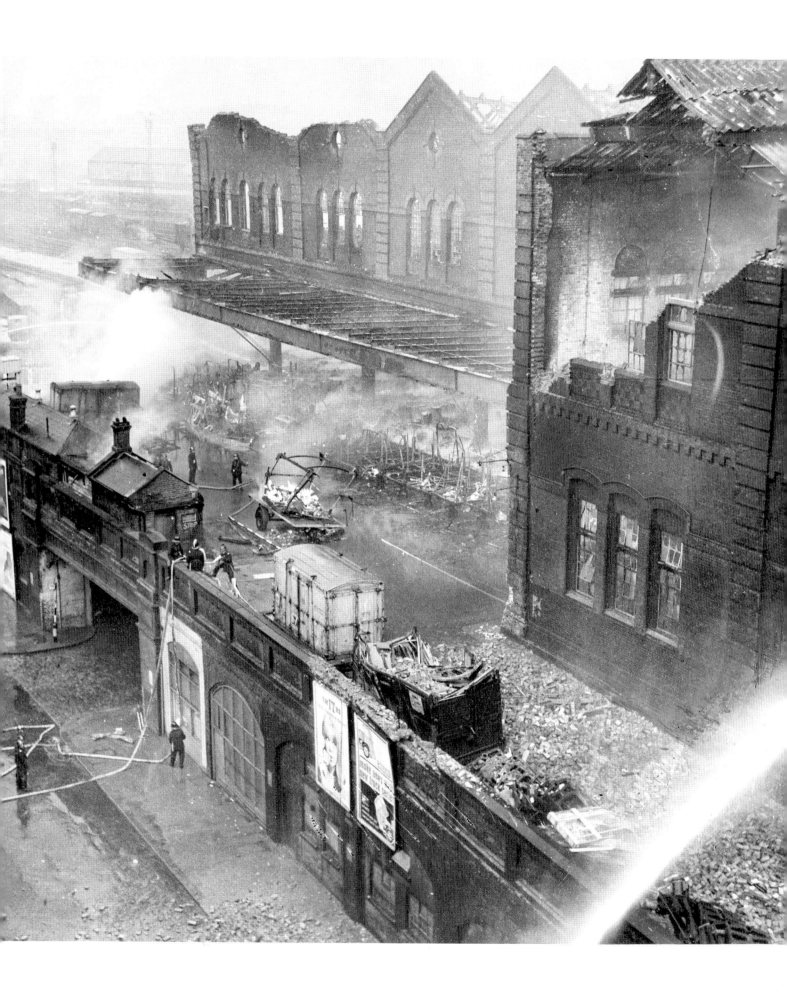

derelict, all windows broken, all doors open. But at least I have the photographs.

It was demolished in 1969.

All three stations were superb examples of craftsmanship – and now all are gone, to be replaced with what? A grim, dingy, concrete bunker of a station, itself due for replacement, an Arndale Centre (the retained clock tower looks woefully out of place – a veritable pearl among swine) and a housing estate that could be anywhere – a poor exchange indeed.

And it's not just stations that we have lost. Take the great viaduct at Belah which stood so impossibly high above the wastes of Westmorland on the lonely line that crossed the Pennine chain at Stainmore summit, at 1370ft the highest in England. Its iron trestles were so spindly that they seemed barely capable of supporting the weight of the lengthy iron ore, coke and limestone trains that used the route. An early 1860s account said of it that 'seen in a clear moonlight, when the snow is on the ground or a fleecy cloud of mist partly envelops it, and one of the long trains happens to be passing, the whole appears to be more like the work of enchantment than a very solid reality'. It was a sight that contemporaries expected to last a long time. A document deposited in the central pier included a poem that declared:

> Westmorland's honour form'd by the skill of man
> Shall ever o'er thy spacious landscape span+

It lasted just over 100 years. Belah viaduct was demolished in 1963.

All we have left of these magnificent buildings and structures are drawings and photographs. The story of their demise was repeated across Great Britain in the 1960s and '70s. It is the theme of this book.

In 2003, Gordon Biddle's invaluable and comprehensive *Britain's Historic Railway Buildings* was published (a revised edition followed in 2011). It is a gazetteer of what still exists. The present work, as its title suggests, is a memorial to what we have lost. It is aimed at those whose interests lie in architecture rather than railways and some of my railway-minded readers may find explanations of aspects of the subject a little obvious. I hope that they will nonetheless find plenty to interest them. My intention has been to give an idea of the range of railway buildings and structures that have been lost and to try and include the typical as well as the extraordinary. The process of destruction has been going on since the dawn of the railway age and I have included some buildings that were demolished well over 100 years ago, in some cases illustrating them with the only photographs known to exist. The emphasis is on the main line companies rather than minor or narrow gauge railways, although there are some examples taken from these in the pages that follow. In a number of cases, the stations or lines remain open, in others, the lines themselves are closed, but the one thing that unites all the buildings and structures in this book is that they are no more: all we have left is the image.

Often, their disappearance was inevitable. Redundancy and changes in the way in which we live our lives led to considerable destruction of obsolete railway buildings and structures. This was by no means confined to Great Britain: exactly the same process can be seen in the USA or Europe but, in the 1960s and 70s, the rate of destruction in Great Britain was probably higher than elsewhere. However, increased understanding of railway architecture, coupled with a growing awareness of the quality of Victorian buildings, has led to it being appreciated to a much greater degree and much of the best of it now enjoys some statutory protection.

LOSS

The demolition of the Euston arch was symptomatic of an attitude towards Victorian buildings that saw them as expendable, as embarrassing relics of a time that many modernists, in particular, had difficulty in coming to terms with. In 1959, the eminent British modernist architect Trevor Dannatt spoke for many when he wrote, 'We still await the moment when British railways will rise in their majesty and sweep away the junk of a century.'[5] While the great Victorian stations were appreciated for their engineering, their architecture was derided. Professor A. E. Richardson said in a lecture to the RIBA in 1939, after praising Barlow's iron roof, 'How fine St Pancras le Vault would look if Lord Stamp [the President of the London Midland and Scottish Railway] would consent to the removal of the expensive Gothic hotel, now almost derelict.'[6]

Railway architecture was considered to be of so little interest once the initial novelty had worn off that, although newly built major stations received mention in the architectural journals and more extended notice in those dealing with engineering, no books appeared on the subject after the 1850s until almost 100 years later.

In 1950, Art & Technics Ltd, a most enterprising publisher who issued a number of pioneering monographs, published Christian Barman's *An Introduction to Railway Architecture*. It was the first time anyone had written a book on the subject treating it from the historical point of view and it was to be many years before any others appeared. Barman pointed out that railway architecture provided 'in itself a complete epitome of the architectural movements of nineteenth century England'.[7]

Christian Barman FRIBA (1898–1980) was a figure of considerable influence in the architectural world of the 1940s. Joint editor of the *Architectural Review* between 1927 and 1931 and a former editor of the *Architects' Journal*, he had worked for Frank Pick as Publicity Officer to the London Passenger Transport Board from 1935 to 1941 and was to write Pick's biography. He was able to say in 1950 that the great majority of Victorian stations survived. Indeed, most remained in a time warp well into the 1960s. Comparison of photographs of most of them taken at the turn of the century and in the mid 1960s would reveal little change. Gas lit and retaining those idiosyncratic details of signage, fencing and ancillary structures, they remained as monuments to the steam age in which they were built.

From the end of the sixties, the position radically changed. The successes achieved in certain well-publicised instances have obscured the sheer scale of the losses. The great majority of those Victorian buildings that were extant when Barman was writing have been destroyed in the last fifty years. Barman chose some outstanding buildings as the subjects for his illustrations. Of those, fifteen have subsequently been demolished. In large areas of the country, the Victorian railway infrastructure, at least in terms of buildings, has effectively vanished. Throughout much of urban Lancashire and Yorkshire, on Tyneside and Teesside, and in South Wales, there are no more than a handful of Victorian stations left through a combination of an official policy of demolition in the late 1960s and '70s and the effects of the inevitable vandalism that follows in the wake of de-staffing stations. In the south, the position is rather happier as more stations remain open and staffed for at least part of the day.

While there is no way in which we could expect to save, or indeed wish to save, everything (only the Church of England, the National Trust and British Waterways are believed to have a larger number of listed buildings and structures in their care

▷ The great cause célèbre of the conservation movement, the Euston arch has to be included in any compilation of lost railway buildings. This is perhaps the earliest photograph of it to have survived, depicting it in its original state before the word 'Euston' was incised across its entablature in 1870. Philip Hardwick's great structure with its lodges stands proud, without the offices added in 1881 on both the east and west sides of the station yard cluttering the view. The roof of the Great Hall is clearly visible above that of the offices fronting it. The gates in front of the arch provide an unfamiliar note. *London Stereoscopic Co./Getty Images*

▽ The Euston arch meets its end early in 1962. Or is it the end? Will we see it rise again, using the stone blocks discovered in recent years, to form the gateway to a new Euston? *National Railway Museum/Science & Society Picture Library*

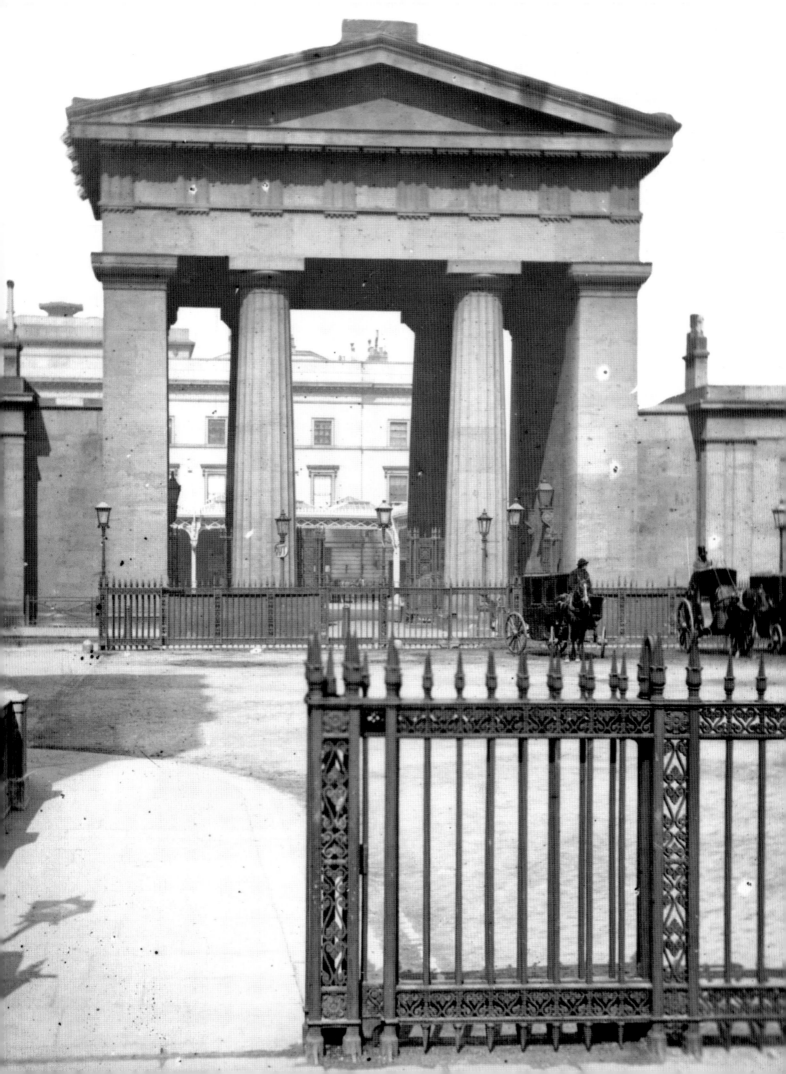

than Network Rail), nevertheless the buildings lost include a range of work of extraordinary quality. Wholesale demolition of Victorian buildings of all types was only to be expected in the 1950s and 1960s when they were generally unappreciated, but much destruction of railway structures has taken place within the last forty years. The small wayside stations, both urban and rural, have been at the heart of the destruction, which is particularly regrettable as Barman felt that it was in these minor stations that "the special idiom of railway architecture is found in its strongest and purest form. No country in the world has a collection of minor stations that can begin to compare with ours for sheer quality."[8]

To take just one company, the London, Brighton & South Coast Railway, located in the part of the country where the survival rates for stations are far higher than elsewhere, some of the most striking losses were the last remaining examples of David Mocatta's small stations for the London & Brighton Railway (which merged with the London & Croydon Railway in 1846 to form the LB&SCR). Hassocks was built in 1841 and demolished in 1973. When replaced by a commodious station designed by the Preston architect, T.H. Myres, in 1883, this Italianate building was converted into a cottage retaining much of its original appearance. Two other Mocatta stations survived into recent times at Horley and Three Bridges. Horley, rebuilt with an upper floor in 1862, was in a neo-Jacobean style, and survived long after its replacement as a station in 1905 as staff accommodation, finally being demolished at the end of the 1960s. Three Bridges, an Italianate building with paired round-headed windows similar to those at Hassocks, went as recently as 1985, as did a fine iron roof for which the Horseley Iron Company was awarded a contract in 1860.[9]

Along the south coast, the original stations for Littlehampton and Bognor, which were opened in 1846 and situated at Lyminster (closed 1863) and Woodgate (closed 1864) respectively, were good examples of a style derived from the local vernacular using knapped flints with red brick quoins and survived largely unaltered since closure. Both were demolished, Littlehampton in the early 1970s and Bognor in the 1980s. A further station of 1846, Yapton, also closed in 1864, was gutted by fire in January 2011. None of these survivals from the dawn of railways in Sussex have been properly recorded. In the London area, the station at Anerley built by the London & Croydon Railway c. 1845 was distinguished by some charming details derived from contemporary cottage ornée designs, including a castellated parapet to part of the station house and a porch enlivened by carved faces. Following a fire in the late 1980s, it was demolished almost overnight. It had been an entry in Gordon Biddle and O.S. Nock's *The Railway Heritage of Britain* (1983) but inclusion in this excellent survey was no guarantee of preservation; the early Italianate station building at Burgess Hill was illustrated but demolished a few years later.

It is not just total destruction that we have seen. Gross mutilation of buildings by the removal of features that formed an integral part of their design has been widespread. In particular, the removal of canopies changes a building's appearance dramatically and insensitive repairs have done much to damage the visual harmony of stations. A case in point is the London-bound platform at Hove, where attractive valancing of characteristic LB&SCR pattern has been replaced by corrugated steel of the type used to clad out-of-town retail warehouses; similar work has been undertaken at the stations on the Brighton line at Streatham Common and Thornton Heath.

This is just one railway company, and one that has fared relatively well, but the pattern is repeated throughout the country. One thinks of the (listed) 1848

structure at Newmarket. It was described by Barman in the following terms: 'There is nothing in English railway architecture quite like the exciting Baroque orangery forms of the original Newmarket station. This building . . . show[s] hieratic station design in the highest stage of its development.'[10] It was torn down in 1981. The North Staffordshire Railway had some lovely neo-Tudor stations on its Churnet Valley line, opened in 1849. All but two of them have gone. Brunel's Great Western Railway from Paddington to Bristol has been proposed as a World Heritage Site although few of the stations designed by Brunel remain in existence. Yet in the mid 1960s, a number of early wayside stations of Brunel design at Shrivenham, Minety & Ashton Keynes and Brimscombe survived, only to be demolished when stopping services were withdrawn. As late as 1976, the listed Brunel station at Stonehouse, Gloucestershire, was pulled down, after British Railways threatened to close it unless consent was given for its destruction.[11] Nor is destruction confined to England; the soaring roof of Glasgow St Enoch, the Scottish Baronial grandeur of Dundee West and the eccentric charm of Oban come to mind.

As far back as the nineteenth century itself, British railway architecture had suffered a bad press. Ruskin, who had little time for railways, said that:

> Another of the strange and evil tendencies of the present day is to the decoration of the railroad station. Now, if there be any place in the world in which people are deprived of that portion of temper and discretion which is necessary to the contemplation of beauty, it is there. It is the very temple of discomfort . . . Better bury gold in embankments than put it in ornaments on the stations . . . Will any single traveller be willing to pay an increased fare on the South Western, because the columns of the terminus are covered with patterns from Nineveh?[12]

In 1891, *The Building News* declared that 'railway companies have rarely given much attention to their stations', describing many of them as 'draughty and comfortless', especially those in urban areas:

> We are pretty well familiar with the description of buildings, or rather sheds, erected along the route of a main line. Let us take as an example, those put up on the metropolitan and suburban lines. These are generally a flat lean-to of the whole width of the platform, with a cut fringe boarding scalloped on the lower edge, sloping from the permanent way to the outer side of the platform. Under this shed, the waiting, refreshment and booking offices are placed, generally clap-boarded structures on framed uprights and cross-bracing. Sometimes the shed is simply tacked on to offices in front of them.[13]

Perhaps unconsciously, the writer in *The Building News* had identified some key elements of what we may call 'Railway Vernacular'. There is a distinction in railway architecture as in other fields of architecture between the polite and the vernacular. Principal station buildings would frequently be 'polite', drawing upon historical styles fashionable at the time in domestic or commercial buildings. While the station buildings themselves derived their inspiration from past styles, be they Classical or Gothic, Tudor or Italianate, and their form from other building types such as estate lodges and cottages, these railway vernacular buildings were something new. Functional they might be but they were nonetheless designed with an eye to their appearance, with good proportions and an appropriate level of decoration. It is these

vernacular structures that have been decimated over the half century and remain most at risk. Until recently, they have seldom been considered of sufficient architectural interest to be listed. This may be a reflection of an attitude that prevailed for many years, certainly into the 1980s, that saw railway architecture in art-historical terms, placing greater emphasis on formal architectural quality than on function, which meant that much greater consideration was given to the 'polite' station architecture than to more utilitarian buildings such as goods warehouses. However, many ancillary structures are buildings of definite character that represent a distinctively Victorian solution to the problems of accommodating the passengers and staff of a new mode of transport, their designers frequently displaying a willingness to make increased use of techniques such as prefabrication and of materials such as iron and glass in a variety of structures from goods sheds to signal boxes, from waiting shelters to canopies.

Waiting shelters are an especially threatened building type. Often built of wood and therefore expensive to maintain, they have been replaced in considerable numbers by what are basically bus shelters. A waiting shelter of 1853 at Lancing,[14] one of the earliest examples of this building type to survive into recent years, with a tiled roof, almost ecclesiastical in pitch, and possessing original iron window frames with diamond pattern glazing bars, was pulled down in 1984. A reduction to single track of the line to Uckfield resulted in the demolition of the 1894 timber shelter at Buxted,[15] a characteristic example of the LB&SCR's standard but attractive design.

Signal boxes, utilitarian yet often delightful structures, which manage to combine function and decoration to an extraordinary degree, have been reduced in number from 9–10,000 in 1948 to just under 500 today.[16] On closure, the great majority have been destroyed as a matter of course as, being located close to the running lines for operational reasons, it is difficult to convert them to other uses unless removed to another site. Some of the earliest designs survived into recent years but have been destroyed largely because few people recognised their significance as important markers in the evolution of a distinctive nineteenth-century building type. An insignificant timber hut at Tilbury used as a storage shed until the 1970s was the last remaining example of the first type of signal box used anywhere in the world. It dated from 1854 but was a direct descendant of a design first used by C.H. Gregory, engineer of the London & Croydon Railway at Bricklayers Arms Junction in 1843–4, having a simple wooden platform with the levers used to control the signals mounted on it and a small hut for the signalman behind.[17] A large number of signal boxes dating back to the 1860s have gone in relatively recent years, examples being the 1863 box at Hardham Junction near Pulborough, one of the earliest boxes to be built by the leading signalling contractors, Saxby & Farmer, and raised up high above the ground on massive wooden posts (demolished 1967),[18] and the 1869 structure at Kemp Town Junction, Brighton, demolished in the mid 1980s.

The loss of wagonload goods traffic has led to the extinction of local goods yards and, along with them, the goods warehouses and stables that served them. Of fifty-seven goods warehouses in the north-west recorded as extant between 1982 and 1988, twenty (35 per cent) have subsequently been demolished.[19] Especially in the south-east, the pressures of demand from car owners have led to the yards being levelled for use as car parks with the loss of any buildings standing in them. Many of these buildings fell within what J. M. Richards described as the 'Functional Tradition'. One of the few railway buildings to be mentioned in Nairn and Pevsner's *Sussex*,

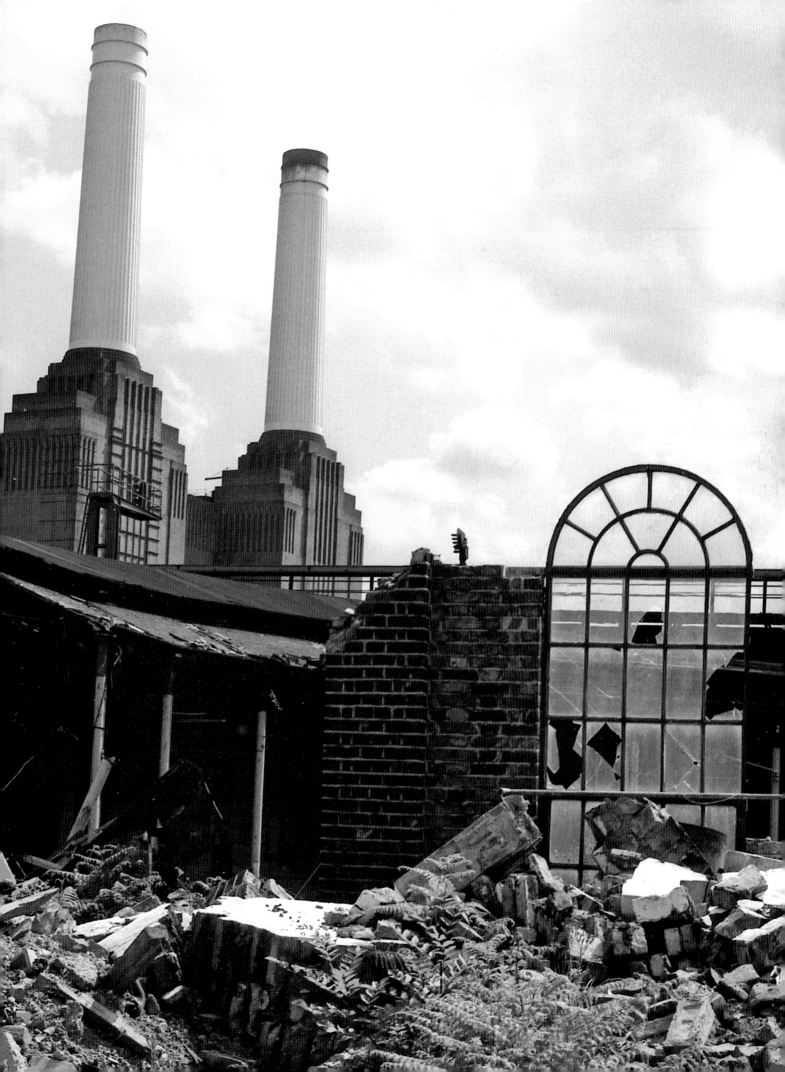

the goods shed at Steyning (1861), was described as 'Still Georgian in proportions and delicacy'.[20] Together with similar structures at Seaford, Littlehampton and East Grinstead, it has been demolished although an example of the same design remains at Arundel. The 1846 warehouse at Lewes survived many years following closure, finally disappearing in the late eighties. A warehouse at Staplehurst, also built in 1846, specifically for the hop traffic, together with a terrace of railway cottages of 1848, all went in a redevelopment of about 1986.

RAILWAY BUILDINGS AND THE HISTORIAN

The subject has not received the degree of study that it warrants from those professionally involved either as architectural historians or industrial archaeologists. Their attitude has, perhaps, been that it is best left to the railway enthusiast. But much of the enthusiasts' interests remain narrowly focussed, either in terms of subject with an emphasis very much on locomotives and train working or in allegiance to a single railway company. In comparison to other building types, there is little in the way of specialist conferences or study days. Although railway buildings have been with us for nearly 200 years, they have not received the same attention as churches, country houses, hospitals, cotton mills, or working class housing. Certainly, there is much more to investigate in terms of identifying the architects and engineers responsible for specific buildings and in dating individual buildings. The range of sources is vast; besides the company minute books in the National Archives at Kew, there are the local newspapers which often explain why stations were rebuilt, with their accounts of public agitation for better facilities.[21] There are the official photographs, local view postcards and the countless photographs taken by amateurs over the years. Original drawings survive in Network Rail's archives, the south-east being especially well catered for in this respect. Others have found their way into record offices.

This material has been systematically worked through by only a few historians; Bill Fawcett's magisterial work on the architecture of the North Eastern Railway shows just how much can be gained by drawing upon the records still in railway hands.[22] Nothing like the same degree of research has been carried out on the buildings of other major companies such as the LNWR.

Unlike the United States where railway history has long been a legitimate branch of historical enquiry, in Britain the subject has only recently received academic recognition with the formation of the Institute of Railway Studies at the University of York in 1995. The term 'anorak' has been used in recent years to describe or denigrate anyone interested in railways. This is not entirely a new phenomenon. Peter Mathias, writing in 1972, memorably described railway history as practised by enthusiasts as being 'an extraordinary chapter in British historiography', their work being 'almost wholly antiquarian in nature, parochial even for the history of technology which forms the central feature of the genre'.[23] Sir Neil Cossons (then Director of the Science Museum, later Chairman of English Heritage) raised a storm back in 1993 when he suggested that railway enthusiasm was a harmless hobby but had little significance beyond that.[24] These comments were rather predictably followed by outpourings of fury from some sections of the railway press, but Cossons' view that the enthusiast body has a tendency to narrowness and a passion for certain aspects of the subject, to the almost total exclusion of others, has more than a degree of truth to it. A glance

at the mainstream railway magazines reveals that their readers are still largely fixated on motive power, be it steam, diesel or electric, with by far the majority of articles and illustrations devoted to it. As an example of this blinkered vision, the demolition of the magnificent pair of locomotive roundhouses, the earlier of which dated from 1869, at Battersea Park in the early 1980s went unnoticed in the railway press, and the failure to fully record these important structures which had survived largely unaltered as a road haulage depot since their closure as an engine shed in 1934 is a matter for regret. The roundhouse at Chalk Farm is well known to many, Londoners and architectural historians alike, but few people realise that south London once had three roundhouses at Battersea (the third was reduced to merely its external walls many years ago).

However, one should not overlook the contribution made by many gifted amateurs to the history of railway architecture. A team from the Great Eastern Railway Society has catalogued several thousand drawings relating to that company in partnership with Network Rail at their Waterloo plans archive. Much work has been done to record buildings that would otherwise have passed unrecorded. The difficulty is that much of this work is hidden away in publications, such as journals published under the auspices of societies whose remit is the history of an individual railway company (such as the aforementioned Great Eastern Railway Society), that are simply overlooked by architectural historians. Most of the monographs are issued by specialist transport publishers and are consequently seldom reviewed outside the railway press. Nor do they find their way into bookshops where they might be seen by a wider public.

What seems extraordinary in retrospect is the length of time that elapsed between the publication of Barman's study and the subsequent works that have been produced. Leaving aside Carroll Meeks's *The Railway Station* of 1956, which also dealt extensively with American and European practice, there was a gap of nearly twenty years before a number of important books came out, including David Lloyd and Donald Insall's slim but useful *Railway Station Architecture* (1967), reprinted from the journal *Industrial Archaeology*, which provided a shortlist, based on one drawn up by the Victorian Society, of sixty stations worthy of preservation (although this was entirely on architectural rather than functional grounds). Of these, seven have subsequently been fully or partly demolished. There followed Jack Simmons's *St Pancras Station* (1968), Alan A. Jackson's *London's Termini* (1969) and Gordon Biddle's *Victorian Stations* (1973), the first and still the only comprehensive survey of the smaller British station. Since then there has been an upsurge in writing on railway architecture, much of it in the form of monographs on the buildings of individual railway companies.

There is still a great deal of work to be done on railway architecture, particularly on the smaller stations as opposed to the great termini, and the tendency for the subject to be studied on the basis of individual companies leads to interesting cross-currents being missed. It was often the engineer of a particular line, rather than an architect, who was responsible for the design of buildings, and this can lead to similar structures appearing in totally different parts of the country. Similar buildings were erected on branch lines to Highworth in Wiltshire, Hemyock in Devon and Southwold in Suffolk. Research has shown that all were the work of a Westminster based engineer, Arthur Cadlick Pain.[25] Philip Brown has drawn attention to the fact that stations on the Bristol & Gloucester Railway and the Southampton & Dorchester

▷ Conversation piece at Victoria station, framed by the elegant platform gates put in at the time of rebuilding in 1908. Although the Grosvenor Hotel, the side wall and the concourse survive at the London, Brighton & South Coast Railway's Victoria station, the 1908 train shed seen here was destroyed for the building of a large office block above the tracks – Fenchurch Street and Charing Cross have both suffered the same fate. The photograph is by John Gay, and was one of the photographs he took as illustrations for John Betjeman's *London's Historic Railway Stations* (John Murray, 1972) although this view, dating from *c.* 1969, was not used. The bowler-hatted gentleman, the railway staff in the characteristic BR uniform of the late 1960s, the platform ticket machine and the pre-war Southern electric on the right sum up a lost era. *John Gay/English Heritage NMR*

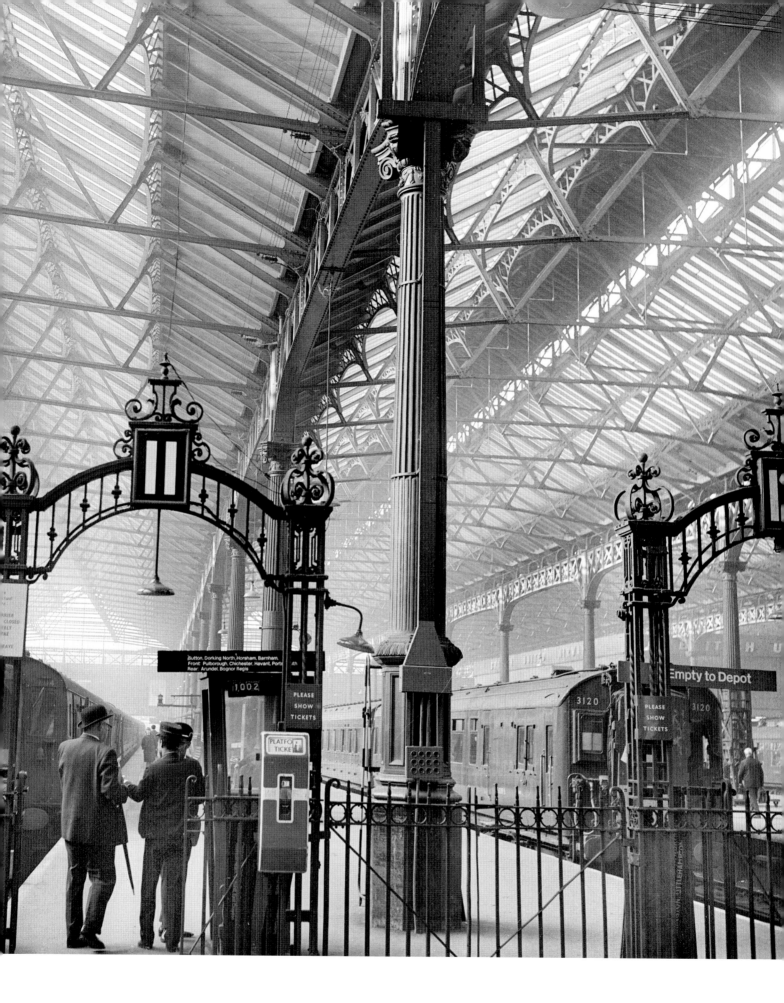

Railway had much in common; Captain W.S. Moorsom was the engineer to both companies.[26] George Hopkins used closely related designs of stations on the Ely & Newmarket Railway in 1879 and on the Maidstone & Ashford Railway of 1884. Some very similar buildings then appeared on the London, Tilbury & Southend Railway in the 1880s.[27] The need for further research is clear.

WHY ARE RAILWAY BUILDINGS DEMOLISHED?

Put simply, the answer is redundancy. As with any building, railway buildings are built to serve a purpose. When that purpose is no longer served, unless a new use can be found for them, they are demolished.

The process of destruction has been going on from the earliest days. As traffic expanded and as technology developed, the earliest buildings to serve the railway rapidly became obsolete, no longer large enough to serve traffic needs. In some cases, they were enlarged, in more out of the way places, such as the intermediate stations on the Newcastle & Carlisle Railway, they survived but the majority were demolished after a relatively short life. This particularly applied to stations in major towns and cities such as at Leeds, where the North Midland Railway terminus by Francis Thompson of 1840 was demolished in the 1850s and replaced by a goods station.

In other cases, it became necessary to re-site a station closer to the centre of a town. The old station would then frequently be converted to a goods station, as at Sheffield where the original terminus at Wicker was subsequently replaced. Alternatively, what was built as a terminus became part of a new through route and again the former station would be rendered redundant, as at Weston-super-Mare.

Sometimes fashion comes into the equation, certainly by the 1920s. What was seen as a hotchpotch of unrelated and dated structures constructed over the years forming an untidy and dirty mess was swept away to be replaced by something clean, modern and efficient, such as the rebuilding of some Southern stations in the 1920s and '30s, among them Wimbledon, Richmond and Kingston upon Thames. Sometimes the initiative was taken by the railway itself, more often it was the result of pressure from the local authority over a long period of time to do something to a public building that reflected badly on the town's image. Victorian architecture had become unfashionable and remained so until the 1960s. Grimy Victorian stations, in the wake of the 1955 Modernisation Programme, did not project the required image of modernity, and were seen, just like filthy steam locomotives, as objects to be swept away and replaced with something new. However, this was on a limited scale and confined to those lines such as the routes from Manchester and Liverpool to Crewe, where station rebuilding could be undertaken as part of the total transformation by electrification of the lines concerned.

The changes began to set in with the introduction of diesel multiple units from 1954 onwards. Until then, train services and the procedures to operate them had changed little since before the First World War. Budgetary controls were ineffective and, into the 1960s, the prevailing culture for maintaining the stock of railway buildings could best be described as one of leave well alone, carrying out repainting but often neglecting basic maintenance so that underlying structural problems became acute. Many wayside stations, especially in industrial areas, fell increasingly into dereliction. For example, views taken in the 1960s of Middleton, Lancashire,

show a station that appears to have been abandoned, although still seeing a regular passenger service.[28]

The 1960s saw a steady reduction in the number of staff at stations, leading eventually in many cases to complete destaffing. Those staff that did remain had much higher expectations as to their working conditions – as the 1970s and '80s passed, they were not willing to work in the same conditions as their Edwardian forbears, while health and safety legislation forced major changes to be made. It was often much easier to provide conditions that complied with these requirements in new premises than to renovate outworn buildings.

Demolition was often a consequence of operational needs. Many lines have been widened from two to four tracks since the middle of the nineteenth century and in consequence stations along these stretches of line have had to be rebuilt, as at Beningbrough. New junctions or new lines have sometimes caused demolition; for example the Channel Tunnel Rail Link resulted in the demolition of the former London Chatham & Dover Railway Ashford station, closed since 1899, but which had survived as a goods station and later offices.

Changing technology is another important factor. It has led in particular to the widespread destruction of signal boxes. The number of traditional mechanically operated boxes has been dramatically reduced in the past sixty years. The enhanced train frequencies and reduced manning of signalling installations have led to irresistible pressure to remove these attractive buildings. Because of their location, close to the tracks and often in isolated locations with no separate access, they cannot, as a rule, be left standing where they are a target for vandalism and their best hope is often dismantling and removal to a less hostile location. They are often quite literally in the way of new track layouts which pass over their site. Goods warehouses – both the small structures in country goods yards and those that towered sublimely over northern industrial districts such as Ancoats – are also the victims of technological change. The type of wagonload traffic for which they were used no longer exists on today's railway – only bulk traffic that does not need to be unloaded and stored in railside warehouses is to be found. The advent of containerisation in the late 1960s put the final nail in the coffin, and mechanised warehousing with fork-lifts shifting pallets in huge single-storey sheds is the contemporary equivalent. The ending of steam traction in 1968 led to the removal of most engine sheds, save for a few converted to electric or diesel traction depots or to other uses such as wagon repair depots. With them went the facilities for servicing the steam locomotive such as the great concrete coaling towers put up from the 1920s onwards.

Destruction through bombing or fire has taken a number of stations, particularly in cities. Holborn Viaduct lost its hotel to enemy action. While, in many cases, the stations concerned were patched up to last, on occasion, an additional twenty years (Forest Hill, hit by a flying bomb in 1944, remained a gaunt ruin, its windows open to the sky, until 1972), ultimately such destruction was taken as presenting an opportunity for rebuilding.

Deliberate demolition has increasingly been a feature since the 1960s. Victorian buildings, often larger than are needed for today's traffic, are expensive to maintain, with much wood that needs to be painted regularly. Coupled with this is the practice of destaffing stations, either completely or for long periods of the day. It is much easier to replace large, dilapidated and buildings, expensive to maintain, with a simple brick or glass shelter than to carry out repairs. Destaffing, which got going in the

1960s, coincided with a rapid escalation of vandalism, which still further encouraged the process. From around 1969, it became normal practice, particularly in urban areas in the north, to demolish all existing buildings when stations were destaffed and replace them with what were essentially bus shelters. In December 1969, the London Midland Region announced the removal of station awnings and the replacement of most platform buildings by bus stop type shelters on the Liverpool–Southport line.[29] The same region adopted a policy of demolishing all timber buildings on the Hope Valley line between Chinley and Sheffield on the grounds that they were too expensive to maintain. Something similar occurred in the South Wales valleys where a station reconstruction programme was launched in 1971, resulting in the erection of vandal-proof brick or concrete shelters, described as 'neater and cheaper to maintain' than the Victorian buildings they replaced at 27 stations.[30] The Southern Region, too, from 1966 adopted a programme of replacing many of its existing run-down stations with prefabricated CLASP buildings, a system originally developed for schools. In addition, timber waiting sheds were in many cases replaced by new shelters, initially of the bus shelter pattern, but more recently in somewhat more stylish glass designs. Crude repairs, using extruded metal to replace ornate timber valancing, are another symptom of this desire to save on maintenance costs.

Another significant cause of demolition has been closure both of stations and entire lines. While closures are generally associated with Dr Beeching in the 1960s, the process started much earlier than that. It began in some areas as early as the first years of the twentieth century, when some inner suburban stations began to feel the effect of competition from the newly electrified tramways. Economies during the First World War led to the temporary suspension of services on many lightly used lines and, while many subsequently reopened after 1918, some did not. The depression in the 1930s hit the railways as badly as any other industry and, in 1930 alone, passenger services were withdrawn from 323 route miles of track.[31] Closures continued throughout the 1930s and beyond until the great wave of Beeching cuts removed local stations from many main lines and left large areas of the country with no rail services at all.

The effect on buildings has been more difficult to measure. Many of the lines closed in the 1930s remained open for goods traffic and the infrastructure did not alter significantly in many cases. 'Ghost' stations, occupied by railway staff, still with nameboards, their paint peeling and the platforms grass grown, continued a shadowy existence into the 1960s. Many stations remained as staff accommodation or were sold off. The 1960s closures resulted in much more destruction. Those local stations along main lines were generally demolished, partly because there was no longer such a need for staff accommodation with staff preferring to buy their own property than rent from their employer, partly because BR was reluctant to have people living a few feet from 100mph trains and this proximity would put off other potential purchasers. A great many of the stations on closed lines went too, especially those in urban areas, where site values were higher and the surroundings less attractive, but a considerable number of the station buildings on rural branch lines in attractive parts of the country survived to be turned into substantial and attractive houses, albeit often so extensively rebuilt as to be barely recognisable. Usually, it was only the main station building and perhaps the goods shed that were retained, signal boxes and timber waiting sheds and other smaller buildings often being demolished when the line was taken up. It was often something of a lottery as to which stations survived and which

did not. This had much to do with the complicated procedures for closing railway lines at the time. There was a requirement for BR to keep the route intact for two years before it was given consent to sell off the trackbed and structures.[32] During this time, stations often became derelict and decayed beyond the point of viable repair.

One major cause of reconstruction has been redevelopment for commercial purposes. This began at Birmingham New Street in the mid 1960s and reached its height in London in the 1980s with the development of air rights over Fenchurch Street, Cannon Street, Charing Cross and Victoria stations. Although the end blocks remained, the airy glass roofs were replaced by office blocks, giving a claustrophobic atmosphere at platform level. Stations have also gone as part of major shopping developments, as at Walsall or Welwyn Garden City, where the station buildings have been replaced with new ones incorporated into the new development.

Although the present-day traveller on the whole does not encounter the run-down semi-derelict buildings that his predecessors would have found in the 1960s, many of the supposedly vandal-proof buildings that represent the majority of stations in many parts of the country are the nadir of railway architecture and present an unwelcoming environment for the rail traveller. Visually, the modern station that deploys this defensive architecture can be in many cases a collection of massive unrelated structures – heavy poles carrying CCTV cameras, large mirrors, tall lamp standards, clunky security fencing – all a great contrast to the much more delicate forms of a traditional station with low gas lamps, painted timber fencing, rustic iron seats, buildings covered in light-painted decorative valancing, all softened by station gardens. Efficiency and economy both have a visual and social cost. Perhaps we have the architecture we deserve?

PROTECTION

The protection of railway buildings by listing came relatively late, reflecting attitudes towards Victorian architecture in the immediate post-war years; listing only began in 1947 and there was much else to identify. There were few listings until the 1960s, although John Dobson's Newcastle Central station was an early exception, listed in 1954. But even some of the most significant of all railway buildings, both now listed at Grade I, Stephenson's Liverpool & Manchester Railway terminus at Manchester and Brunel's station at Bristol Temple Meads were not listed until 1963 and 1966 respectively. Notoriously, St Pancras did not achieve Grade 1 listed status until 1967. Most railway listings, particularly of smaller stations, had to wait until the national accelerated re-survey that commenced in 1982 with even such early buildings as Micheldever (London & Southampton Railway, 1840) and Hexham (Newcastle & Carlisle Railway, 1835) not being listed until 1983 and 1988. An exception was made for some of Charles Holden's Underground stations, some of the first 1930s buildings to receive statutory protection in 1971, years ahead of many of the small stations of the 1840s.

Listing was even later for other types of railway building such as goods warehouses and signal boxes. Following the publication of the definitive *The Signal Box, a Pictorial History* in 1986, the Signalling Record Society identified some of the most significant boxes and this, together with recommendations from the National Railway Museum, formed the basis for subsequent listings intended to preserve

examples of each of the principal designs.

Management of listed railway buildings presents a number of challenges. Firstly, they are often still very much buildings in heavy daily use. They occupy what are often large and valuable sites in the centre of towns and cities. In this respect, they are perhaps little different from other public buildings. But in many cases, they do not lend themselves to re-use when redundant. Signal boxes are often located a few feet from high speed main lines, they may obstruct sight lines at level crossings and are often isolated on railway land with no road access. Much the same applies to many other railway buildings where safety is a paramount consideration.

Railway buildings are best not seen in isolation. Often built to standardised designs or at least to a recognisable house style, they can only be explained in the context of the development of a particular company's architecture. This has led to anomalies in the past whereby several examples of virtually identical standard designs have been listed but other individual designs of greater significance have not. Another problem is that a railway station is frequently more than the sum of its parts. In this respect, railway stations are no different to churches or country houses in that they are often an agglomeration of work of different periods and in diverse styles reflecting the changing needs and demands of their owners. They reflect both change and continuity in the way in which the central core has been extended over a long period of time to cater for the growth of traffic so that they are, in many cases, a palimpsest and this quality should be recognised.

If only the main station building is listed, it may stand in isolation, losing much of its impact through the removal of all the ancillary structures that surrounded it such as signal box, goods shed, awnings and waiting shelter, not to mention such details as traditional paling fences, light fittings and signage. These groups of buildings and details have, over the years, often been whittled away one by one so that what is left lacks coherence. This phenomenon was highlighted by the specialist in Great Eastern Railway architecture, George Pring, who pointed to the example of Thetford where the buildings comprised the original 1845 station with a red brick addition of 1889, a signal box of 1883 and a row of Norwich and Brandon Railway cottages also dating from 1845. Of these, only the 1845 station building was listed and the visual unity of the station as a whole remained under threat.[33]

English Heritage commissioned a review of listings of railway buildings and structures in 2001 and its division of railway history into a number of distinct epochs informed the criteria deployed when assessing for listing. Current guidance is based on the Selection Principles for Transport Buildings available on the English Heritage website www.english-heritage.org.uk, which sets out criteria on which railway buildings should be assessed and provides some indication of those building types that are especially rare. There is evidence of a movement away from the individual building to groups of buildings with the proposition that the completeness of the station complex is a factor that should be taken into consideration. The principles for selection for listing highlight the significance of early British railway buildings as being the first of their kind in the world. Later nineteenth century and twentieth century buildings that exist in much greater numbers have to possess considerable architectural or historical interest to be candidates. A number of post-war buildings such as Manchester Oxford Road station and Birmingham New Street signal box have met these criteria and been listed.

THE FUTURE OF THE RAILWAY'S PAST

What lessons have we learned since the destruction of the Euston arch in 1961? British Railways had shown little interest in its Victorian buildings in the 1950s and '60s but it was merely reflecting widespread public indifference to nineteenth century architecture. By the mid 1970s, BR, by continuing to demolish worthwhile buildings, was increasingly looking out of step with a new conservation-minded outlook. SAVE Britain's Heritage's 'Off the Rails' exhibition at RIBA's Heinz Gallery in 1977, with Binney and Pearce's influential *Railway Architecture* following in 1979, alerted many people to what we were in danger of losing. Simon Jenkins's fiery introduction to the companion booklet to the 'Off the Rails' exhibition summed up a growing view that British Rail was simply incapable of looking after its architectural legacy:

> No group of British architects have had their work less cared for than railway architects. No aspect of British craftsmanship has been less conserved than that of our railway engineers.[34]

Fortunately, the appointment in 1976 of Sir Peter Parker as Chairman of the British Railways Board brought in a man with a personal commitment to the environment, far more sympathetic than his predecessors to the great legacy of buildings and structures the railway had inherited. Parker's attitude inevitably permeated BRB management to the extent that, instead of regarding the railway heritage merely as a liability, it began to see it as something positive. Biddle and Nock's *The Railway Heritage of Britain* of 1985 was a guide to the wealth of buildings and structures in the hands of the BRB published on the initiative of the BR's Director (Environment), Bernard Kaukas (his appointment itself a sign of changing times), and with the full backing of the Board. Despite this, several of the buildings singled out for illustration in this officially sponsored book have since been demolished. The conference 'The Future of the Railway Heritage' convened by the Royal Society of Arts- Cubitt Trust Panel in 1984 and the establishment of the Railway Heritage Trust in 1985 marked a turning point in the preservation of the railway heritage on a long-term basis. Initially funded by the British Railways Board and, since rail privatisation, by Network Rail and BRB (Residuary) Ltd, the Trust is an independent company (albeit solely funded by the railway industry), limited by guarantee, whose role is to support with grants the conservation and restoration of historic railway buildings and structures in the ownership of the Trust's sponsors and acts as a catalyst between them and outside parties on finding alternative uses for property no longer required for operational purposes. Since its foundation, the Trust has supported over 1,100 projects by providing grants totalling over £36.1 million and has succeeded in attracting much external funding.

There is certainly a much greater appreciation of the value of its architecture by Network Rail. Evidence of this is to be seen in the superb restoration carried out to the Grade II* listed 1882 trainshed at Brighton, a structure saved from demolition after public protest in the early 1970s. Other positive signs are the willingness to enter into partnership with local authorities to renovate stations in a sympathetic manner as, for example, the unlisted station at Emsworth, Hampshire where much of the architectural interest of the station is the contrast between work from 1847, 1872, 1891 and 1899. There is the initiative of enlightened local management where a programme of signal box refurbishment undertaken by the Operations Manager

of Network Rail, Ely has given sympathetic treatment to a group of mainly unlisted signal boxes which have been repainted in a traditional green and cream colour scheme.

There are still great pressures brought to bear on historic railway buildings. On the one hand, the destaffing of stations has led to greatly increased risks of vandalism, graffiti and arson and on the other, there are the commercial pressures inevitably imposed upon an organisation that is obliged to obtain maximum value for taxpayers in the face of reduced grants from central government. The railway industry may also put forward the argument that a railway infrastructure organisation should be building for the future rather than acting as a custodian of the past, although the example of St Pancras illustrates just how creative re-use can enrich the travelling experience of customers today.

Yet things have improved greatly from the days when the destruction of the Euston arch was sanctioned. Destruction of a monument of such quality is today fortunately inconceivable. Many stations are in far better condition than they were fifty years ago, although there are still plenty that give cause for concern. Much of the credit for what is being done today should be given to the amenity societies and campaigning groups such as the Victorian Society and SAVE Britain's Heritage, to those who have been involved in the detailed and often delicate work of listing buildings, and to the work of the Railway Heritage Trust in helping to finance the restoration of railway buildings and securing their future by imaginative re-use. There is a need for further research, using the records that exist in abundance so that the remarkable collection of buildings and structures that survive are not destroyed or left unrecorded through sheer ignorance of their significance, but on the whole there are reasons for optimism, although not complacency.

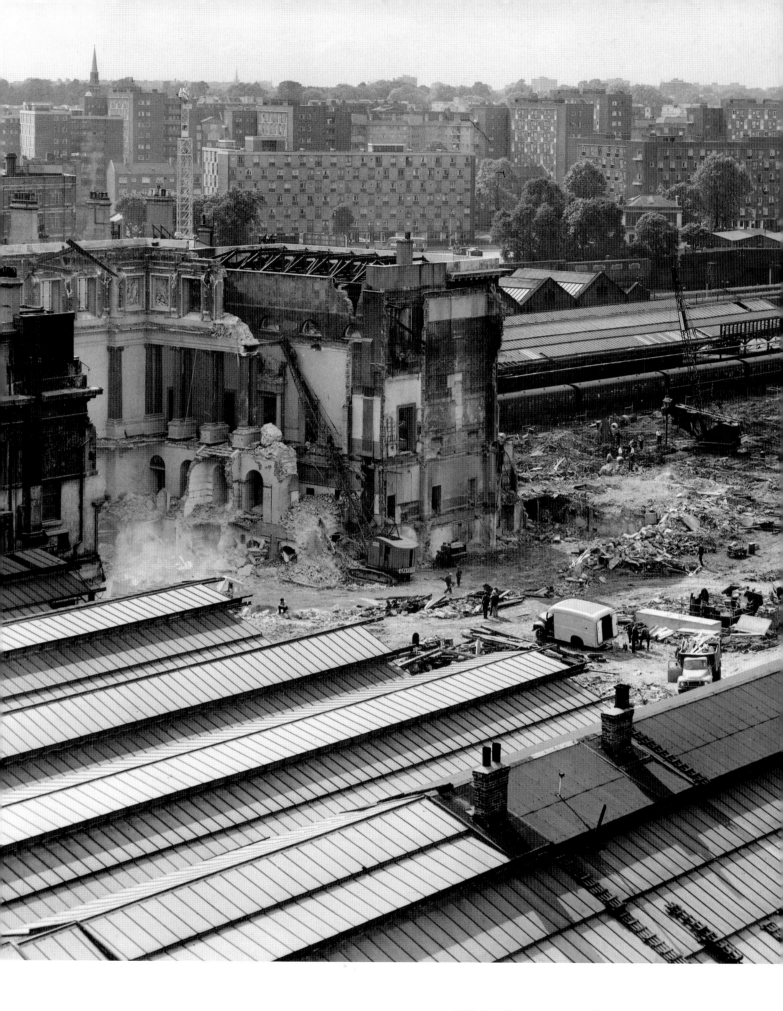

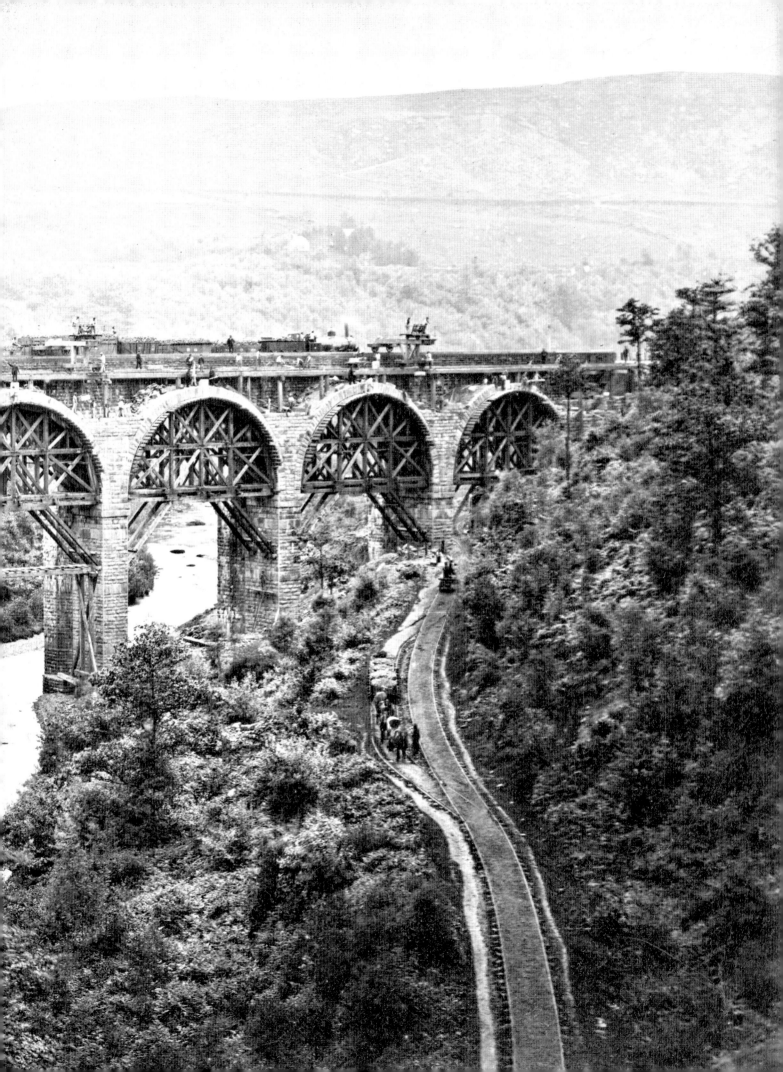

EARLY RAILWAYS

Many early railway buildings survived only for a few years before replacement but it was not uncommon for obsolete station buildings to be turned into staff accommodation, and in this form a number lasted into the 1960s. A considerable distinction was made between the monumental buildings erected at principal stations and the often rudimentary structures provided at wayside stations in the early years. The contrast between say, the Birmingham termini of the London & Birmingham Railway and the Grand Junction Railway and the station building provided at Wednesfield Heath is striking. Many early railway stations took their stylistic cues from classicism and some, such as Lytham, compare well with other contemporary public buildings. Brunel can be said to have introduced to railway buildings the neo-Tudor style which was, with Italianate, to form the principal style employed for much of the rest of the nineteenth century. Other buildings owed more to pre-railway precedent, such as the early stations on the Leicester & Swannington Railway which resembled toll cottages and some, as in the case of the Bodmin & Wadebridge railway workshops, which had more in common with vernacular buildings. As Britain pioneered the introduction of railways, it is especially regrettable that so many relics of these early days were destroyed as recently as the 1960s and '70s.

◁ MERTHYR TRAMROAD

This is perhaps the most significant illustration in this book. It is the only photograph that has come to light showing the Merthyr Tramroad – better, but erroneously, known as the Penydarren Tramway – in operation. It was on the Merthyr Tramroad that Richard Trevithick in 1804 tried out his experimental steam locomotive, the first to run on rails. So what we are looking at is one of the most important of all nineteenth-century images, the only known photograph of what was, briefly, the first steam railway in the world. The tramroad had been built in 1800–02 and, having finally fallen out of use after 1871, was lifted c. 1890. The view is a detail of a photograph by Joseph Collings of Cardiff, one of a series taken to show the widening of the Taff Vale Railway from single to double track northwards from Navigation to Merthyr. It was taken in 1862 and shows, in the background, Brunel's Quaker's Yard viaduct undergoing widening under the supervision of John Hawkshaw. On the tramroad, a southbound train, drawn by two horses and comprising five drams (wagons), stands in the loop while a northbound train of a single dram passes. The line, with a path for horses and the clearly visible stone blocks, stands out well, as do the cast iron tram plates. Although the route is now a path and a few of the stone blocks survive in situ, the word 'lost' can be truly applied to the tramroad and the other early railways that both preceded and followed it. *Joseph Collings/John Minnis Collection*

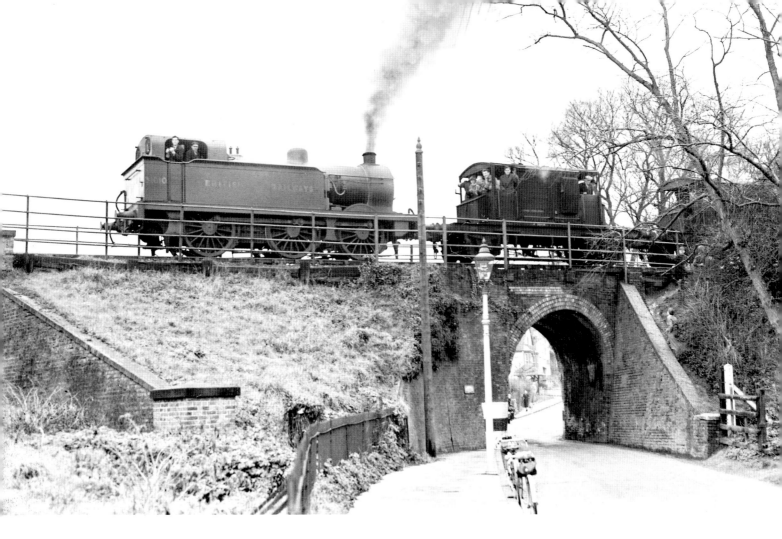

◁ WHITSTABLE

The Canterbury & Whitstable Railway was
the oldest public steam railway in the south
of England, with George Stephenson as
its engineer, and opening in 1830. By the
time it was finally closed to all traffic in
1952, one of the few remaining pieces of
infrastructure from its early days was this
unassuming bridge carrying the railway over
Church Road, Whitstable. Often claimed to
be the oldest railway bridge in the world, its
demolition for road widening in May 1969
was a great shame. It is seen here on 29
November 1952 with the last public train
to run on the line. The train included
two brake vans for railway enthusiasts to
experience the last run, hauled by No. 31010
of class RI built in 1890, which monopolised
the traffic on this line for many years.
Brian Hart Collection

▷ WADEBRIDGE

The Bodmin & Wadebridge Railway was
the first public railway in Cornwall and was
linked to the rest of the railway network
as late as 1895 when the London & South
Western Railway's North Cornwall line
joined it. In this view at Wadebridge of
c. 1900 are, on the left, the B&W engine shed
and, to the right, its workshops. Owing more
to vernacular barns and stables than to the
classical tradition that informed some of the
more monumental structures of the early
railway age, they dated from the opening
of the line in 1834. Some of the earliest
surviving railway buildings in England, they
were demolished in the 1960s.
John Minnis Collection

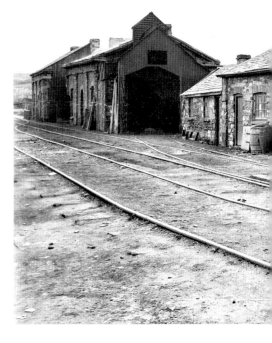

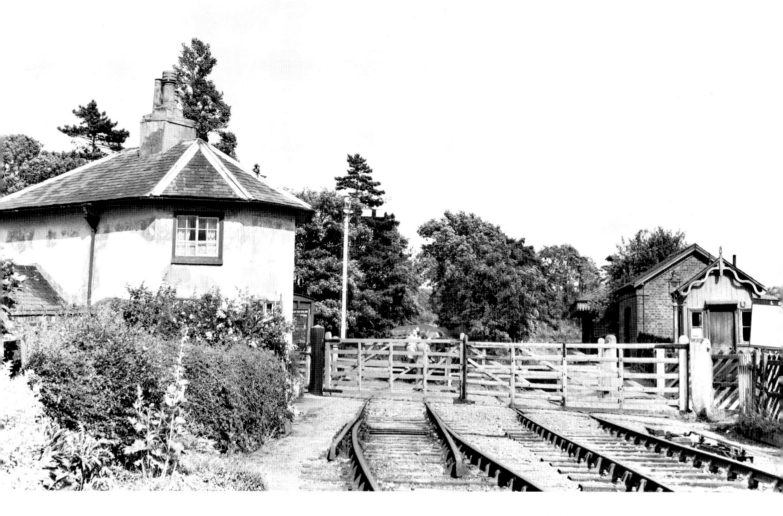

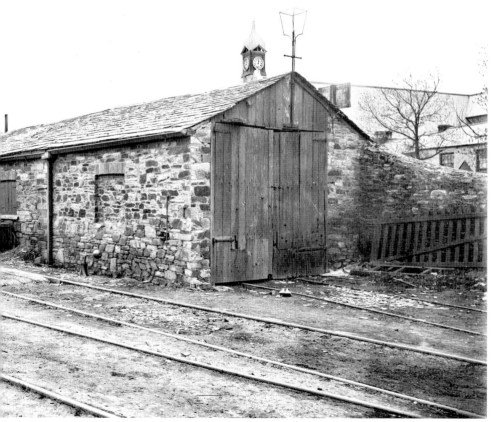

⬠ GLENFIELD

The Leicester & Swannington Railway was the earliest steam-powered railway in the Midlands and the oldest part of what was to eventually become the Midland Railway. It lost its passenger service early in 1928 but remained open for goods until 1966. To the end, it retained some of the earliest buildings, such as this crossing keeper's house at Glenfield, dating from the opening of the line in 1832 and seen here on 13 July 1952. Combining crossing keeper's accommodation and booking office and taking much of the inspiration for its design from toll cottages, its destruction for road widening came soon after closure of the line. It was replaced as a station in 1875 and its successor is just visible behind the goods shed of 1877 to the right. The 1875 station, too, has gone without trace. *L&GRP/Robert Humm Collection*

◁ WOLVERHAMPTON

Many of the very earliest wayside stations were of the simplest construction. This is the original Grand Junction Railway Wolverhampton station, located north of the town at Wednesfield Heath. Osborne, in his *Guide to the Grand Junction Railway* (1838), described it as 'a station of some importance' with 'a neat and commodious office for the reception of passengers, and the transaction of business', and with 'a private room for women'. Francis Wishaw in *The Railways of Great Britain and Ireland* (1842) was even more complimentary, drawing attention to how the intermediate stations were built 'in an economical, yet sufficiently convenient manner' and 'without any pretensions to studied design'. Certainly at Wolverhampton's three bay single-storey building, drip moulds were the sole concession to decoration. Effectively replaced by Wolverhampton General (High Level) in 1852, it remained open initially, being renamed Wednesfield Heath, before final closure in 1873. Photographed *c.* 1950, it lasted into the late 1960s. *H.W. Robinson/John Minnis Collection*

◁ FARNBOROUGH

Farnborough was one of the original stations on the London & Southampton Railway. Designed by Sir William Tite, it comprised both a hip-roofed station building, dating from 1839, of a type seen elsewhere on the line at Basingstoke and Micheldever, and a magnificent colonnaded addition believed to date from 1844 with five Ionic columns and the central part of the entablature brought forward slightly. The station was used by Queen Victoria prior to the opening of Windsor station in 1851. When she wanted to travel to Southampton or Gosport for the Isle of Wight, she would take a carriage from Windsor to Farnborough and take the train from there. We are looking west – the loop on the right side is roofed over. The station was completely rebuilt in 1900–03 with the quadrupling of the line. *LSWR/John Minnis Collection*

◁ MANCHESTER M & L

The original 1839 Manchester terminus of the Manchester & Leeds Railway was, following the opening of Manchester Victoria station at Hunts Bank in 1844, turned into a goods station, and the principal building survived as such until 1967. It was of simple classical design, its six bays defined by the use of a giant order, and remained little altered to the end, even retaining the raised M&LR lettering below the cornice. Photographed in 1952. *C.H.A. Townley*

⊲ LEA BRIDGE

Lea Bridge, on the section of the Eastern Counties Railway between Stratford and Broxbourne opened in 1840, had a handsome Italianate building located on the bridge carrying the road over the railway. The cupola housed a bell, rung to warn intending passengers of the approach of a train. The bell, dated 1846, was removed in 1917. It had not been rung since about 1882. The building itself may well have been built in 1846. The station, seen here *c.* 1905, was closed in 1985 but the building was demolished many years before that. *G.W.J. Potter/John Minnis Collection*

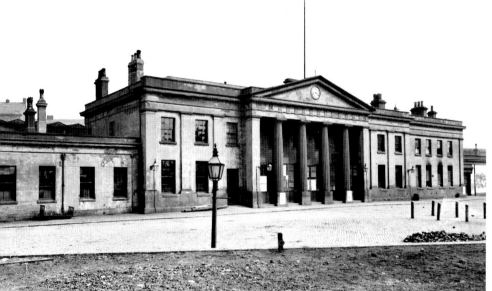

⊲ LEICESTER MIDLAND COUNTIES

The process of rebuilding stations has been going on since the inception of railways and many of the finest early buildings were lost in the nineteenth century. Among them was the Midland Counties Railway station of 1840 at Campbell Street, Leicester. By local architect William Parsons, it was, like many contemporary city stations, built in the neo-classical style customary for public buildings. Its symmetry is marred by the wing to the right, a later addition of *c.* 1857–8. It was replaced in 1892 by the London Road station, of which the booking hall and porte-cochère alone survive today. *R&CHS Jeoffry Spence Collection*

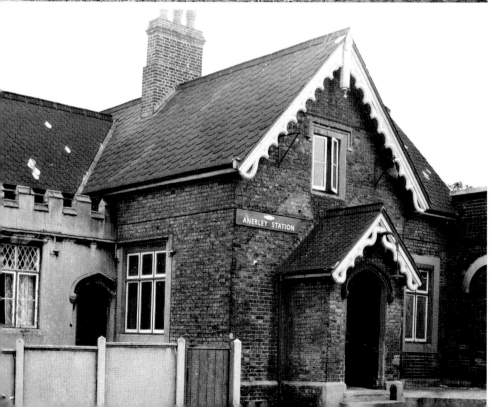

⊲ ANERLEY

Anerley was a particularly sad loss of the 1980s. Built for the London & Croydon Railway *c.* 1846, it was possibly the work of Henry Roberts who acted as the architect to the company. Cottage-like in appearance, it had label stops in the form of heads to the doors, a crenellated parapet, diamond pattern tiles to the roof and lattice pane iron windows. It was extended and given a new canopy in the 1870s. After fire damage, it was demolished almost overnight. *Lens of Sutton Collection*

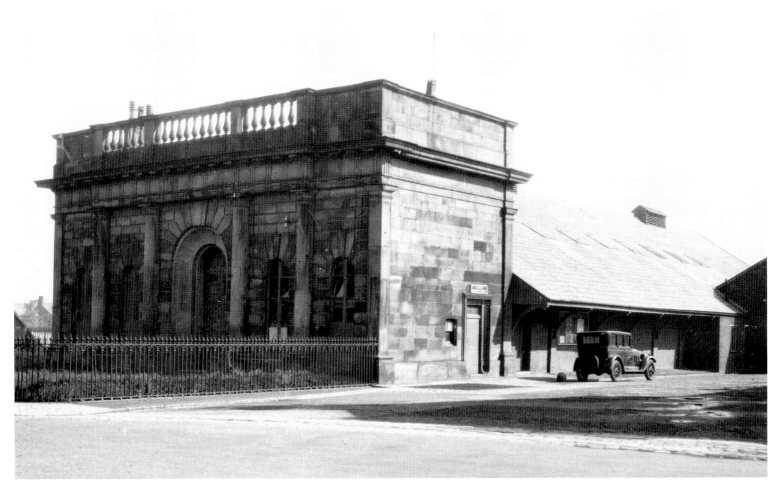

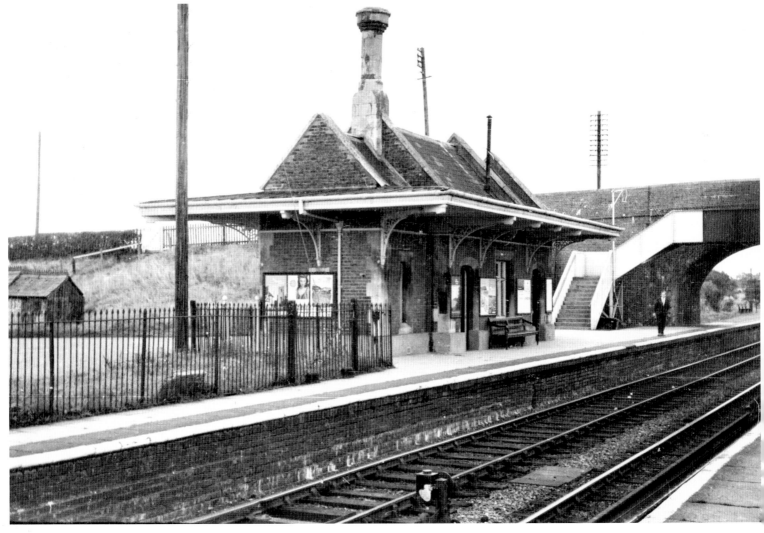

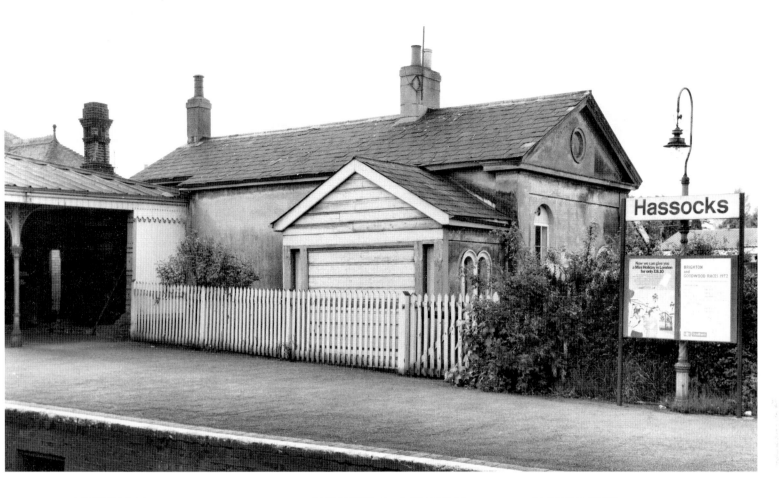

LYTHAM

Lytham old station is another of the particularly regrettable losses of the 1960s. Built in 1846 by the Preston & Wyre Railway, it had been closed as long ago as 1874 but was retained for goods until 1963. It had a fine Doric building of five bays with a heavily rusticated façade, while the train shed behind was also of interest, being constructed with laminated timber ribs, sprung directly from the walls to form steeply pitched arches. *L&GRP/Robert Humm Collection*

MINETY & ASHTON KEYNES

Brunel was a great exponent of the neo-Tudor style, employing it at many wayside stations as well as at the Bristol terminus of the Great Western Railway. The need to protect waiting passengers led him to construct canopies cantilevered on all four sides of the building, obviating the requirement for columns which would obstruct the platform. This marriage of a historicist style with practical additions to suit present-day needs was entirely typical of his ingenuity. Today, there is but one survivor of his neo-Tudor wayside stations, Culham. Minety & Ashton Keynes, the first station out of Swindon on the Cheltenham & Great Western Union line, opened in 1841 and is seen here shortly before its demise, following closure in 1964. *D. Thompson*

HASSOCKS

David Mocatta, architect to the London & Brighton Railway, opened in 1841, was one of the most significant early railway architects. As well as the fine classical terminus building at Brighton, he designed an important series of wayside stations which were the first to be constructed on modular principles. Using a standard plan, he devised elevations that could be classical, Tudor or Italianate and which were depicted in exquisite perspective drawings now in the RIBA Drawings Collection. It was assumed that most were destroyed in the nineteenth century but three survived into recent times. Horley (demolished 1968) and Three Bridges (demolished 1985) were both extensively rebuilt with upper storeys being added but Hassocks survived little altered. It had been replaced as a station by a commodious set of buildings in the Domestic Revival style by T.H. Myres in 1880 and then became staff accommodation. This view of 21 May 1972 shows it retaining many of its original Italianate details, including paired round-headed windows and the gable end treated as a pediment. The following year it, together with the successor station, was demolished and the latter replaced with prefabricated CLASP buildings. *John Scrace*

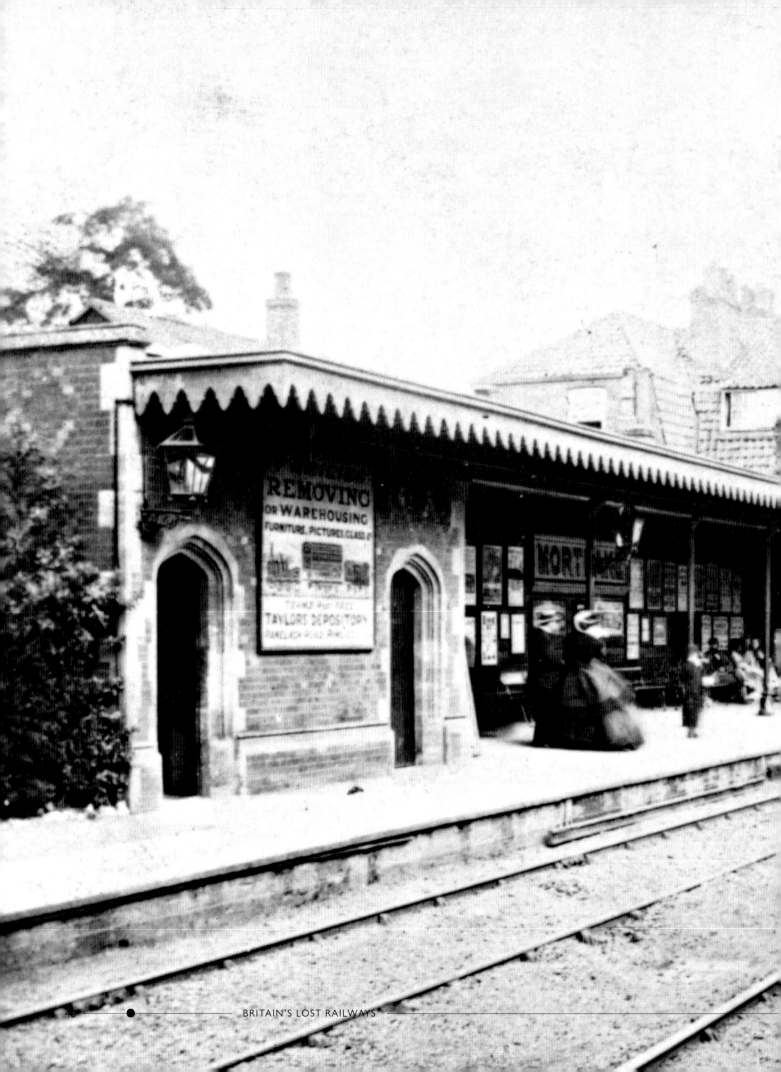

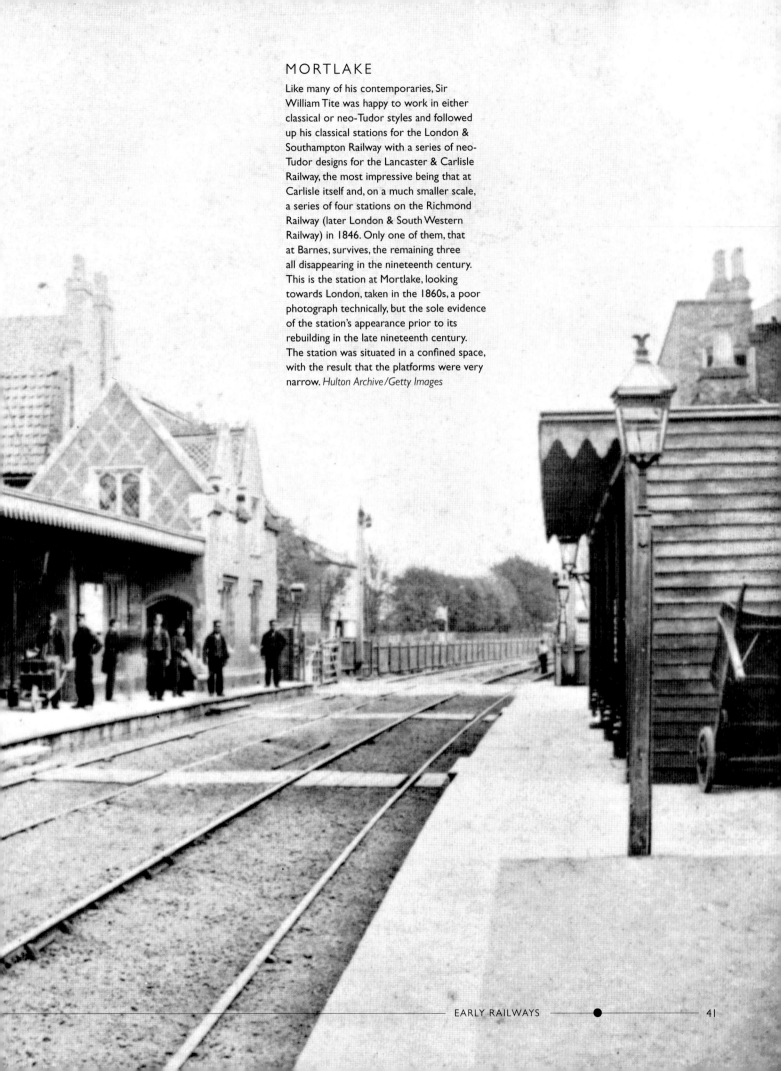

MORTLAKE

Like many of his contemporaries, Sir William Tite was happy to work in either classical or neo-Tudor styles and followed up his classical stations for the London & Southampton Railway with a series of neo-Tudor designs for the Lancaster & Carlisle Railway, the most impressive being that at Carlisle itself and, on a much smaller scale, a series of four stations on the Richmond Railway (later London & South Western Railway) in 1846. Only one of them, that at Barnes, survives, the remaining three all disappearing in the nineteenth century. This is the station at Mortlake, looking towards London, taken in the 1860s, a poor photograph technically, but the sole evidence of the station's appearance prior to its rebuilding in the late nineteenth century. The station was situated in a confined space, with the result that the platforms were very narrow. *Hulton Archive/Getty Images*

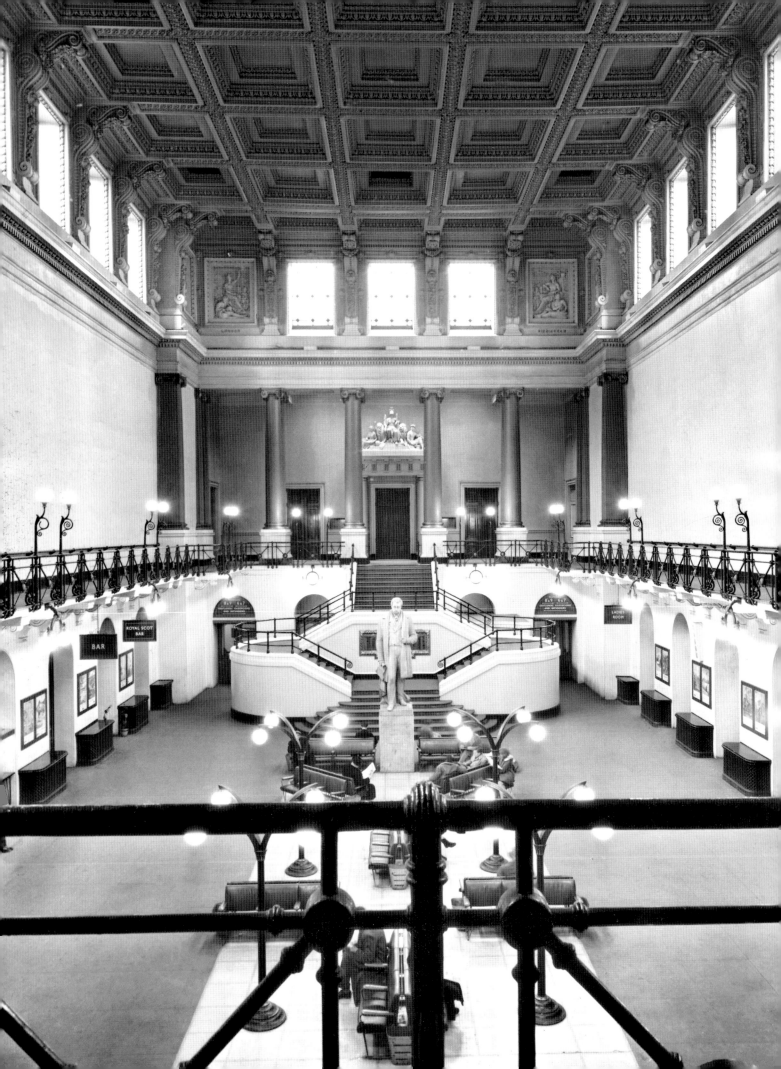

MAJOR TERMINAL STATIONS

The great London termini include both the best-known failure of the conservation movement, Euston, and the greatest success, St Pancras. One represented thoughtless demolition, carried out with stubbornness in the face of opposition, the other the triumphant re-use of what is now seen as a great asset to London. But in between these two extremes, there has been a tremendous amount of change to London's termini over the past fifty years. Victoria, Charing Cross, Cannon Street, London Bridge, Liverpool Street and Fenchurch Street have all had major rebuilds, either of their head end buildings or of their train sheds, Holborn Viaduct and Broad Street have completely disappeared and Blackfriars has been rebuilt. Only Marylebone, King's Cross, Paddington and Waterloo look very much as they did. The first three have been or are undergoing major renovations and the latter, following its rejection for listing in 2010, faces an uncertain future.

◁ EUSTON GREAT HALL

The Great Hall at Euston was one of the greatest of all station interiors. Designed by P.C. Hardwick, Philip Hardwick's son, it was opened in 1849 and formed both a concourse and a waiting room, something that was rarely repeated in Great Britain, although it became standard practice in many other countries, especially in the United States. The room was 125ft 6in long by 61ft 4in wide and 62ft high, with a staircase leading to a gallery running around the Hall and to the company's offices. At attic level were a series of bas-reliefs representing London, Birmingham, Liverpool, Manchester, Northampton, Chester, Carlisle and Lancashire. Above all this was a coffered ceiling and consoles of the grandest proportions. The London, Midland & Scottish Railway did its best to ruin the effect by putting up an enquiry kiosk filling the middle of the Hall but, in 1953, it was removed and the Hall was redecorated to Hardwick's original colour scheme. This photograph was taken shortly after the work was completed.
Science & Society Picture Library/Getty Images

▷ EUSTON ARCH

This is the familiar face of Euston, taken by the London & North Western Railway's official photographer on 7 September 1904, from one of the windows of the ugly 1881 link block to the Euston Hotel, which obscured the view of the arch from the Euston Road. The arch's accumulation of soot over the years gave it great power. If it had survived, it would undoubtedly have been cleaned and, while still magnificent, as it appeared in Bourne's celebrated volume of London & Birmingham Railway engravings, it might have lost some of its grandeur.
Science & Society Picture Library/Getty Images

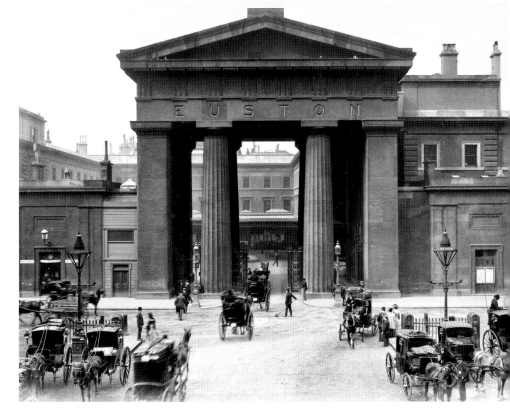

▷ EUSTON

The great sweep of Platforms 1 and 2 at Euston had an elegance that is hard to recapture in the station of today. They were where the principal express trains from the north and Scotland arrived and they dated, in the form seen in this photograph of c. 1903, from 1873. The cab road, with access from what is now Eversholt Street, lies between them. The admirably clear signage of the London & North Western Railway is much in evidence while the locomotive is an 'Improved Precedent' 2-4-0 designed by F.W. Webb, a successful and long-lived design.
York & Son/English Heritage NMR

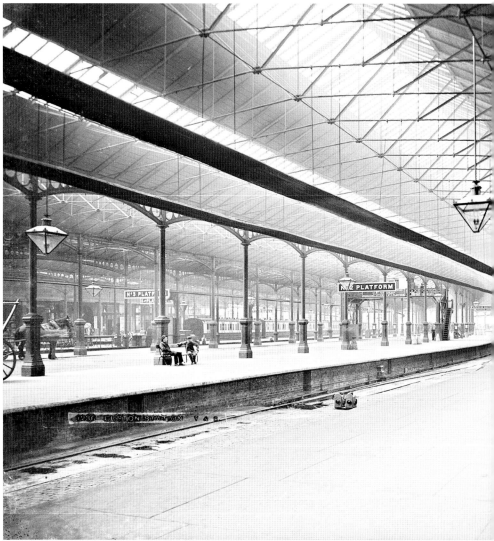

◁ NINE ELMS

Nine Elms, the London terminus of the London & Southampton Railway, was a late surviving example of a major early railway station in the capital. Designed by Sir William Tite in 1838, it belonged, with Euston, to the heroic era of railway building. With the opening of Waterloo in 1848, so much nearer central London, it was converted into the principal London goods depot of what was now the London & South Western Railway. In this role, it survived the Second World War, albeit damaged by bombing, until final demolition in 1963. Photographs taken shortly before demolition reveal that, although some features had been lost, the building was perfectly repairable. Behind the building, much of the original iron train shed had survived. This photograph, with staff and numerous children, was taken *c.* 1900. *R&CHS Jeoffry Spence Collection*

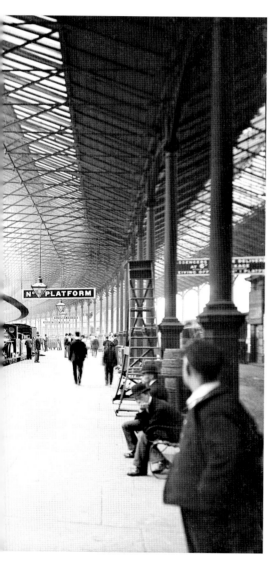

△ NINE ELMS

The remains of Nine Elms, patched up after bombing, survived until 1963 and can be seen in that year, half demolished. *Lens of Sutton Collection*

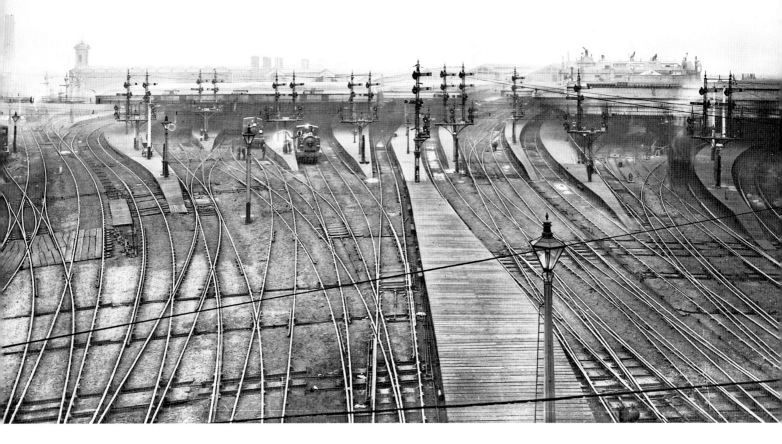

WATERLOO

The old Waterloo was fabled for its complexity. Growing up piecemeal, it became a nightmare for passengers and parodied in literature, most famously in 1889 by Jerome K. Jerome in *Three Men in a Boat*: 'We got to Waterloo at eleven and asked where the eleven-five started from. Of course nobody knew; nobody at Waterloo ever knows where a train is going to start from, or where a train is going to, or anything about it.' Three views taken between 1893 and 1902 show the old station.

△ A general view from the west gives an idea of the extent of the station. To the left are locomotive sidings, then the 1884–5 North station (known as Khartoum), the 1860 Windsor station, and the Central Station of 1848 which had an extraordinarily long Platform 4 tapering in and then out. In the midst of all this was an engine shed and finally the 1878 South station which had a single long island platform. The whole station was completely rebuilt between 1900 and 1922 with the present airy structure. *R&CHS Jeoffry Spence Collection*

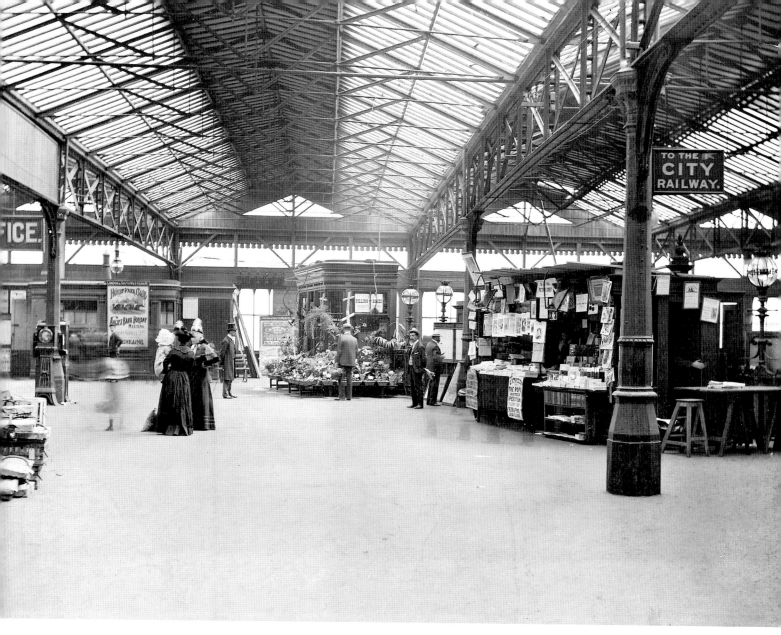

TO THE
CITY
RAILWAY.

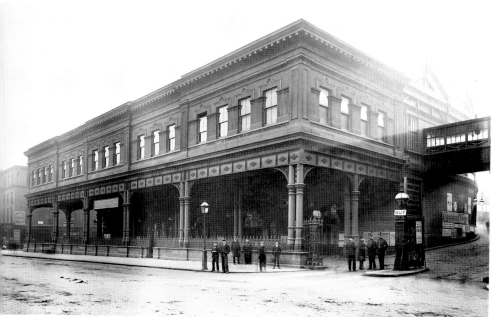

△ The South station concourse, shortly after 1902. By comparison with the rest of the station, the concourse was both well-lit and spacious, to cater for race-day crowds. It is a little ironic that it was the earliest part of the old station to go, replacement occurring in 1909 when the first stage of the present station opened. *R&CHS Jeoffry Spence Collection*

◁ The exterior of the South station *c.* 1893 from Waterloo Road. The cab road is to the right with the footbridge connecting the South station concourse to the rest of the station above it. The façade, some 160ft long, is supported on paired iron columns above a carriageway. *R&CHS Jeoffry Spence Collection*

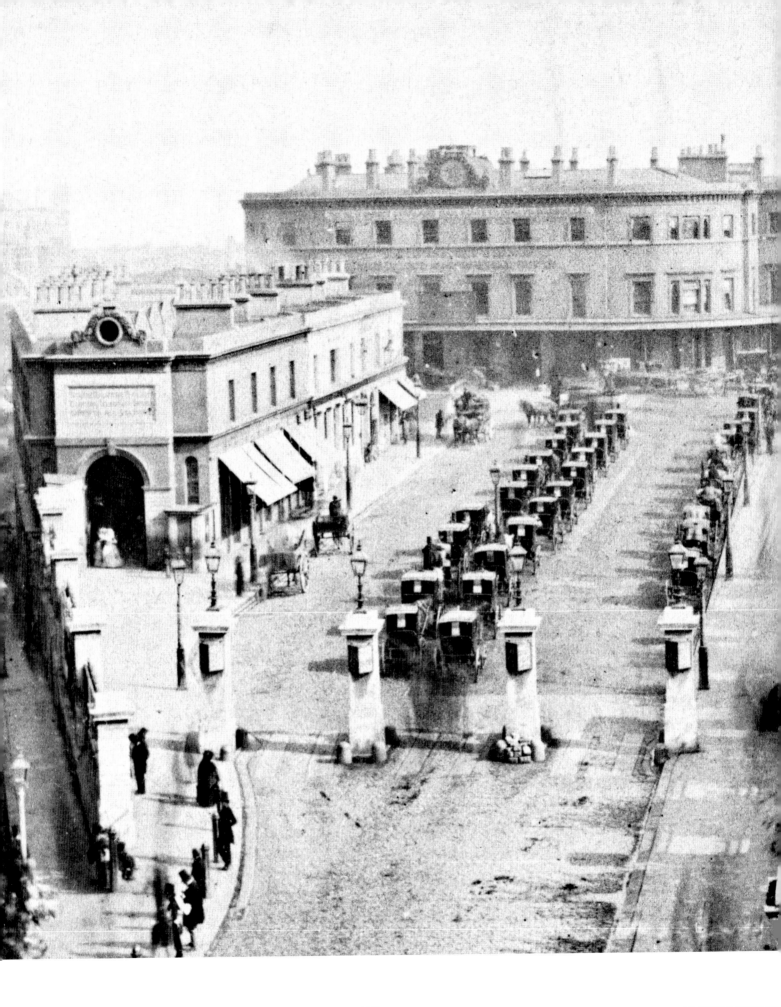

LONDON BRIDGE

◁ A view of London Bridge South Eastern Railway station taken *c.* 1860, shortly before the line was extended to Cannon Street and Charing Cross. There are two known photographs of the station in this state: the other, probably taken at the same time but from a position a little further away, was reproduced by Gavin Stamp in *The Changing Metropolis* (Viking, 1984). The station is seen as rebuilt by Samuel Beazley, the work being completed in 1851, the year of Beazley's death. It replaced the Joint Brighton, Croydon and Dover station, a very handsome Italianate building by Henry Roberts which lasted no more than six years and was held by the *Illustrated London News* to be 'of less merit than its predecessor'. The building at right angles to it was completed in August 1851 and included shops and a refreshment room, with offices on the first floor. On the right are the grounds of St Thomas's Hospital. Just visible on the right is the London, Brighton & South Coast Railway station. The new through line transformed this scene beyond recognition, the high level tracks necessitating the demolition of half of Beazley's station building and filling the foreground with a highly intrusive bridge. *English Heritage NMR*

▽ London Bridge is another London terminus to have suffered from the effects of bombing. This view of *c.* 1937 shows, on the extreme left, the corner of the South Eastern Railway premises, while in the centre the London, Brighton & South Coast Railway's Italianate frontage of 1853–4 fills most of the photograph. To its right stands the former Terminus Hotel of 1861 by Henry Currey, a failure as a hotel, and which was purchased by the LB&SCR in 1893 for use as offices. In 1940, heavy bombing reduced both SER and LB&SCR frontages and the former hotel to little more than shells. The station buildings were patched up and stood in semi-ruinous state for over thirty years before eventual replacement by the present station buildings in 1975–8. The former hotel was demolished in 1941. *R&CHS Jeoffry Spence Collection*

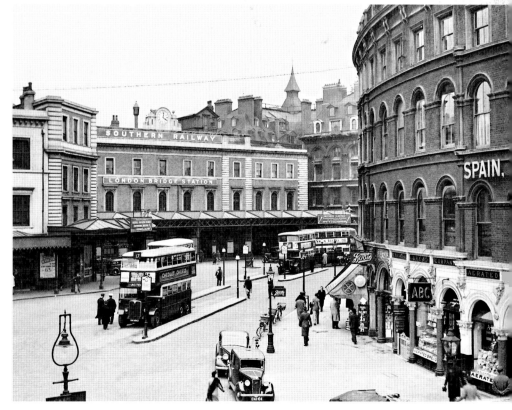

BROAD STREET

Along with Holborn Viaduct the only other central London terminus to have been completely obliterated, Broad Street is truly 'lost'. The plaza and office buildings of Broadgate occupy a large area that was the city terminus of the North London Railway. Opened in 1865 and designed by William Baker, the chief engineer of the London & North Western Railway with which the NLR was always associated, the station building was in a broadly Italianate style with a French Second Empire roof. Any claim to architectural grandeur that it possessed was soon negated by the two covered footbridges added at the front of the station in 1890 providing access from pavement level to the raised platforms. The station was bustling with through services to Richmond, Poplar and Chalk Farm, to stations on the Great Northern such as High Barnet, Enfield and Potters Bar and, briefly, to Birmingham. In continuous decline from the introduction of electric tramways in the early 1900s, Broad Street ended up as a shadow of its former self. The main station block was closed off in 1957, with the booking office resited in a hut on the concourse, and the trainshed roofs were removed in 1967–8. Trains ran only in the rush hour and it was no surprise when it closed completely for redevelopment in 1986. *London Stereoscopic Co./Getty Images*

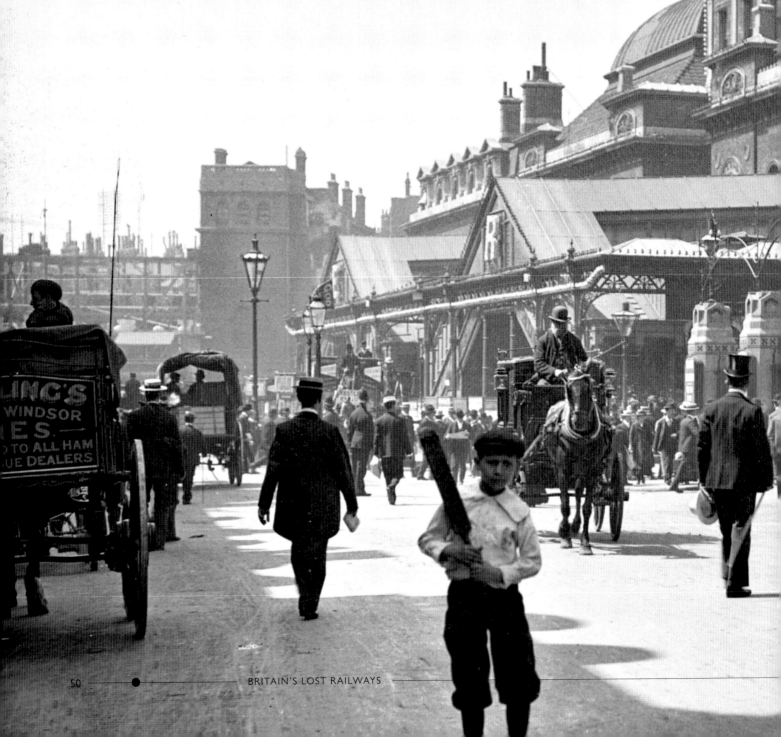

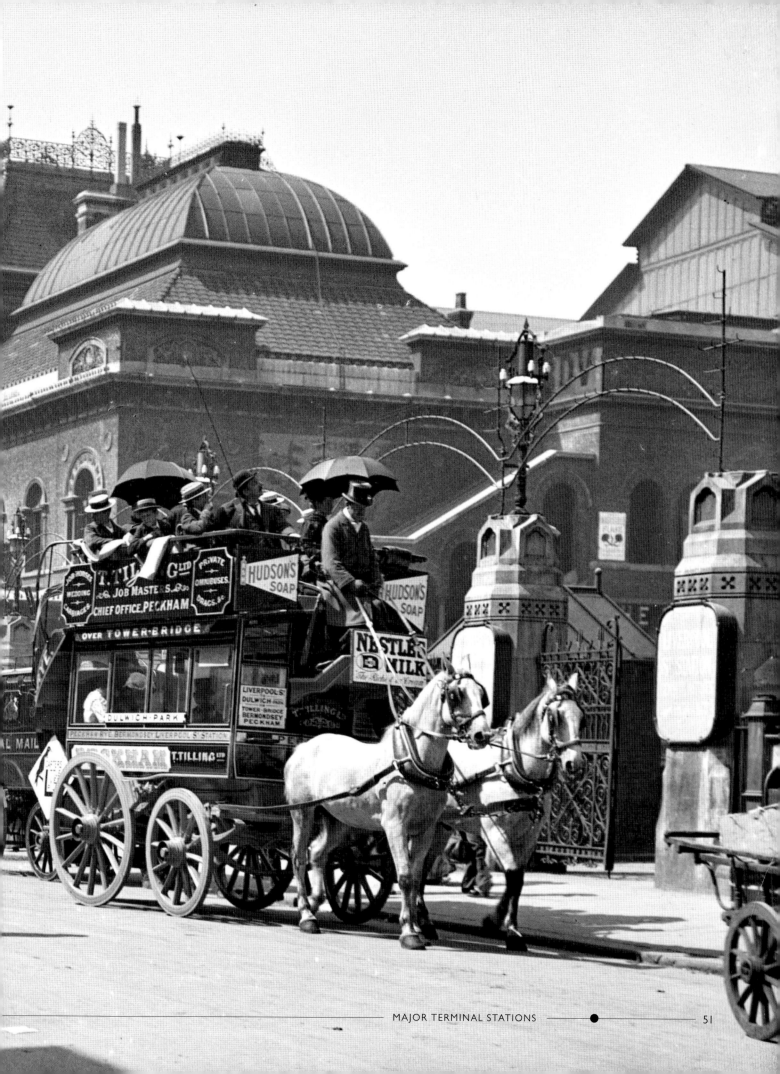

CANNON STREET

▽ Cannon Street, the South Eastern Railway's city terminus, opened in 1866. The great iron roof, at 108ft taller than St Pancras, was, together with the bridge over the Thames, designed by Sir John Hawkshaw and is seen here soon after opening. The towers, which housed water tanks for hydraulically powered lifts, remain today, flanking the massive office block by BDP of 1987–91 that covers the platforms and tracks. The signal box, located over the tracks on an iron gantry, was an early design of Saxby & Farmer, with the signals projecting through the roof of the box. It was replaced in 1893. *English Heritage NMR*

▷ The City Terminus Hotel, which formed the frontage of Cannon Street station, was the work of E.M. Barry. Barry used an eclectic mix of Renaissance motifs, making much use of Blanchard's white-glazed terracotta for decoration. The hotel closed in 1931 and was converted to offices, known as Southern House. In 1941, both the roof and the former hotel were severely damaged by bombing and in 1958 the roof was taken down, followed by the demolition of Southern House in 1963. *John Minnis Collection*

▽▷ The rarely photographed interior of Cannon Street, seen in the mid 1950s. The view shows that the roof was unusually well integrated with the hotel, the rear elevation of which was in a rather more pure classical style than the street frontage. *John Minnis Collection*

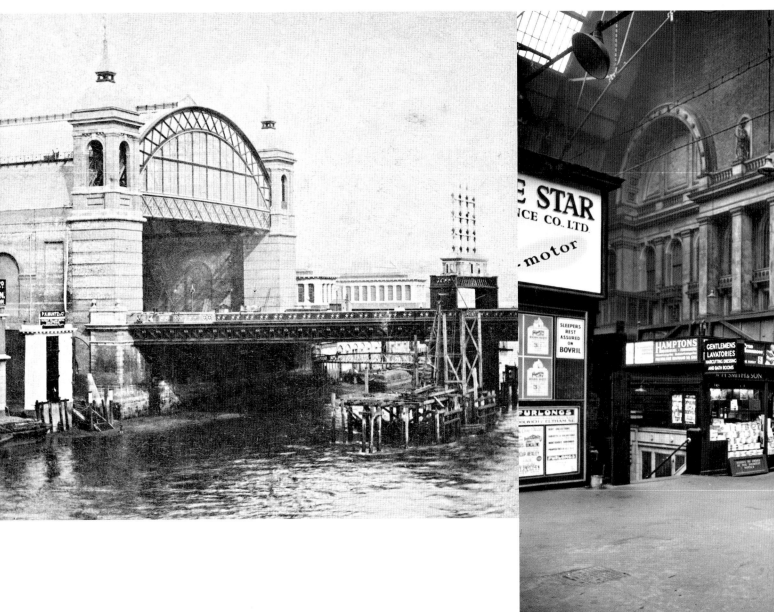

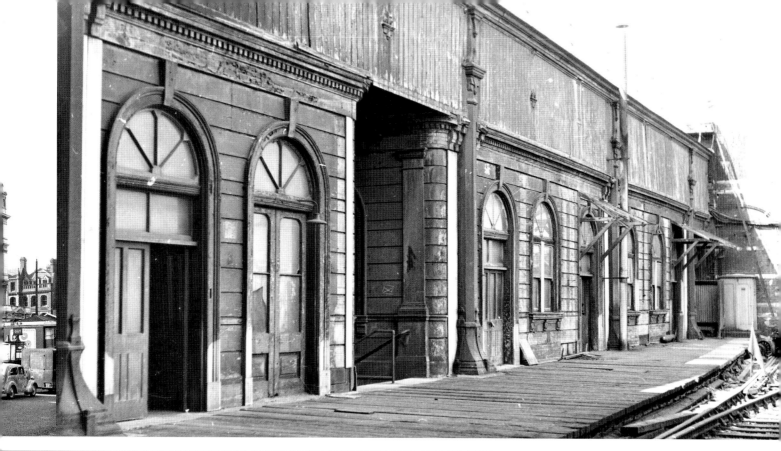

BLACKFRIARS ORIGINAL STATION

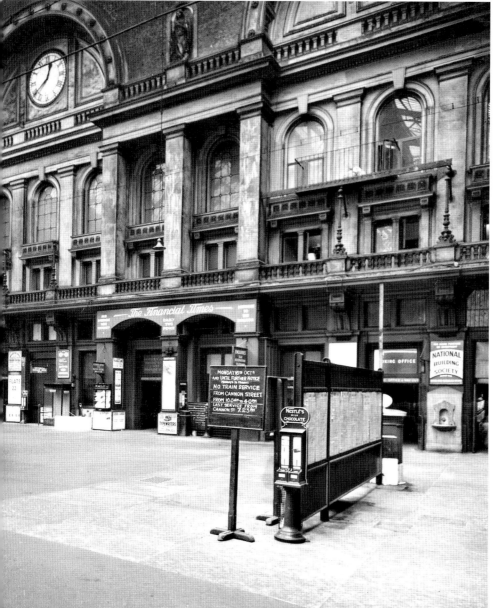

△ A curious remnant of a long-lost station that thousands of commuters passed daily without noticing was the first station at Blackfriars. Known as Blackfriars Bridge and opened in 1864, it was located on the south side of the river, immediately to the south of the bridge. The tracks were on a viaduct, so that the station was on two levels with the lower part used as a goods depot and the upper for an impressive passenger station with a train shed roof, 401ft long and 87ft wide. The exterior of the building was polychrome Gothic, a style much favoured by the London, Chatham & Dover Railway, and was the work of John Taylor Junior with the engineering work by Joseph Cubitt and T.F. Taylor. The station was a victim of ever-increasing traffic and, following the building of a second river bridge immediately to the east of the original one, and the opening of the new St Paul's station (renamed Blackfriars in 1937) on the north bank, Blackfriars Bridge closed to passengers in 1885. The roof was taken down the following year but substantial parts of the old buildings remained in use as a goods depot until 1964. Most of the remaining fabric was demolished soon after but some evidence was still visible into the 1980s. This view, taken in the 1960s, shows some of the station offices, which, unlike the exterior, were classical in style, together with the cut-back end wall. *Lens of Sutton Collection*

VICTORIA

Victoria comprised two separate stations side by side, that to the east being used by the London, Chatham & Dover Railway (from 1899, jointly managed with the South Eastern Railway as the South Eastern & Chatham Railway) and that to the west by the London, Brighton & South Coast Railway. Both stations were completely transformed, the SE&CR by a new frontage building in 1907–8 and the LB&SCR by a new frontage building incorporating an annexe to the Grosvenor Hotel and a new and greatly enlarged train shed behind in 1901–8. All that survives, therefore, in this photograph by York & Son of *c.* 1903, is the high SE&CR train shed roof on the left and the great mass of J.T. Knowles's Grosvenor Hotel on the right. The timber frontage buildings visible were those erected in 1860 (LB&SCR) and 1862 (LC&DR), both of which were intended only to be temporary and which staggered on in increasing decrepitude, their sagging walls half hidden by advertising. The LB&SCR buildings are largely obscured by a large iron and glass canopy by Handyside & Co., added in 1880, part of which was removed to Hove following the 1908 rebuilding.

York & Son/English Heritage NMR

▷ The 1860 train shed of the London, Brighton & South Coast Railway Victoria terminus *c.* 1903. The ridge and furrow roof, designed by the LB&SCR's engineer, Robert Jacomb Hood, was supported on transverse wrought-iron lattice girders with the columns placed down the centre of the cab road to lessen the risk of a roof collapse caused by a train derailment and to keep the platforms clear of obstructions. The cabs entered on an incline from Eccleston Bridge and exited into the station forecourt. Work on rebuilding the station has commenced with the southern end of the train shed demolished and replaced by temporary platform awnings, and an area in the right foreground boarded off. The arched entrances to the platforms were much favoured by the LB&SCR. The company was also a pioneer in the use of electricity for lighting and early electric light fittings are prominent. Reminders of traffic now lost to railways include the milk cans on the right, offloaded from a passenger train. *York & Son/ English Heritage NMR*

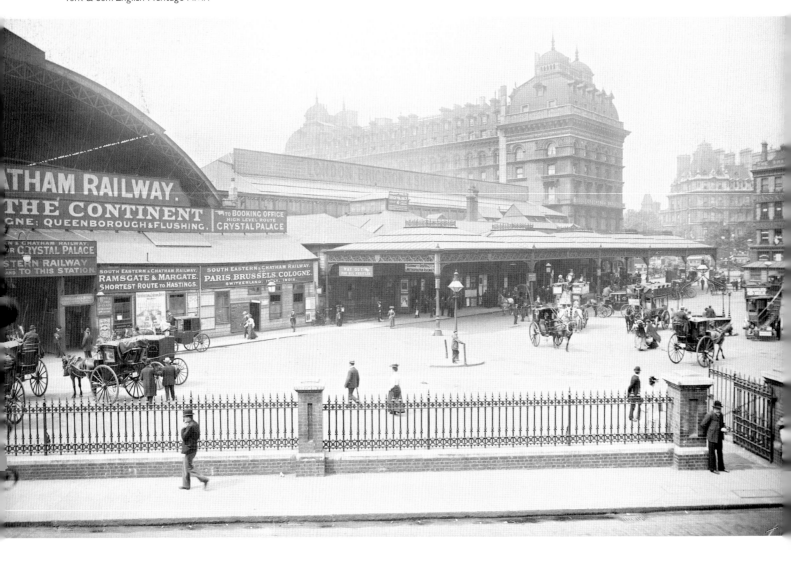

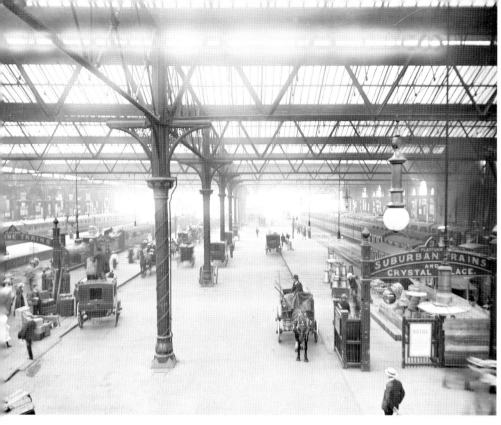

The 1908 Victoria station provided some impressive (and long-gone) facilities for passengers including the first class Ladies' Waiting Room, seen here immediately after completion in 1908 in this Bedford Lemere photograph. As in the booking office and refreshment room, extensive use was made of glazed tiles, the decoration incorporating the LB&SCR company initials within wreaths. Below the framed photographs of places such as Arundel and Chichester served by the company were panels where timetables could be pasted. A bell was provided to summon a waitress from the adjacent tea room to serve tea and light refreshments. The wicker furniture is of the type fashionable in dainty tea rooms of the period and one wonders how long it lasted in heavy daily use. *Bedford Lemere/English Heritage NMR*

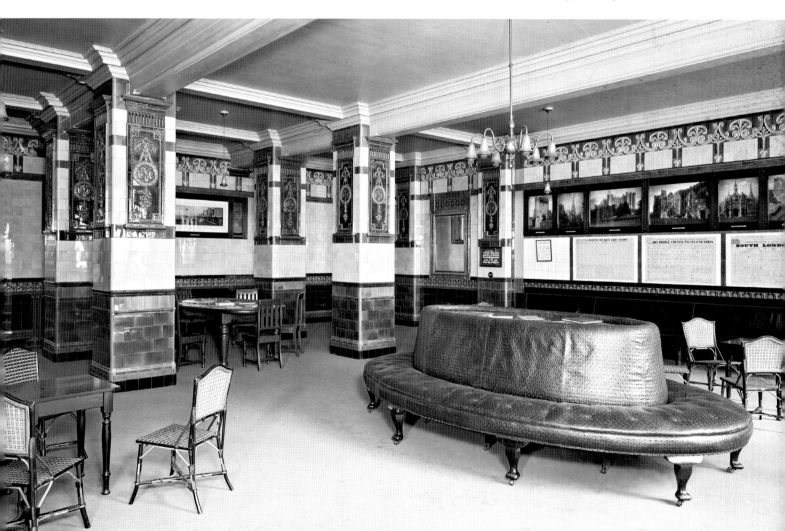

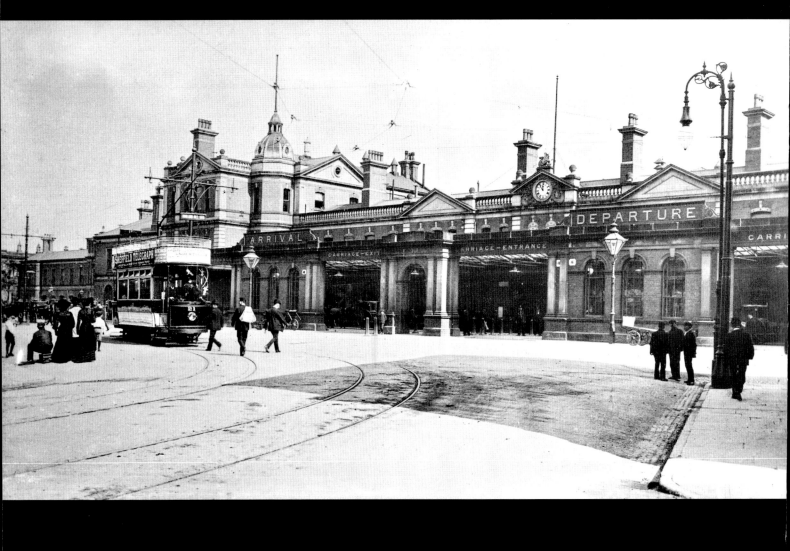

Losses among large provincial stations have generally resulted from two factors: first, the elimination of duplicate facilities following nationalisation, which for example resulted in the closure of the Great Central line with the loss of stations such as Nottingham Victoria, and second, modernisation, either on an individual basis, such as at Leicester, or as part of a modernisation scheme, such as the London Midland Region electrification programme of the 1960s which saw Manchester London Road, Stafford, Wolverhampton, Birmingham New Street and Bletchley stations rebuilt, along with a host of minor stations. The losses have included stations of a wide variety of periods and styles, from early buildings such as those by Francis Thompson at Derby to the twentieth-century station at Nottingham Victoria, soaring roofs such as those at Bradford Exchange and Glasgow St Enoch, and from the Italianate of Wakefield Westgate via the Domestic Revival of Burton-upon-Trent to the Scottish Baronial of Dundee West.

◁ DERBY

One of the greatest losses of recent years has been the buildings at Derby. The station had been subjected to a great deal of change over the years. Parts of the original 'Trijunct' (so named because it was the junction of three railways) station of the 1840s by Francis Thompson survived, much altered in the shape of a long range of gaunt hip-roofed blocks. In 1892, the 1855 screen was moved forward and a new block built in front of the Thompson station buildings by Charles Trubshaw, the Midland Railway's architect. The domed tower visible next to the screen in this view of c. 1910 is typical of his fondness for neo-Baroque flourishes and may be compared to those at the Station Hotel, Bradford, built in 1890. The overall roof behind was damaged by bombing and replaced by concrete awnings in 1954. The station buildings were torn down, after some protest, in 1985 and, more recently, the concrete awnings, too, have followed. *John Alsop Collection*

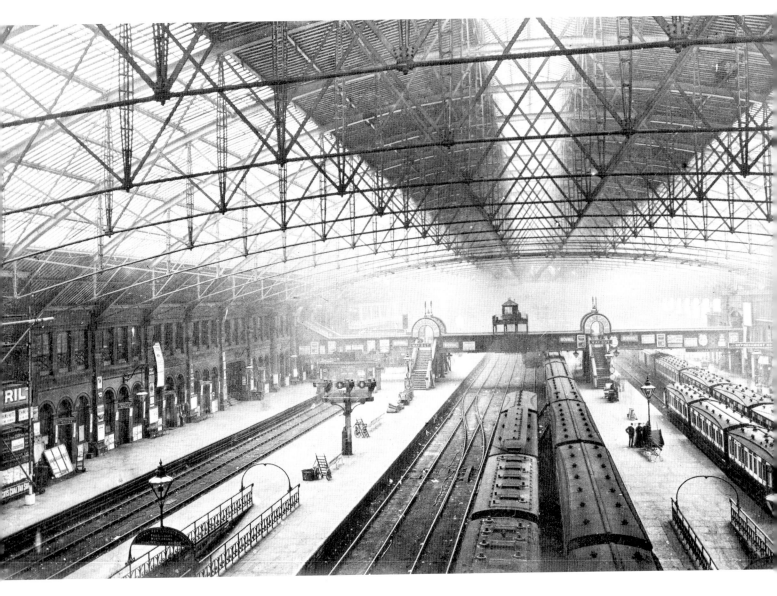

△ BIRMINGHAM NEW STREET

The present station at Birmingham New Street, buried beneath the Palisades shopping centre, is widely acknowledged to be one of the least prepossessing in Britain and its replacement, after little over forty years, is imminent. By contrast, its predecessor had airy twin spans of overall glass roof, separated by an approach road for taxis. The overall roofs were destroyed by bombing in the Second World War and replaced by unsightly temporary corrugated iron awnings until the whole station was completely rebuilt in the late 1960s as part of the West Coast electrification programme. An interior view of New Street *c.* 1905, taken from the west end screen towards the central footbridge, shows the single-span trussed-arch roof of 1854, the widest in the world at the time of construction. It was the work of E.A. Cowper of Fox, Henderson & Co. *John Alsop Collection*

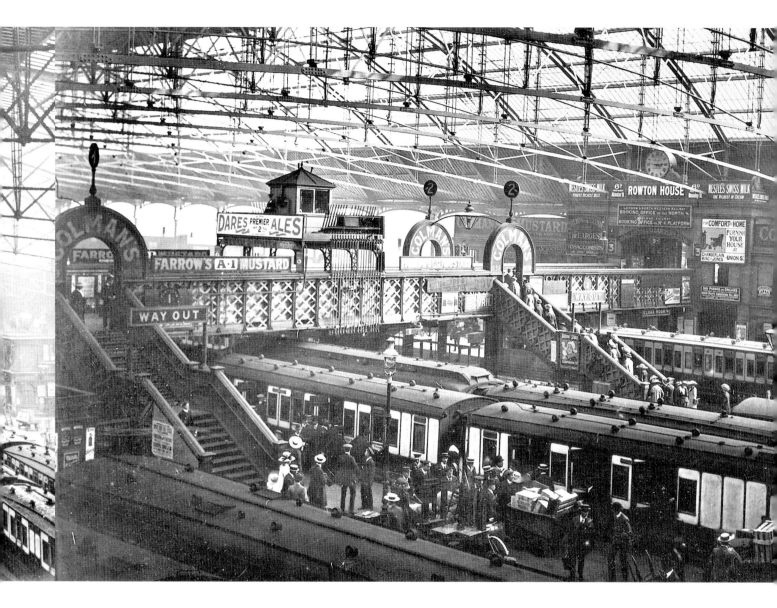

BIRMINGHAM NEW STREET

A close-up view of the footbridge at Birmingham New Street, the hub of the station, in 1911. The footbridge dated from 1874, as did the diminutive No. 3 signal box (visible behind the Dares Premier Ales sign) with its exposed lever frames which were used to operate the points within the station. The view shows tie bars added in 1906–7 to strengthen the roof, which are not present in the previous photograph. *R&CHS Jeoffrey Spence Collection*

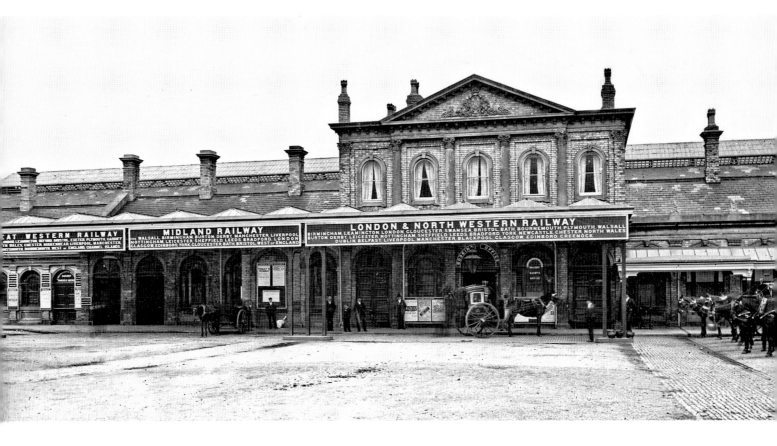

⌂ WOLVERHAMPTON

Yet another casualty of the 'total modernisation' approach of the London Midland Region during its 1960s electrification of the West Coast main line was Wolverhampton High Level, which was completely rebuilt in 1964–7. Designed by the Shrewsbury & Birmingham Railway company's architect, Edward Banks, and completed c. 1852, it was a confident neo-classical work, with the town's coat of arms set within its pediment. It had an overall roof and was greatly extended with new awnings in 1884. It is seen here c. 1900 in a Midland Railway official photograph in which the great clarity of the London & North Western Railway's signage is readily apparent. *MR/John Minnis Collection*

▷ CRYSTAL PALACE HIGH LEVEL

One of the most extraordinary sights in south London of the 1950s was the decaying bulk of the London, Chatham & Dover Railway's Crystal Palace High Level, built in 1865 for the vast numbers of people who visited the Crystal Palace at Norwood, destroyed by fire in 1936. This is the earliest known photograph of the station, taken c. 1880 and showing the High Victorian Italianate façade by E.M. Barry which, with its heavy brick rustication, has echoes of his work at Dulwich College. Four lines entered the station, each with platforms on either side, so as to enable the large numbers of anticipated passengers to board or leave trains quickly. It is also the only known view of the original Saxby & Farmer designed signal box, which opened at the same time as the station itself and was replaced at the end of the nineteenth century. *R.S. Carpenter Collection*

▷ In its latter years, the High Level station was almost deserted save for rats, which scurried away at the approach of a train. With its twin spans of roof and elaborate towered façades at each end of the building, it was a magnificent structure and would have made a fine exhibition hall in its own right. The view here shows it just as demolition was beginning in 1961. Its near neighbour, the Low Level station on the London, Brighton & South Coast Railway, was almost as grand, and survives, albeit minus its overall roof which was replaced in the 1900s. *J.L. Smith/Lens of Sutton Collection*

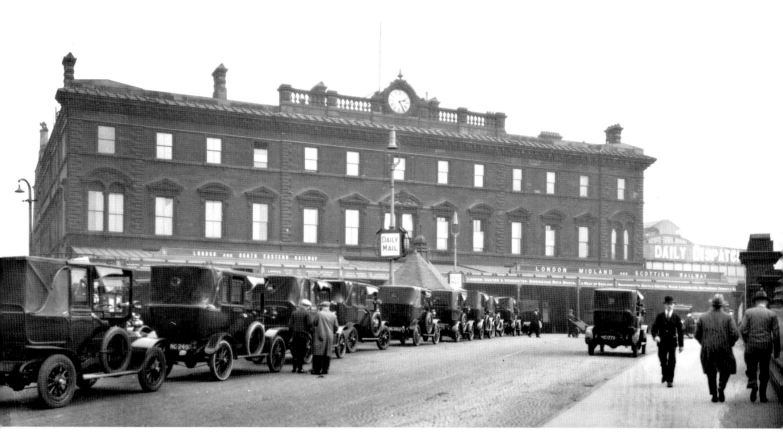

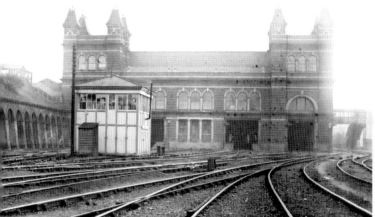

△ MANCHESTER LONDON ROAD

What is now the principal Manchester station, Piccadilly, retains its Victorian train shed (seen here on the right), but the station building was rebuilt in 1960–5 and again more recently. Seen in this photograph of 12 September 1927 is the 1866 station building, designed by Mills & Murgatroyd, of what was known until 1960 as Manchester, London Road. The station was jointly owned by the London & North Western Railway and the Manchester, Sheffield & Lincolnshire Railway. *John Minnis Collection*

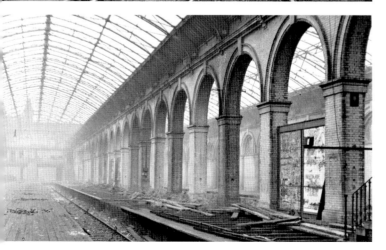

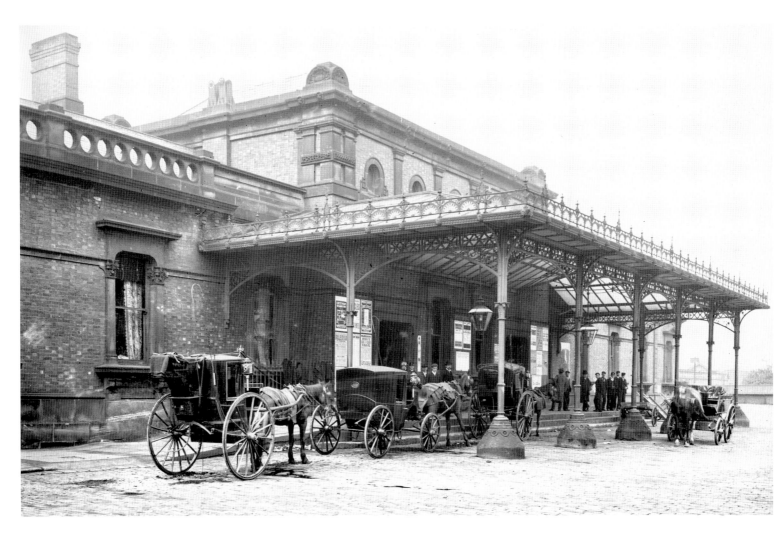

◬ WAKEFIELD WESTGATE

In addition to carrying the main line trains of the Great Northern Railway on their way to Leeds via the West Riding & Grimsby Joint line, Wakefield Westgate was used by the Midland and the Great Central companies, which serves to explain why this view of *c.* 1900 is taken from a large format Midland Railway official photograph. The station, opened in 1867, was to the design of the Leeds architect J.B. Fraser (1835–1922) and carried out in conjunction with his engineer brother John Fraser. J.B. Fraser was best known for Cavendish Road Presbyterian Church (now part of Leeds University) and St Augustine's Church, Leeds. The Wakefield station is in an eclectic Italianate style, quite heavy in effect but ameliorated by the ornate iron canopy. Its slender columns are protected by their massive bases. The station was rebuilt in 1966–7, retaining the footbridge and waiting rooms on the west side. *MR/John Minnis Collection*

◷◬ LIVERPOOL CENTRAL

Opened in 1874, Liverpool Central was the terminus of the Cheshire Lines Committee (composed of the Great Northern, Great Central and Midland companies) route from Manchester and housed the offices of the committee. Demolition of the buildings to make way for a new deep level station began in 1971, a year before the station closed. Almost approaching palazzo style with its symmetrical façade, it had a segmental arched roof, the work of Sir John Fowler, who, working with W.M. Brydone, designed an elegant overall roof employing light iron tie rods in place of trusses, following a scheme he had previously used at Victoria (London, Chatham & Dover Railway). It is seen here in 1888. *Photomatic*

◷ BIRKENHEAD WOODSIDE

In a most atmospheric photograph, the twin arches of the roof of Birkenhead Woodside are seen *c.* 1952. The station, opened in 1878, was an unlikely outpost of the Great Western Railway on the banks of the Mersey – the GWR shared the station with the London & North Western Railway through their ownership of the Birkenhead Joint lines. It had an impressive booking hall that was never used for its intended purpose due to access problems. Its high pitched roof was of a type associated more with a church or public hall than a railway station. The Birkenhead Joint engineer was R.E. Johnston but the architect's name is not known. Following closure in 1967, the entire station was demolished. *L&GRP/Robert Humm Collection*

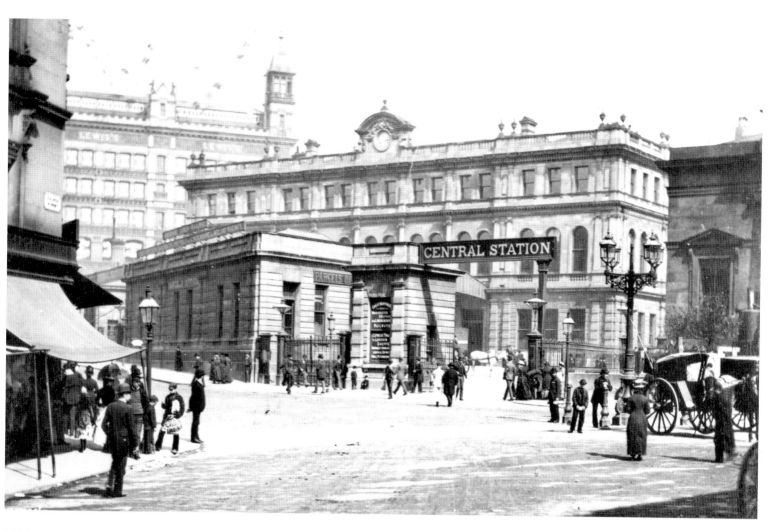

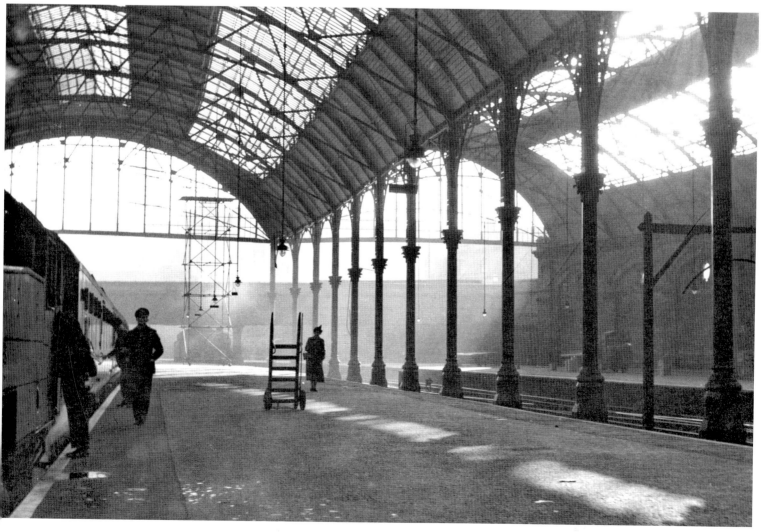

GLASGOW ST ENOCH

Glasgow's St Enoch station was built by the City of Glasgow Union Railway, promoted by the Glasgow & South Western Railway and the Edinburgh & Glasgow Railway and taken over by the G&SWR in 1883. Although having no part of the ownership of the station, it marked the culmination of the Midland Railway's push for the Anglo-Scottish trade, opening in 1876 (although not yet completed), the same year as the Settle & Carlisle line. The Midland influence on the G&SWR is evident in the great arch of the trainshed designed by Sir John Fowler and James F. Blair, like St Pancras the work of Handyside & Co. but smaller, its width being 204ft as compared to St Pancras's 243ft and its height 83ft as opposed to 110ft. Again like St Pancras, it sprang directly from platform level with no ties or trusses. A second lower span – seen to the left in this 1960s photograph – was added in 1904. The station closed in 1966 and, after serving for some years as a car park, the entire station and attached hotel was torn down in 1976–7 and replaced by a shopping centre. *John R. Hume/RCAHMS*

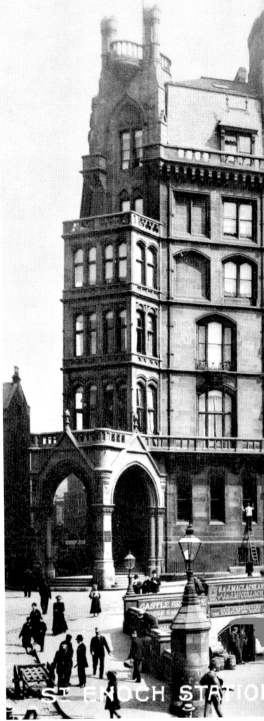

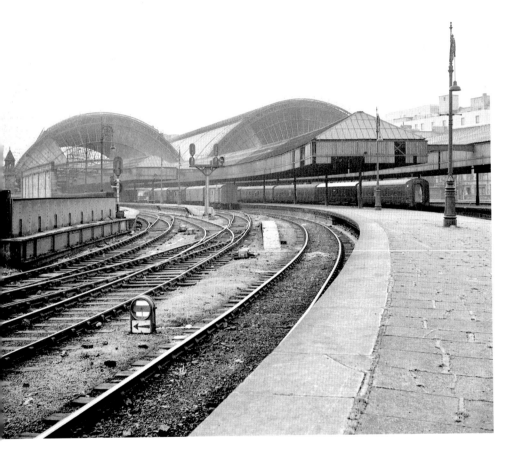

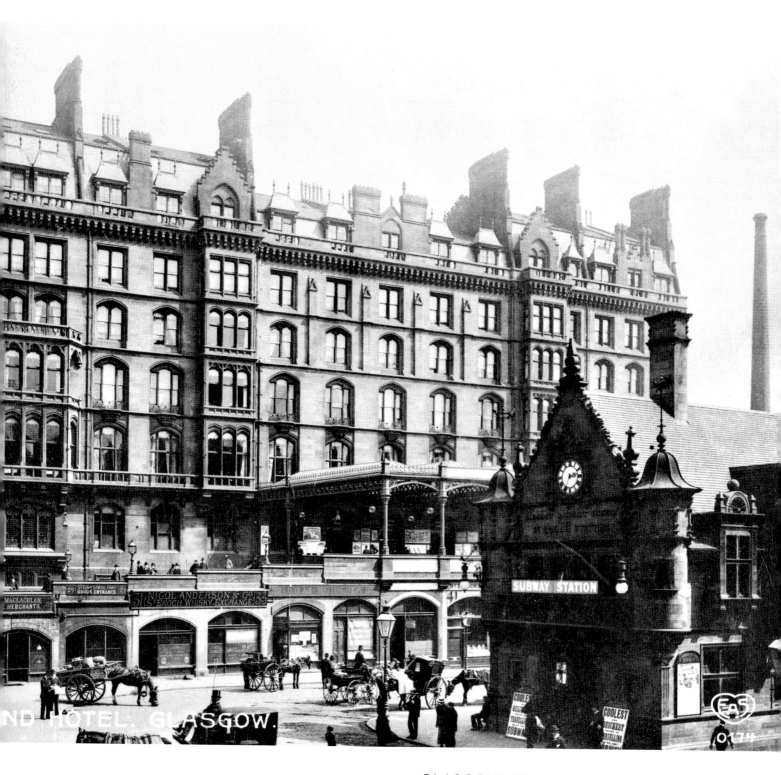

△ GLASGOW ST ENOCH HOTEL

The St Enoch Hotel was a fitting accompaniment to the iron train shed behind. Opening in July 1879, it was Scotland's first purpose-built railway hotel. The largest hotel in the country, it outlasted the station, closing in 1974. Designed by Thomas Willson of London, assisted by Miles S. Gibson of Glasgow, it was constructed of a particularly rich red sandstone and while it shared a Gothic porch with its equivalent at St Pancras, its style was more eclectic with nods to traditional Scottish style in some crow-stepped gables. *John Minnis Collection*

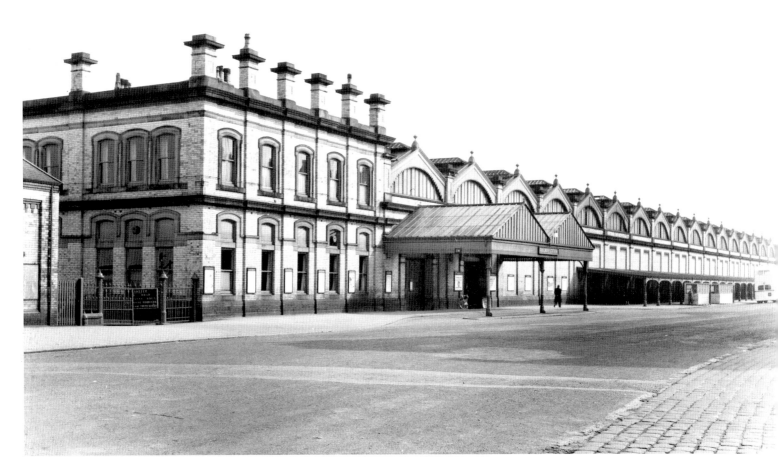

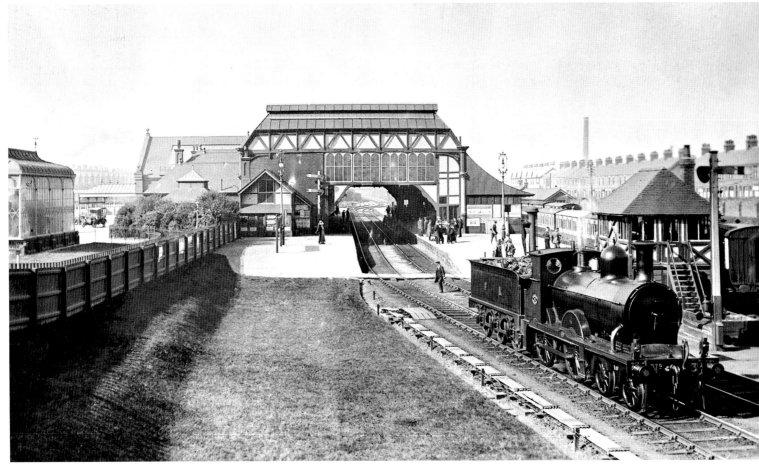

BRITAIN'S LOST RAILWAYS

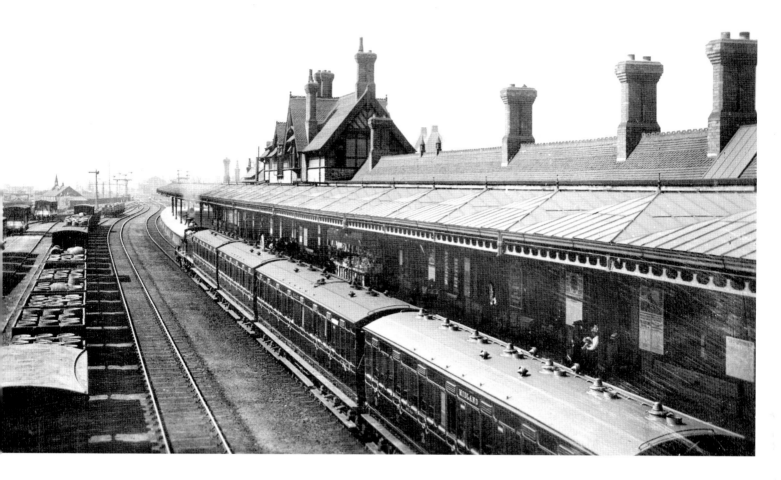

FLEETWOOD

The Lancashire & Yorkshire Railway developed Fleetwood as a major port. A new and vast station was built when the line was extended in 1883. Built in the yellow brick with red brick dressings favoured by the L&YR, it was suitably imposing to try and attract custom for the sailings to Ireland for which the company competed with the Midland Railway in nearby Heysham. Seen here in March 1955, it was closed in 1966. *L&GRP/John Minnis Collection*

BARROW-IN-FURNESS

When Barrow-in-Furness Central, the Furness Railway's principal station, was built in 1882, it was done on a lavish scale with a handsome overall roof. The detailing showed some Arts & Crafts touches. The signal box, which alone survives, is also of a distinctive design built by the FR, making much use of X-framing, picked out in contrasting colours and, with its hipped, tiled roof and stone base, clearly intended to appeal to the eye. The curious structure looking like a conservatory, just visible on the left, housed the celebrated locomotive known as 'Old Coppernob', one of the first examples of the preservation of a steam locomotive. The shelter, together with much of the station, was destroyed by a bomb in May 1941 ('Coppernob' survived) and the ruins of the station were finally demolished and replaced with a somewhat bland structure in 1958. This photograph was taken after 1910 when the locomotive, formerly No. 22 and one of six of the type built by Messrs Sharp Stewart & Co. in 1896 for main line services, was renumbered No. 33, and before 1920, when it was again renumbered No. 45, before meeting its end in 1929. *John Alsop Collection*

BURTON-UPON-TRENT

The Midland Railway rarely essayed the Domestic Revival (Irchester is the only other example) but when it did, the results were spectacular. Burton-upon-Trent was rebuilt in 1883 with a single island platform with two faces, with a footbridge up to a station building on an overbridge. The new station employed the full panoply of features associated with the style: picturesque asymmetry, half timbering, oriel windows, elaborate bargeboards, ornamental tiles and tall, panelled chimneys. These were combined with MR ridge and furrow awnings to produce a richly decorated building. It must have been expensive to maintain but its replacement in 1971 with a simple modern structure represented a considerable loss. *John Alsop Collection*

MANCHESTER EXCHANGE

Exchange station was the result of a row between the London &
North Western Railway and the Lancashire & Yorkshire Railway. The
former had made increasing use of the latter's Victoria station but the
L&YR would not agree to joint ownership of the station. The LNWR
therefore built its own station just to the west of Victoria which it
called Exchange, opened in 1884. A connecting platform, at 2194ft
the longest in Britain, was formed in the 1920s by joining Platform 3
of Exchange and Platform 11 of Victoria after the amalgamation of
both companies into the London, Midland & Scottish Railway. This
view, taken soon after opening, has a haunting quality to it and shows
how the station was raised up above the river Irwell. The station
building was extremely conservative for its date of construction; at
a time when other railways had begun to toy with Domestic Revival,
Exchange is in the purest Italianate that would not have been out of
place in the 1850s. *R&CHS Jeoffrey Spence Collection*

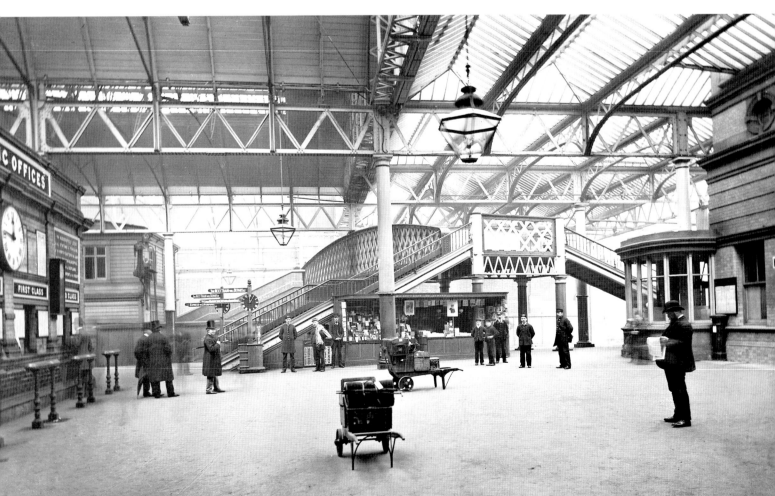

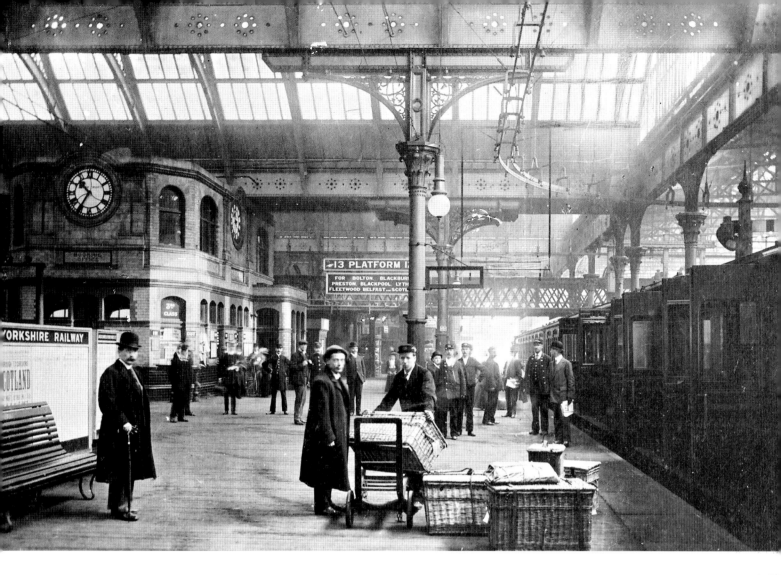

◁ MANCHESTER EXCHANGE

A view inside the station, taken soon after opening. The footbridge passes over the through tracks from Victoria station and by it is Platform 3, later to be extended to the right to form the celebrated longest railway platform in Britain. The W.H. Smith & Sons bookstall has large numbers of yellowbacks (cheap reprints in yellow board covers, the nineteenth-century equivalent of a paperback) on sale. Exchange station lost its station building in 1940 when the roof took a direct hit. The station was closed in 1969 to passengers but remained open for parcels traffic. It has now been demolished and the site used as a car park. *R&CHS Jeoffrey Spence Collection*

△ MANCHESTER VICTORIA

Much of Manchester Victoria station, the hub of Lancashire & Yorkshire Railway services in the area, was demolished in 1992–5 when the Manchester Evening News sports arena was built. Until then, the two westerly island platforms had survived largely as rebuilt in 1884 when the station was extended. The booking hall and roof, seen in this view of *c.* 1910, went in 1992. The track seen in the foreground is part of the overhead parcel-carrier system patented by John Aspinall, the company's chief mechanical engineer.
An electrically powered trolley was operated by a man on a seat attached precariously behind the electric motor and raised or lowered a basket containing parcels from the trolley to the platform. The system ended following bombing in 1940. *John Alsop Collection*

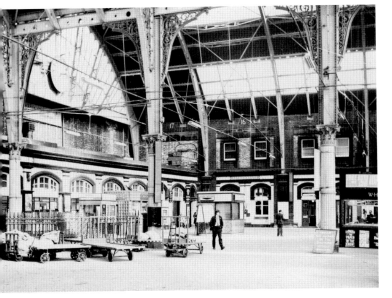

◁ BRADFORD EXCHANGE

While there are still two termini at Bradford, both are a shadow of what they once were. The Midland Railway station, Forster Square, retains its hotel and its front screen wall but, since 1990, has occupied only a small part of its former site. Exchange, owned by the Lancashire & Yorkshire Railway and used in addition by the Great Northern, was closed in 1973 and replaced by Bradford Interchange (i.e. linked to a bus station), slightly further south from the city centre. The old station had a great iron roof, designed by the L&YR's engineer, William Hunt, put up when the station was rebuilt in 1888. It had two spans, each 100ft wide, and its most notable feature was the provision of handsome radial glazing in the end screens at both ends of the roof. There was never a station frontage as such, only the end screen. The photograph was taken on 21 March 1972 and clearly shows the spandrel brackets, which were particularly ornate, and the modest single-storey offices within the train shed. The station was demolished immediately after closure to allow for construction of the bus station. *John H. Meredith*

◁ MIDDLESBROUGH

Middlesbrough's station buildings, designed by the North Eastern Railway's company architect William Peachey and opened in 1874, still exist but the great iron roof, 60ft high, that accompanied them is long gone, much of it demolished in an air raid. Described as 'the most Gothic of trainsheds' by the American architectural historian Carroll L.V. Meeks, Middlesbrough's roof fully matched the opulence of the station buildings. Here its skeleton is seen the morning after the raid on August Bank Holiday 1942. The remains were finally removed in 1954. *R&CHS Jeoffrey Spence Collection*

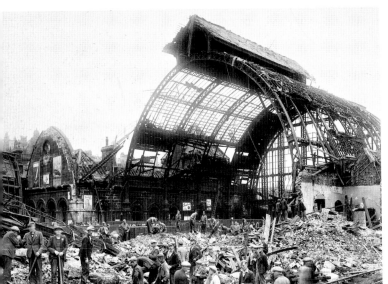

◁ LEICESTER

The Midland Railway station at Leicester was the work of Charles Trubshaw, the MR's architect, who had carried out a rebuilding on spacious lines in 1892. These later rebuildings lacked the soaring roofs of the 1860s but the result was a practical and imposing structure, albeit far larger than is needed today. Although the listed booking office and porte-cochère on London Road bridge remain, the rest of the station was again completely rebuilt in the 1970s and '80s, one of the largest station redevelopments of that period. *John Alsop Collection*

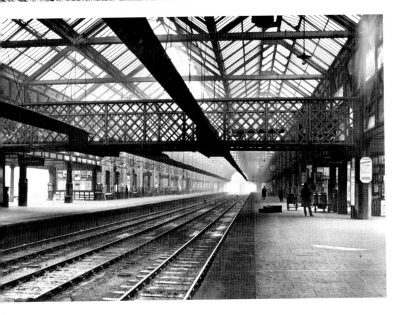

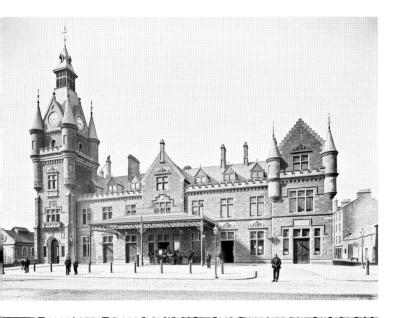

⊲ DUNDEE WEST

Perhaps the most tragic loss in Scotland was the wonderful station at Dundee West, built in 1889–90 for the Caledonian Railway of red sandstone in the Scottish Baronial style. The composition was perfectly balanced, with the clock tower complemented by the corner turrets of the building. It was the work of the Caledonian's Northern Division engineer, Thomas Barr, while the trainshed behind was by Cunningham, Blyth & Westland. No better illustration of changing attitudes to Victorian buildings may be found than the way in which Alan Reiach and Robert Hurd included a photograph of the building in their 1944 book *Building Scotland: A Cautionary Guide* (with a foreword by the Secretary of State for Scotland) captioned 'our stations and garages are no cause for pride. How ludicrous and sordid is this station in Dundee . . .' In such a climate of opinion, it was perhaps no surprise that, following the decision to rationalise Dundee's railway facilities and the subsequent closure of the station in 1965, the buildings were torn down. The photograph is one of a series taken by the local photographer Alexander Wilson, showing the reconstruction of the station, taken immediately upon completion in 1890. *Dundee Public Libraries*

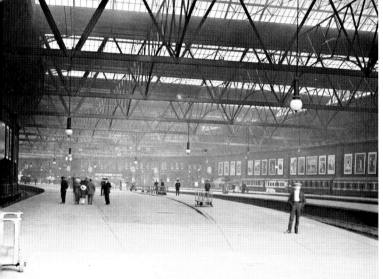

⊲ EDINBURGH PRINCES STREET

Although the Caledonian Hotel that formed the frontage of the Caledonian Railway's Princes Street station in Edinburgh still exists, the station behind entirely disappeared following closure in 1965, another example of the rationalisation of facilities. In this photograph of 1913, the great sweep of its 850ft long roof by Cunningham, Blyth & Westland is evident. The roof formed part of the complete reconstruction of the station in 1893–4. Its ridge and furrow design is similar to their other work at Dundee West (1889) and Leith Central (1903), both now demolished. *J.B. Sherlock/John Minnis Collection*

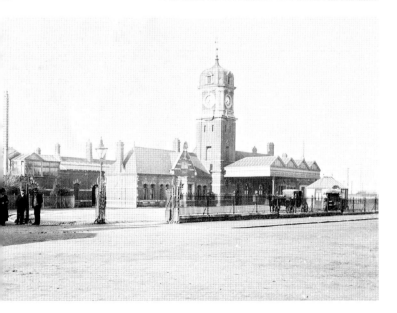

⊲ SOUTHAMPTON WEST

Southampton West became the principal station for the city in 1895 when an impressive new station was built in the red brick, broadly Flemish style favoured by the London & South Western Railway from the 1880s. Generous in scale, it had a grand clock tower. The Southern Railway rebuilt the down (south) side in 1933–5 (severely damaged by bombing in 1941) and the rest of the station went in 1966–7 at the time of the Southampton and Bournemouth electrification. *John Alsop Collection*

NOTTINGHAM VICTORIA

Nottingham Victoria is another of the great provincial stations we
have lost. The Great Central Railway's main line to London, the
last to be built, died gradually over the 1950s and '60s – Victoria
was perhaps its most significant casualty. It was designed by the
local architect, A.E. Lambert, who also did the main building at the
Midland Railway station (still extant, now Grade II*). A grand Flemish
Renaissance style building, built of local hard red bricks and Darley
Dale stone, Victoria station was opened in 1900 and is seen here in
1927. Only the tower of the station survived destruction in 1967 to
make way for the dark and depressing Victoria Centre shopping mall.

Topical Press Agency/Getty Images

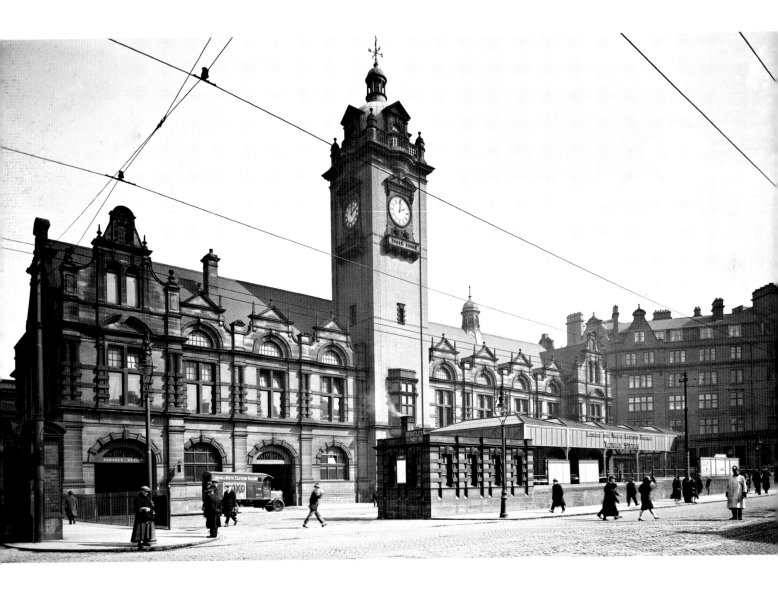

▽ NOTTINGHAM VICTORIA INTERIOR

The interior of the station, which was set at a lower level than the booking hall, was as impressive as the exterior with extensive use of glazed bricks, terracotta and faience by Burmantofts. This is seen clearly in this view of *c. 1910* which shows how airy and open the station was, with its great roof by the Horseley Co. towering 40ft above the platforms. *John Alsop Collection*

▷ BIRMINGHAM SNOW HILL

Birmingham Snow Hill, the Great Western Railway's principal station in the city, was rebuilt between 1906 and 1912 to the design of its new works engineer, W. Y. Armstrong. It had broad island platforms reached by stairs from a combined concourse, cab road and booking office, seen shortly after completion. On the left is the rear of the former Great Western Hotel, built in 1863, and purchased by the GWR at the start of the rebuilding of the station and converted into offices. The facing of the booking office was in faience with each ticket office window forming an aedicule, a most dignified arrangement. The extensive glazing included some decorative coloured glass in the end walls. After the electrification of the West Coast main line and the rebuilding of New Street, Snow Hill began a long decline. The former hotel and the roof over the concourse were demolished in 1969–70, so little care being taken over the work that, as the steel trusses came down, they knocked large pieces out of the faience. The station was by this time described as the largest unstaffed halt in the country with just a single unit railcar on a service from Wolverhampton Low Level using the station. It closed in 1972 and lingered on, increasingly derelict, until demolition in 1977–8. Much missed by Birmingham's residents, it was a great contrast to the claustrophobic New Street and a much smaller station, incorporated into a new development on the site, was opened in 1987. *National Railway Museum/Science & Society Picture Library*

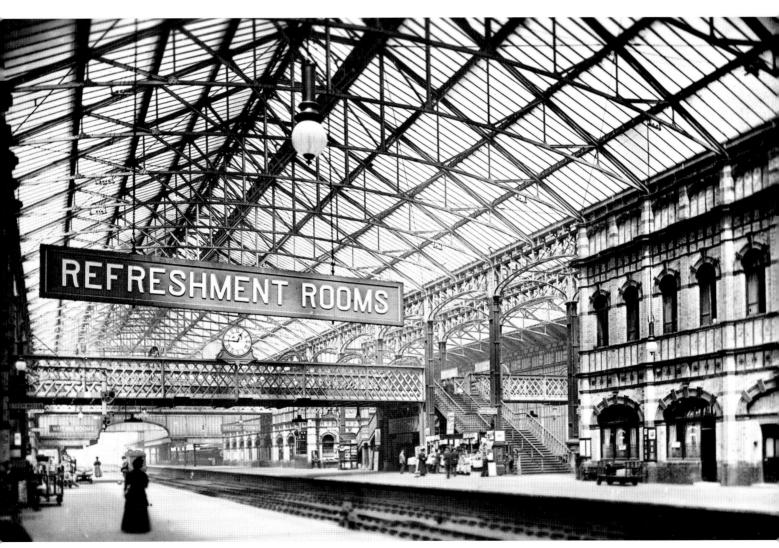

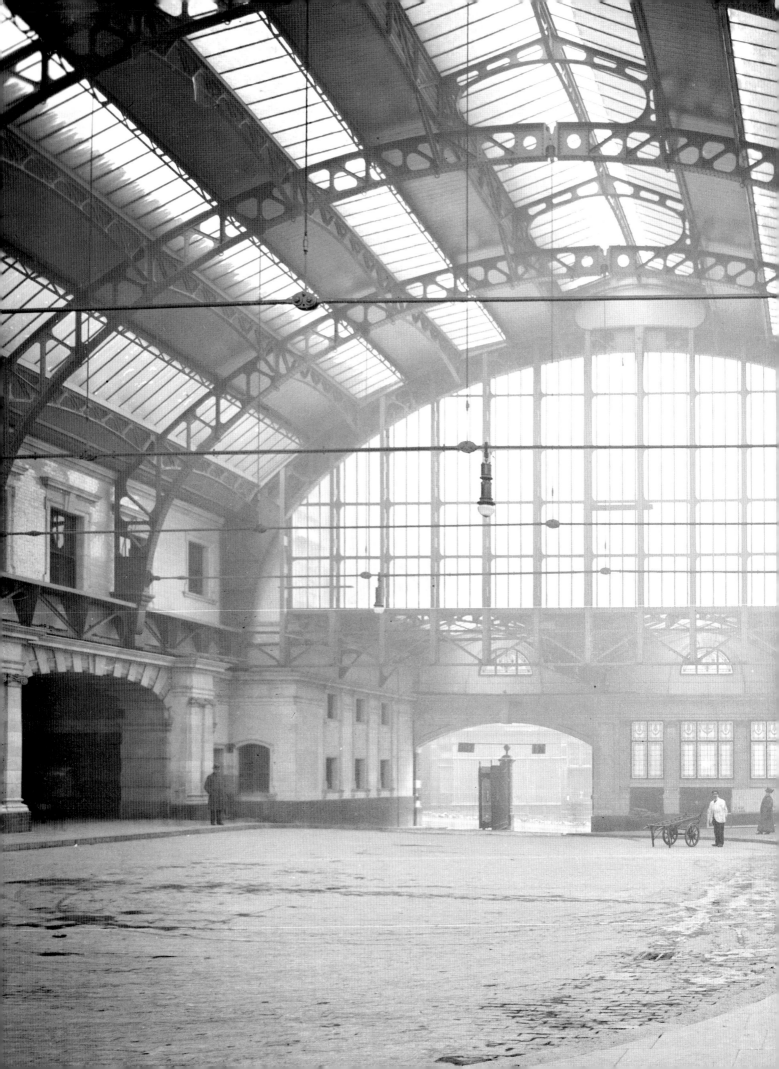

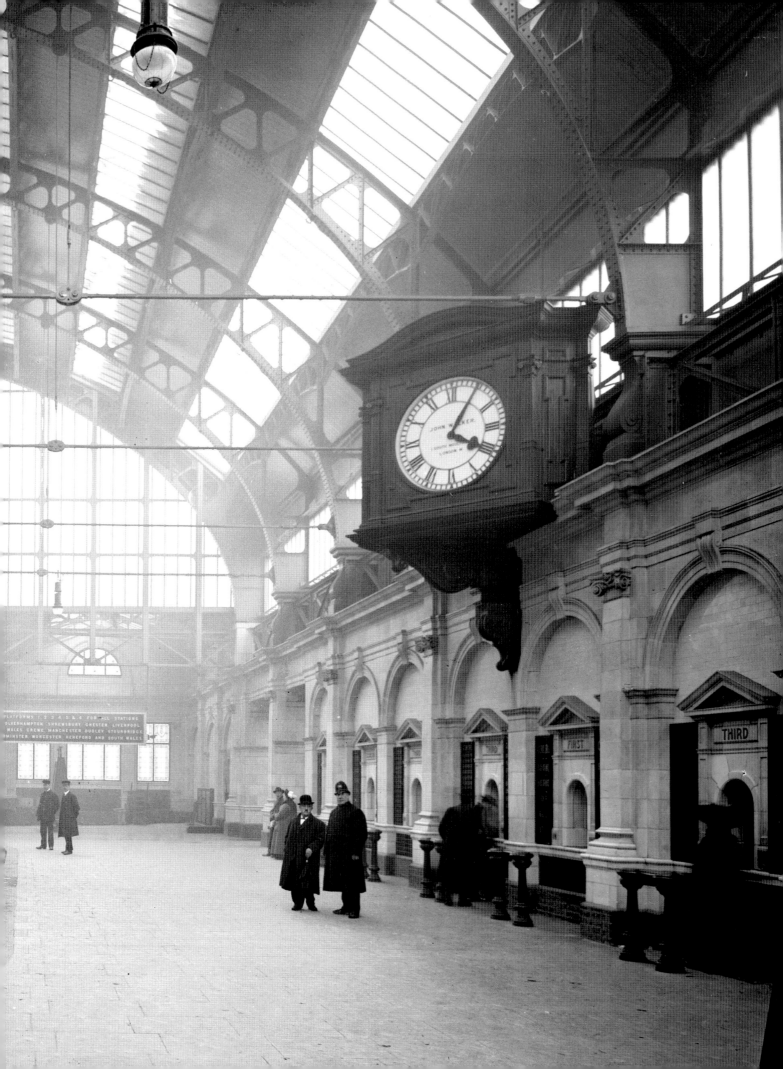

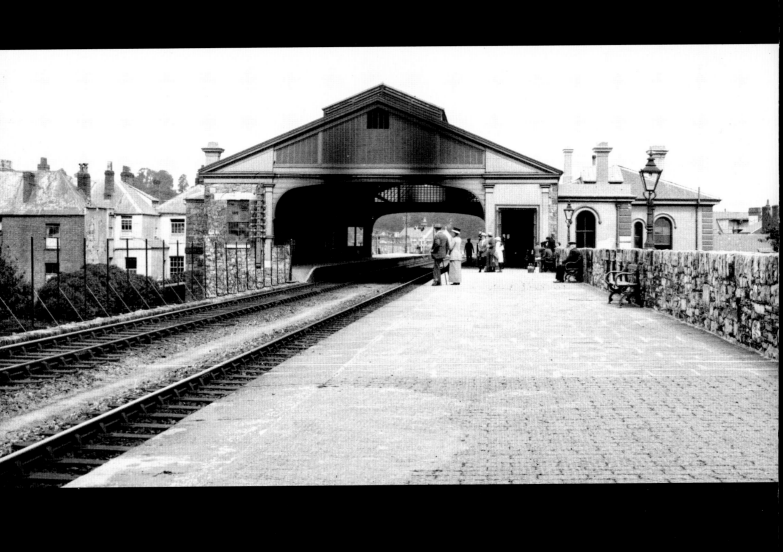

URBAN AND SUBURBAN STATIONS

Stations in urban areas have been particularly subject to destruction over the past fifty years. They experienced neglect during the war years from which many of them never recovered. In the north, particularly, industry had grown up around them, which meant that they tended to be in the less desirable parts of town and were consequently of little appeal for residential conversion or other forms of re-use. In addition, they were especially susceptible to the vandalism endemic in declining inner city areas from the 1960s onwards. The removal of staffing only exacerbated this and the extensive passenger and staff facilities were simply not required when trains rarely consisted of more than a couple of coaches and no ancillary business, such as parcels or excursion traffic, was undertaken.

◁ EXETER ST THOMAS

Although the main buildings of Exeter St Thomas station, designed by Brunel in 1846, still survive and are listed, the overall roof so characteristic of many of his stations was removed in the 1970s. The photograph taken on 11 June 1921 looking towards London, shows it to have had some handsome classical detailing with pilasters and entablature, complementing the Italianate station building. This harmony between roof and station building contrasts with many stations where the iron roof, the work of an engineer, bears little relation to the architect's work on the building. Its demolition leaves Frome as the sole survivor on the main line while that at Ashburton still exists as part of a garage, although both lack the elegance of St Thomas. *L&GRP/John Alsop Collection*

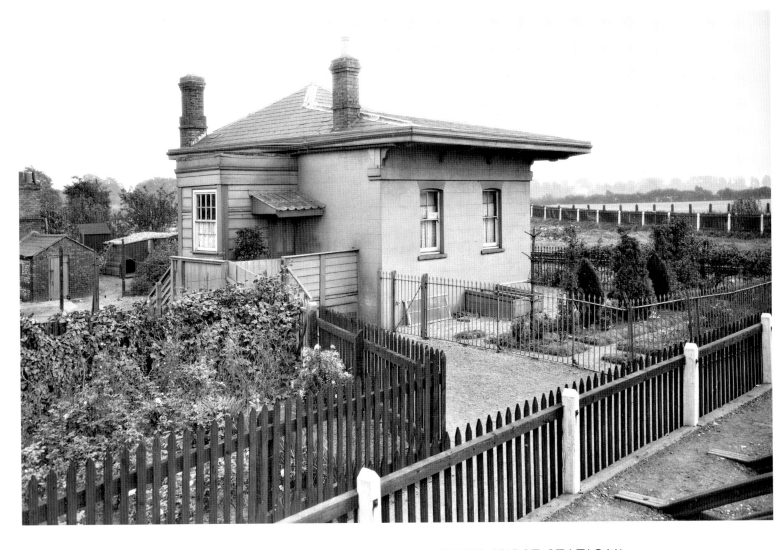

◁ GLOUCESTER

The T-shaped house at Gloucester, like a number of other early railway stations, has its low-pitched hipped roof extended to form a canopy to shelter waiting passengers. It had a short life, opening in 1847 and closing just four years later in 1851. It managed to survive as staff accommodation until 1971. *John Minnis Collection*

▷△ LEWES (FIRST STATION)

The station at Lewes is one of the finest on the former London, Brighton & South Coast Railway, well preserved and listed Grade II. It is the third station in the town, replacing the second of 1857 in 1889, on more or less the same site. The first, a terminus in Friar's Walk of 1846, survived as accommodation until 1969. Although the round-headed windows enclosed by the pilasters are a little uncomfortable, overall it was a most handsome classical building with a giant order of panelled pilasters and rich Corinthian capitals. It is another of the most significant losses of railway buildings. *John Minnis Collection*

▷ LEWES (SECOND STATION)

The second station at Lewes (1857–89) had a relatively short life, being demolished because it was necessary to ease the tight curves through the station. It was unique on the Brighton system in being built in a style resembling a Swiss chalet, with deeply overhanging eaves and the upper portion constructed of timber with diagonal boarding. Massive timber eaves brackets, fretwork valancing along the eaves, window frames with an extraordinary margin light arrangement, fish scale tiles and iron ridge ornament all added to the effect, while the ground floor had brick nogging between X-framed panels. The only discordant note is introduced by the brick-built addition to the right of the main building with its conventional plate glass sash windows and slate roof, although even this has been given some elaborate valancing along the eaves to try and make it fit in. The sole comparable example is Matlock Bath where such a style is appropriate, given its appellation of 'England's Switzerland', although Swiss influence was also evident at some of Austin & Paley's Furness Railway stations and on the Callander & Oban line. *R&CHS Jeoffry Spence Collection*

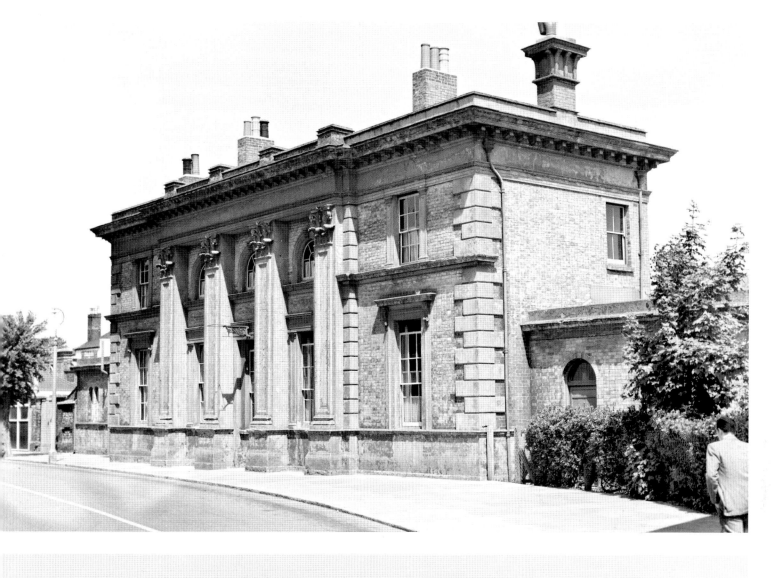

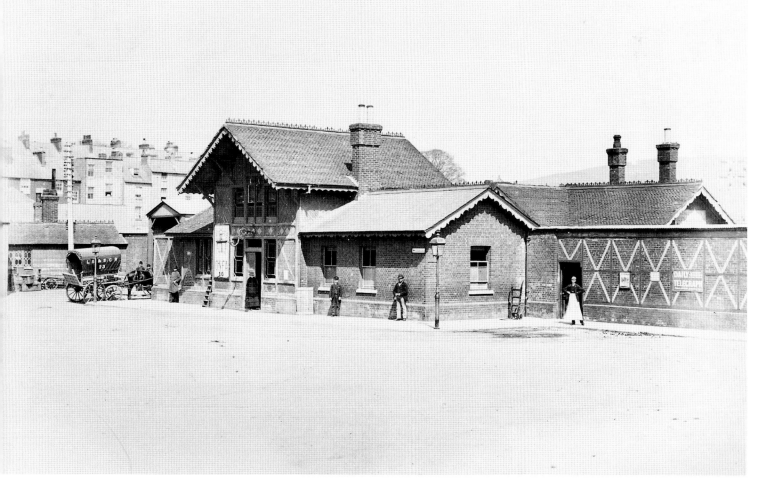

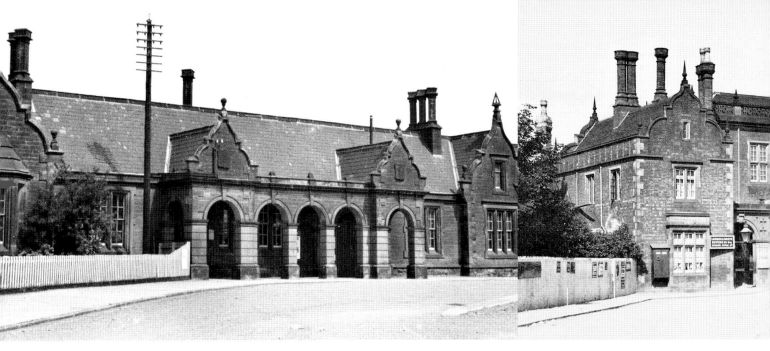

△ TWEEDMOUTH

Benjamin Green was one of the greatest early railway architects and the stations he designed for the York, Newcastle & Berwick Railway mostly survive. One that does not is the 1847 station at Tweedmouth, closed in 1964. Photographed here in May 1937, it was built in Green's usual neo-Jacobean style, well proportioned as with all his work, and had an especially handsome loggia. *John Minnis Collection*

△▷ TAMWORTH

Tamworth was one of the greatest casualties of the London Midland electrification scheme. The Midland Railway Derby–Birmingham line crossed the Trent Valley line of the London & North Western Railway at this point and each company had platforms on its respective lines. The rebuilding was intended to improve interchange between the two routes but it resulted in the demolition in 1962 of J. V. Livock's magnificent neo-Jacobean station building of 1847, the most impressive of the series of stations this highly accomplished railway architect designed for the Trent Valley Railway and one of the most convincing essays in the style. In later years the building, seen here *c.* 1904, had its loggia ruined by insensitive alterations but this was scarcely an excuse for its removal. *John Alsop Collection*

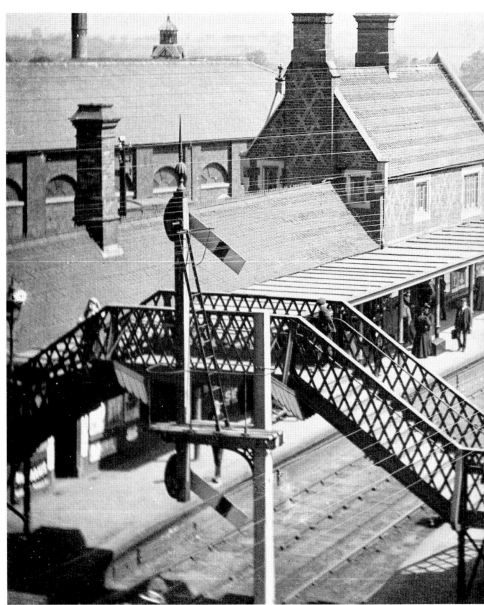

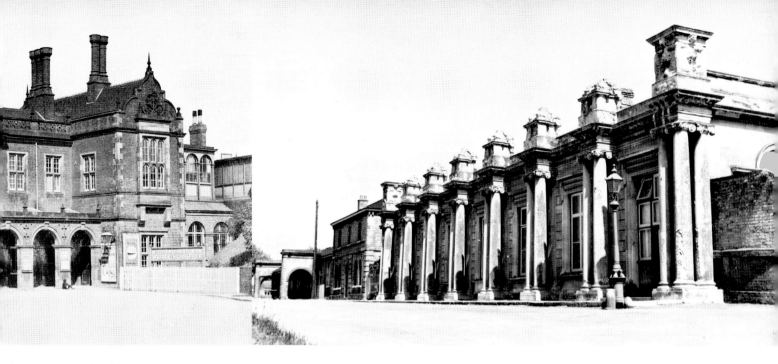

NEWMARKET

The demolition of the original Newmarket station, most memorably described as a 'baroque orangery' by Christian Barman and prominently illustrated in his *Introduction to Railway Architecture* in 1981, is one of railway architecture's most serious losses. It was built in 1848 as the terminus of the Newmarket & Chesterford Railway, which made up for the simplicity of its other stations by commissioning this extraordinary design. The paired Ionic columns set up a powerful rhythm articulating the seven bay façade. Their termination above the deep cornice is striking. The adjacent stationmaster's house was, by contrast, in a restrained Italianate. After replacement by a new station in 1902, the old station, photographed in June 1953, was retained for goods traffic, often including thoroughbred racehorses for which it provided appropriately distinguished surroundings. *K.G. Carr/Pamlin Prints*

CONGLETON

Congleton was an example of the North Staffordshire Railway's long-standing enthusiasm for neo-Tudor buildings. Opened in 1848 and the work of the company's architect H.A. Hunt, it was completely rebuilt in the mid 1960s as part of the London Midland Region's Manchester electrification programme. In this view, looking north, the kneelers, ornamental roof tiles, diapered brickwork and tall chimneys so characteristic of the company's architecture are particularly evident. *John Alsop Collection*

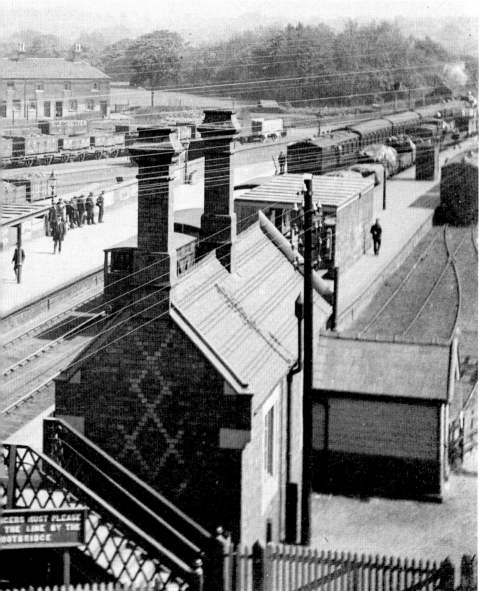

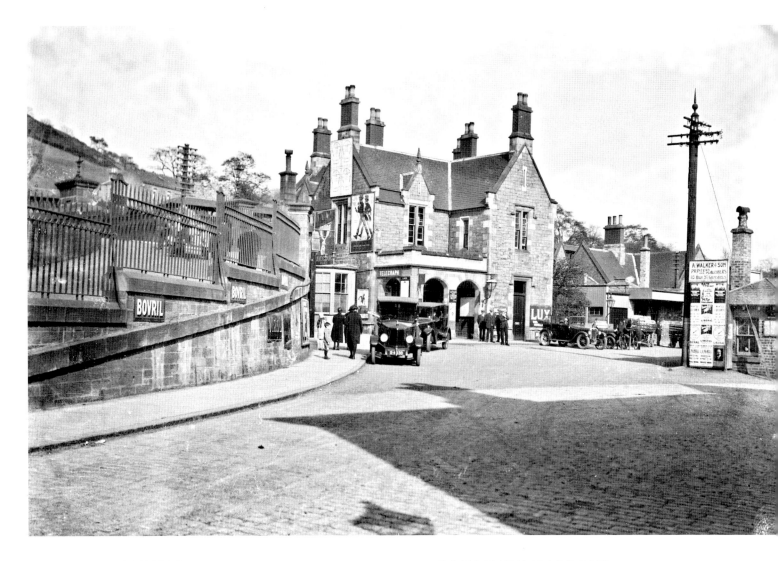

△ GALASHIELS

The romantic Waverley route of the North British Railway was
closed in 1969, the only cross-border main line to be lost, although
the reconstruction of part of it from Edinburgh to Galashiels is due
to begin shortly. Galashiels station was opened in 1849 and shows
how the neo-Tudor style was equally popular north of the border.
This view was taken in the late 1920s when the station was already
being blighted by advertising and the cars, an Armstrong-Siddeley on
the left (probably a taxi) and an open Austin to the right, help confirm
the date. The line was raised up at a higher level here. No trace of the
station is left today. *RCAHMS*

▷△ RAMSGATE HARBOUR

One of the most extraordinary locations for a station was that at
Ramsgate Harbour. Here, the railway emerged from a tunnel straight
into a station at the base of the cliffs right on Ramsgate Sands. The
station's location reflected the competition between the South
Eastern Railway, whose Ramsgate Town station at the back of the
town was opened in 1846, and the London, Chatham & Dover Railway,
which opened Ramsgate Harbour in 1863, hoping to skim off much
of the day trippers' market. While undeniably convenient for the
holidaymaker, the noise and dirt of engines was long regarded as
a blight on the resort and following the railway grouping of 1923,
the railways of Thanet were rearranged by the Southern Railway and
the line to the sands was closed, shortly after this photograph was
taken on 20 June 1926. The tracks were soon taken up but the
station roof survived into the 1990s as an amusement arcade.
A.W. Croughton/Lens of Sutton Collection

▷ OTLEY

Otley was on the Otley & Ilkley line, owned jointly by the Midland
Railway and the North Eastern Railway, and opened in 1865. Built
of local ashlar stone in classical style with well detailed window
surrounds incorporating half columns, it was similar to the terminus
at Ilkley. The other platform buildings in this view of *c.* 1906 are
typical MR structures of the early 1900s. Although the station is still
open, all this has gone, a victim of the move to unstaffed stations.
John Alsop Collection

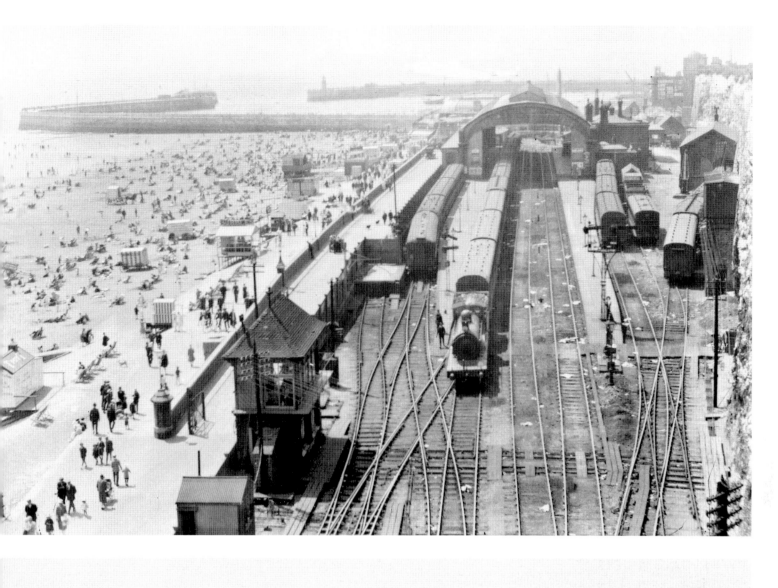

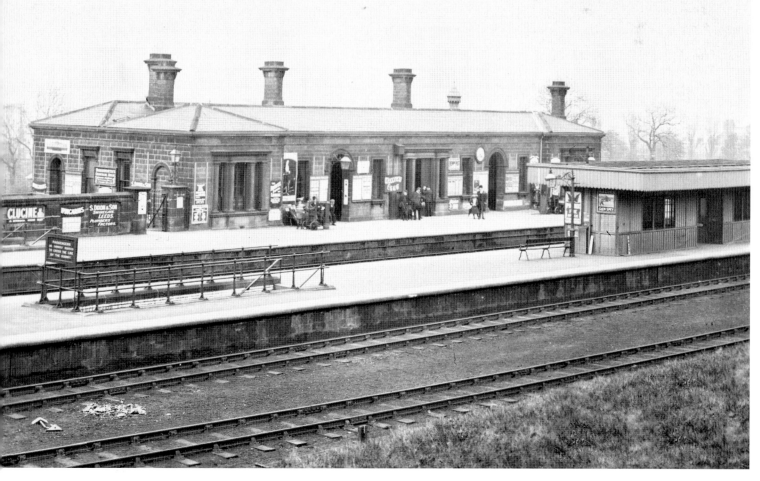

▷ BOW

The North London Railway had particularly
substantial and imposing stations in the inner
suburbs, designed by its architect Edwin
Horne. In 1869–70 he rebuilt, at a cost of
£25,000, the original station at Bow, which
dated from 1850. The new building was
the most impressive of all the company's
stations. In an eclectic mix of Venetian Gothic
and Florentine motifs, he emphasised the
immensely high first floor of the building,
occupied by the Bow & Bromley Institute.
Equipped with an organ by Brindley & Foster,
its premises were praised by the *East London
Observer* which opined in its 2 April 1870
issue that 'a finer hall does not exist in the
East End of London'. In front of the building,
the Bryant & May Match Tax Testimonial
Fountain by Rowland Plumbe was erected
in 1872. The effect was magnificent, as may
be seen in this photograph of 1928 when
the station had seen little alteration since
construction. But why was such a grand
station built there? Possibly the proximity
of the company's works just to the south of
the station may have had something to do
with it but the presence of the Institute is
likely to be a more convincing explanation.
The subsequent decline of the station must
be related – it was closed to passengers in
1945, the fountain was removed in 1953, and
the upper part of the building was destroyed
by fire in the early 1950s and demolished
in 1957, while the lower part survived as a
ruin until 1975. The NLR route through the
station site is now that of the Docklands
Light Railway, whose Bow Church station
is located nearby. *National Railway Museum/
Science & Society Picture Library*

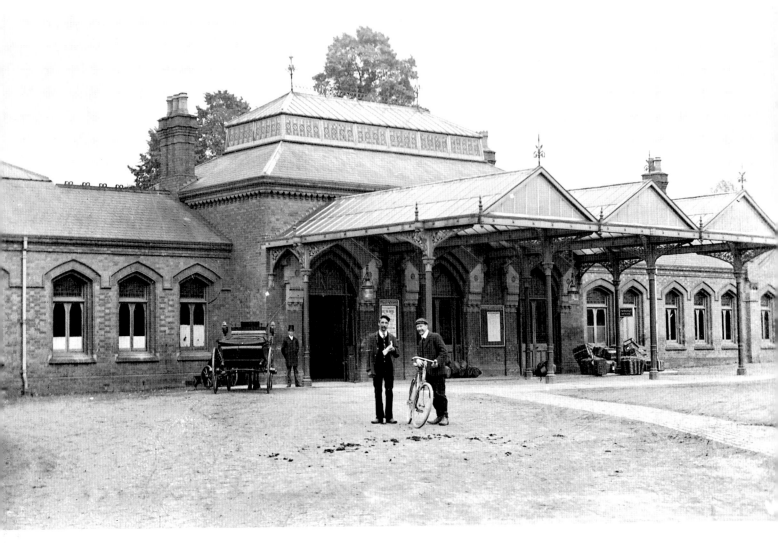

◁ KENILWORTH

The usually somewhat parsimonious London & North Western
Railway pulled out all the stops when it rebuilt Kenilworth station
in 1883 in Gothic style, a relatively late use, perhaps reflecting the
association of the town with its castle. The station building had
coloured glass in the upper parts of the windows, a lantern roof to
the booking office and some handsome iron canopies of the ridge and
furrow variety. Even more extraordinary, the signal box had pointed
windows and elaborate brickwork to its lower stage replacing the
usual blue and red brick and cast iron locking room windows, so as to
match the remainder of the station. This was something almost unique
on the LNWR, so wedded was it to its standardised buildings. After
closure to passengers in 1965, the buildings lingered for many years
before succumbing to demolition in May 1983. *John Alsop Collection*

▷ KENILWORTH INTERIOR

The interior at Kenilworth, seen here in 1959, was even more ornate
than the exterior. Its roof structure was of great complexity with
extensive use of moulded beams, pierced brackets and finials, while
the booking office screen was a tour de force in panelled wood
topped by cresting and more finials. *Alan Searle*

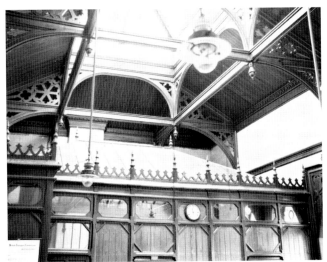

▷ HEYWOOD

Levels of decoration at fairly minor stations
in industrial districts could be remarkably
high. Heywood on the Lancashire & Yorkshire
line to Bury had bargeboards of singular
complexity, while the ornamental ironwork
surmounting what was already an elaborate
footbridge was unusual. Heywood was
opened in 1848 but the buildings seen here
dated from 1871. They were demolished
before closure of the station in 1970.
John Alsop Collection

▷ FOREST HILL

The London, Brighton & South Coast Railway
had a reputation for providing ornate if
not extravagant stations, but it excelled
itself at Forest Hill in the south London
suburbs. Following many complaints that its
predecessor of 1854 was inadequate, the
company rebuilt the station in 1881–3, in a
style that commingled Venetian Gothic with
Florentine Renaissance to remarkable effect,
the whole topped off with a tall clock tower.
Why Forest Hill should receive such largesse
is unknown but it was then a wealthy district
and Samuel Laing, the company's chairman,
lived not far away in Sydenham. Part of the
1854 Italianate station building, which was
retained, is visible in the background. The
impressive appearance of the station was
further heightened by a glass and iron flower
shop just outside it. The whole glorious
mixture was severely damaged by a flying
bomb in 1944 and although it was roughly
patched up, leaving gaping holes where the
clock faces punctuated the tower, the ruin
was replaced in 1972 by one of the rather
dismal CLASP buildings as part of the
Southern Region's campaign to rid itself of its
most decrepit stations. *John Minnis Collection*

▷ HALIFAX NORTH BRIDGE

Halifax North Bridge was not a station of any
great architectural distinction but is included
here because it is typical of many stations
in the manufacturing districts in Lancashire
and Yorkshire, sandwiched between mills and
other industrial premises. It was on a line
owned jointly by the Lancashire & Yorkshire
and Great Northern companies. Opened in
1880, it comprised an island platform – all
that could be accommodated on the narrow
site, which was little more than a shelf cut
out of the hillside – and timber buildings,
which were to Great Northern Railway
design. It was photographed on 26 May 1955,
three days after closure to passengers.
H.B. Priestley/Mile Post 92 1/2

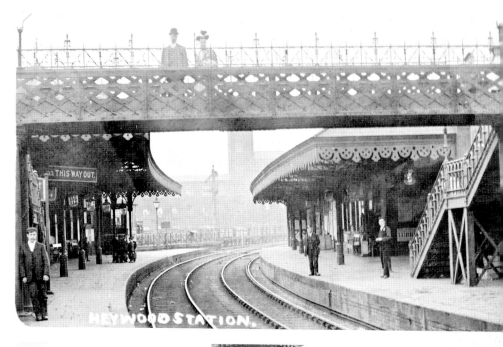

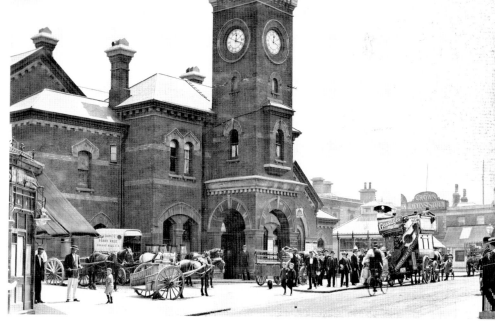

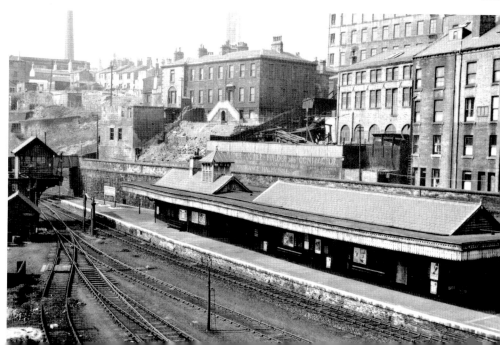

OBAN

The Callander & Oban Railway built a number of charming timber stations in an exotic style owing a little to Swiss chalets, a little to the American stick style and a lot to Victorian ingenuity. Key features were deep overhanging eaves, large windows with margin lights and decorative timbers in the gable ends. The apogee of the style was the terminus at Oban, built in 1880, which had a jolly clock tower and an iron and glass concourse behind it. It was replaced by a remarkably dull building in 1986, despite a vigorous campaign to save it, a great loss both to railway architecture and to the town. With the recent destruction by fire of Taynuilt station, this style of building is now extinct. *John R. Hume/RCAHMS*

HYNDLAND ROAD

A suburban terminal opened in 1886 as part of the North British Railway's extensive Glasgow suburban network, Hyndland Road closed when a new through station was opened nearby in 1960 as part of the Clydeside electrification scheme and was demolished soon after. The design of its unadorned façade reflects the classical tradition still strong in Glasgow and fits in well with the neighbouring tenement blocks of this well-to-do area. *John R. Hume/RCAHMS*

GOUROCK

Competition between the Glasgow & South Western Railway and the Caledonian Railway for the steamer traffic in the Firth of Clyde to the resorts of Dunoon and Rothesay and the Isle of Arran was intense. Both companies fought to retain the traffic by the provision of ever more elaborate stations and piers. In 1889, a costly extension from Greenock to Gourock was constructed by the CR, providing the architect James Miller with his largest commission. The Gourock terminus was a tour de force in Miller's distinctive and attractive half-timbered style, taking its inspiration from the fashionable Domestic Revival of the period, complete with a corner tower and coved eaves. Doors were placed at intervals along the side of the structure to enable quick and easy access from two trains at once to the steamers waiting alongside the pier. The clock tower was lost in a Second World War air raid but the remainder survived until its destruction in the 1980s. The station remains open but there is little more than a steel skeleton of a section of the canopies left. *Bedford Lemere/RCAHMS*

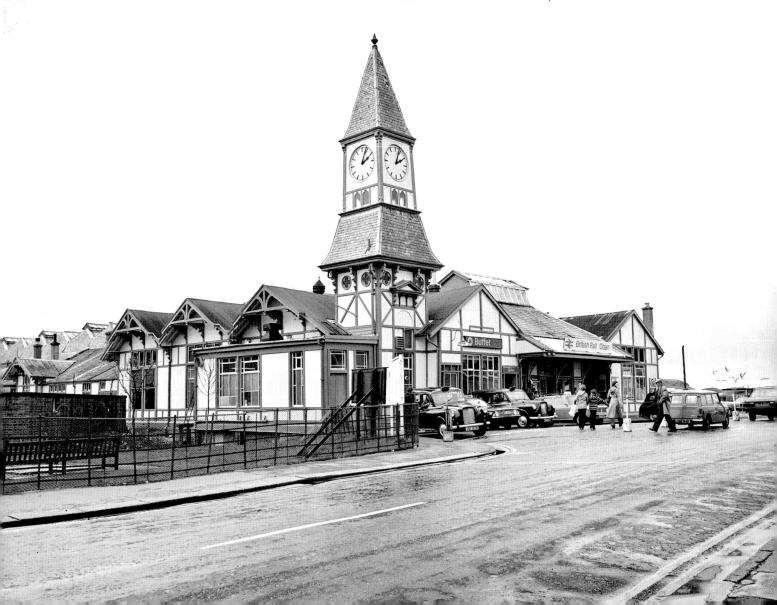

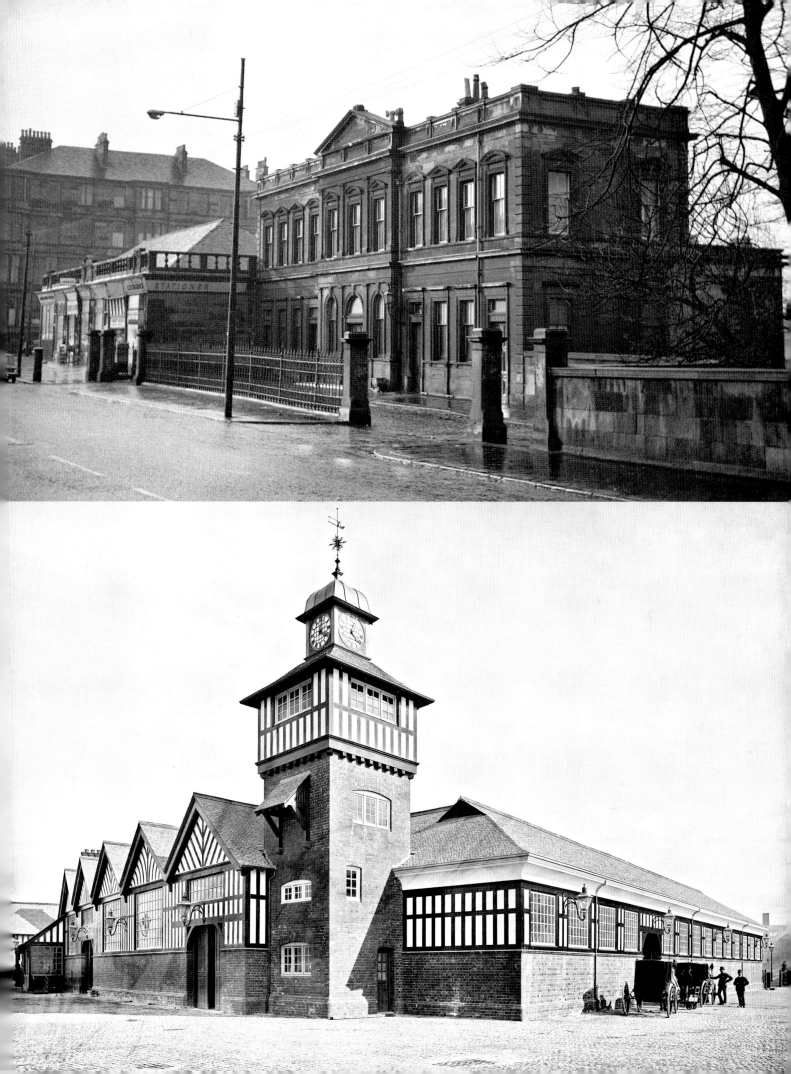

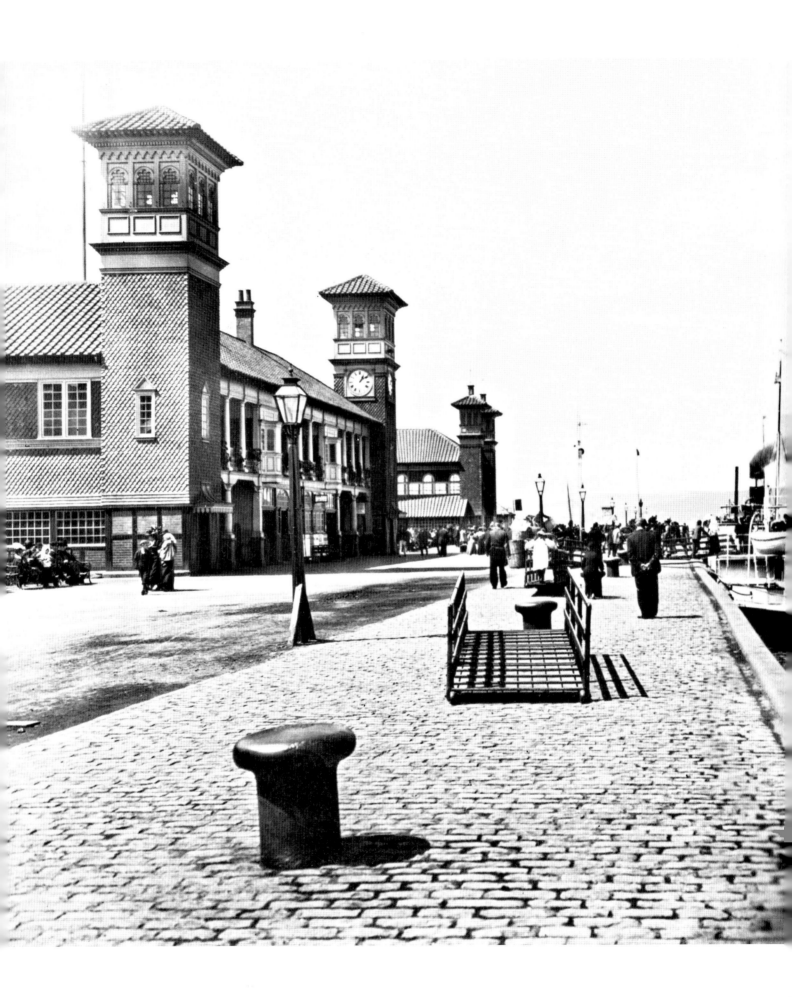

BRITAIN'S LOST RAILWAYS

◁ GREENOCK PRINCE'S PIER

In retaliation for the Caledonian Railway stealing a march on them at Gourock, the Glasgow & South Western Railway rebuilt its station at Greenock Prince's Pier. Actually owned by the Greenock Harbour Trust, the design of the new station was again entrusted to James Miller, a rare example of the same architect undertaking two stations intended to compete with one another – a second instance is at Nottingham, where A.E. Lambert did both Victoria and Midland stations. The results certainly equalled, if not exceeded, his work at Gourock. The new station was opened in May 1894 and was described as 'Spanish style blended with a treatment of the Renaissance', and while Gourock made do with one tower, Greenock had four, its two central ones echoed by smaller versions at the extremities of the building. Rationalisation of Clyde services took place in the 1950s and the steamers ceased to call. Following a short period as an ocean terminal, Prince's Pier was closed in 1966 and subsequently completely demolished, the site now serving as a container terminal. *Getty Images*

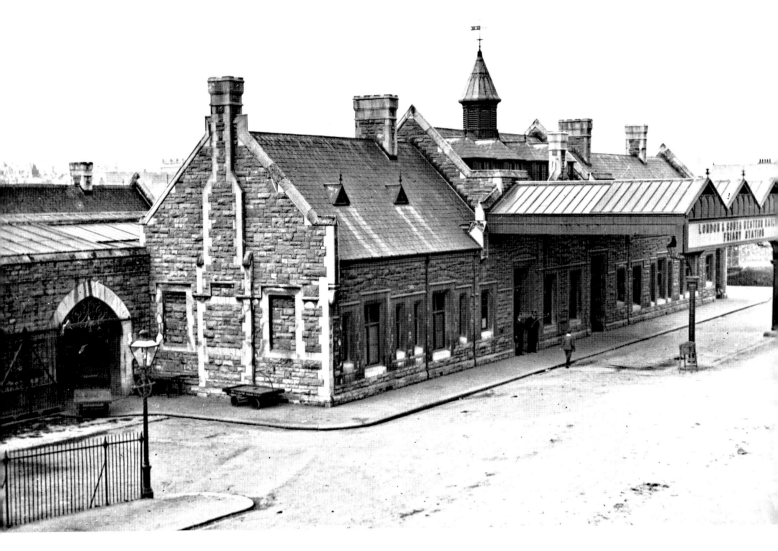

PLYMOUTH FRIARY

Plymouth saw competition between two companies, the Great Western Railway and the London & South Western Railway, and the inevitable rationalisation that followed state ownership of the railways saw the closure of the LSWR's Plymouth Friary station to passengers in 1958. The LSWR was a late arrival in Plymouth, Friary station not opening until 1891. It was much more substantial than the GWR's timber station at North Road and became a goods station after closure to passengers. The buildings went in 1977. *L&GRP/John Minnis Collection*

NELSON

Nelson is an example of a station where the station building is at ground level and the platforms behind are raised on an embankment. It was given this distinctive, almost French looking, building on rebuilding in 1892. With its mansard roof and large windows, there was nothing else quite like it on the Lancashire & Yorkshire Railway. If it were not for the canopy, it could be mistaken for a bank. The platform buildings survive and have recently been restored but the station building went *c.* 1970. *John Alsop Collection*

FORT WILLIAM

The terminus of the West Highland line for seven years, until the Mallaig extension was opened in 1901, Fort William had an appropriately impressive building with a squat tower and a concourse lit by a large semi-circular window with attractive art nouveau glazing. It made an appropriate conclusion to the long journey from Glasgow, beautifully sited by Loch Linnhe as seen in this photograph of *c.* 1938. A Bedford WTB coach and a K2 class locomotive 'Loch Shiel', specially named for service on the line, complete the period piece. A decision was taken to build a new road along the lochside and the station was in the way. It was demolished in 1975 and a new and much simpler station built further out of the town centre. *C.E.J. Fordyce/Lens of Sutton Collection*

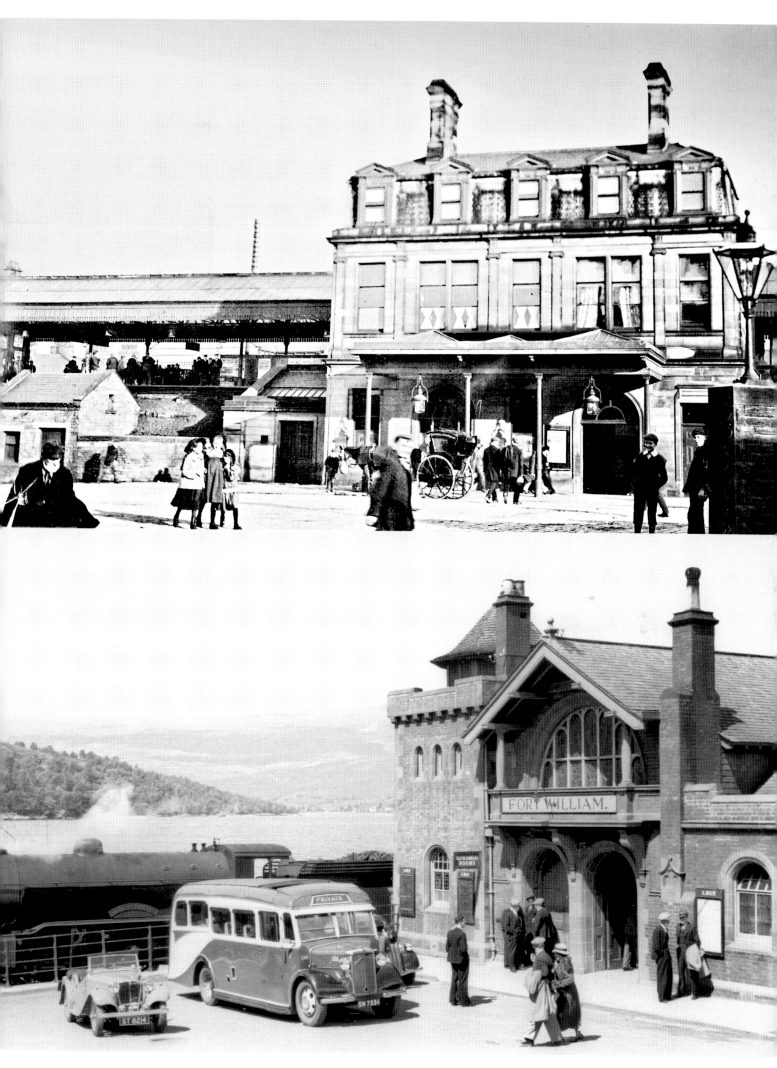

◁ KIRKLEE

The Glasgow Central Railway, opened in 1896 and operated by the Caledonian Railway, saw the construction of some fine stations designed by the great Scottish architect J. J. Burnet. The principal buildings of one, Kelvinside, remain albeit rebuilt after extensive fire damage. But Kirklee, which survived into the 1960s after closure in 1939, has been demolished. Burnet employed some handsome Arts & Crafts detailing such as the chunky piers to the covered entrance to the platforms and the balustrade, the broad eaves of the central portion of the building and the large grouped windows. The building is seen in a derelict state. *John R. Hume/RCAHMS*

▷ BOTANIC GARDENS

Botanic Gardens was another 1896 station for the Glasgow Central Railway, designed by James Miller, who displayed his talent for endless and imaginative variations on the Domestic Revival theme in this, a station designed to harmonise with its parkland setting. The twin towers give it the feel of a pavilion rather than a railway station, which is presumably exactly what Miller intended – a light-hearted building to capture the holiday mood of a weekend visit to the Gardens. This delightful building, like the others on the Glasgow Central Railway, closed as a railway station in 1939 but was then used by a succession of businesses until, in its final incarnation as a nightclub, it was burnt down in January 1970. *Bedford Lemere/English Heritage NMR*

⟩ MUNDESLEY-ON-SEA

Located on the Norfolk & Suffolk Joint Committee (Midland & Great Northern Railway/Great Eastern Railway) loop line between Cromer and North Walsham, intended to open up the Norfolk coast to holidaymakers, Mundesley-on-Sea station opened in 1898. It was a most spacious station with wide and lengthy platforms, extensive awnings and one of the best Domestic Revival buildings put up for a railway company. This photograph, looking towards Cromer, was taken soon after opening (building materials are still scattered around) and depicts a GER Massey Bromley 0-4-4T waiting in the station. Sadly, traffic never lived up to expectations and the station was demolished after closure in 1964. Nothing, other than a row of cottages, is left at the site today.
R&CHS Jeoffry Spence Collection

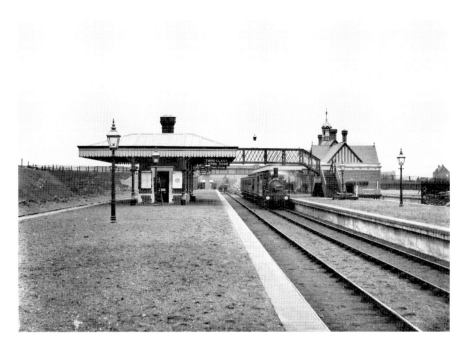

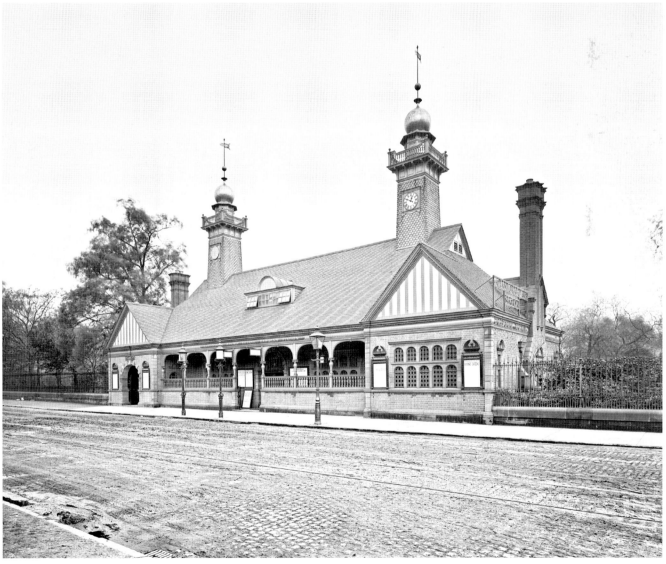

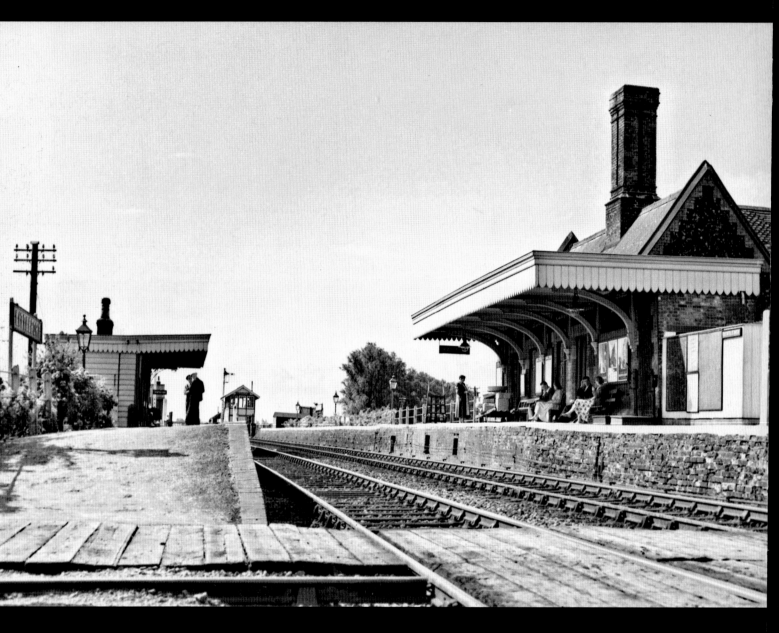

△ LITTLEPORT

The first photograph in the country stations section of Christian Barman's *An Outline of Railway Architecture* (1950) was of Littleport on the Great Eastern Railway line to King's Lynn. Built by the Eastern Union Railway in 1847, it used the local carstone to good effect and was, like the other EUR buildings, in Tudor style. The gently curved brackets are especially attractive. Photographed in 1953, it was demolished in the 1970s although the waiting shelter opposite lasted into the twenty-first century. Fortunately the contemporary building at Downham Market remains, as do several other examples of the EUR's buildings. The 1884 signal box beyond remains, recently sympathetically renovated. *L&GRP/John Alsop Collection*

COUNTRY STATIONS

Certainly until the 1860s, country stations were inspired by contemporary designs for lodges and cottages, and were excellent examples of the picturesque, replicated in large numbers. Italianate became known as 'the English railway style' but it was rivalled in popularity by the many neo-Tudor or neo-Jacobean stations. Gothic was used less frequently and neo-classical rarely. Local materials were often favoured although few railway stations from this period could be mistaken for vernacular, with the hand of an engineer, if not an architect, clearly present. Some companies, notably the South Eastern Railway and the Oxford, Worcester & Wolverhampton Railway, favoured economical timber buildings from the outset and from the 1860s, greater economy was exercised more widely by the railway companies. Increasingly, country stations fell into two broad categories: those where a two-storey stationmaster's house was attached at one end of a single-storey booking office block and those where the stationmaster occupied separate accommodation nearby. At stations on main lines or where there was a passing loop for trains to cross each other requiring a second platform, there would be a shelter opposite the main building. This would sometimes match the main building in style, but more often it would be a simpler timber structure. Completing the ensemble would be a signal box, a goods shed in most cases, and, where traffic was heavy, a footbridge. Wayside stations along busy main lines tend to have fared worst, with most of those closed in the 1960s demolished soon after closure, due to their close proximity to the track and consequent difficulty in re-use for non-railway purposes. Those that have remained open, too, have in many cases had their buildings replaced by basic shelters. On lines that have been closed altogether, many more stations have been converted into houses although there has been a tendency in some areas for station sites to become rural slums with parts being used as dumps or scrap yards. Stations with two-storey houses attached have had better survival prospects due to their greater adaptability for new purposes than small single-storey structures.

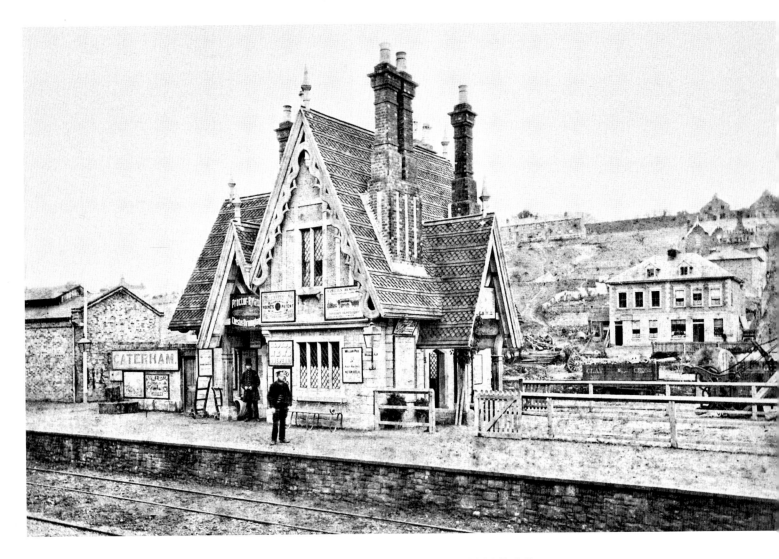

△ CATERHAM

Almost a caricature of the country railway station, Caterham was opened as the terminus of a branch from Purley in 1856 and this photograph was taken within a few years of opening. The building by Richard Whittall of Abingdon Street, Westminster, is in the picturesque landscape tradition and looks like something out of Loudon's Encyclopedia. The complex story of the line's genesis is told by Jeoffry Spence (from whose collection this print has come) in *The Caterham Railway* (Oakwood Press 1952, rev. edn 1986) but after much infighting, it ended up in the hands of the South Eastern Railway who doubled the line and rebuilt Caterham station in 1897–1900. The almost identical station at Kenley, however, survives today. *R&CHS Jeoffry Spence Collection*

▷△ OAKAMOOR

On a railway noted for its picturesque stations, Oakamoor on the North Staffordshire Railway's Churnet Valley line, was, along with Alton (still extant and owned by the Landmark Trust), perhaps the most attractive of the lot. Designed by Henry A. Hunt, it was built in 1849 in the NSR's favoured Tudor style and is seen here before it was extended in 1894, when it lost the delightful porch over the entrance. The equally charming tiled canopy (a great rarity since canopies generally had leaded or glazed covering) lasted until the station was demolished in 1970 following the line's closure to passengers in 1965. The Churnet Valley branch train, which is in the spilt milk and madder lake livery used prior to 1896, is hauled by Class C 2-4-0T of 1883. *John Alsop Collection*

▷ BRAYTON

The Maryport & Carlisle Railway was a small but lucrative provincial company and besides its imposing headquarters at Maryport, it espoused handsome neo-Tudor stations, built in the local sandstone. Brayton was opened in 1845 and closed in 1950. It was typical of many early wayside stations, its design closely related to that of an estate lodge. The hip-roofed brick signal box (closed in 1967) and diagonally boarded waiting shelter are also typical of M&CR practice. Only Aspatria survives of the M&CR's stations. *John Alsop Collection*

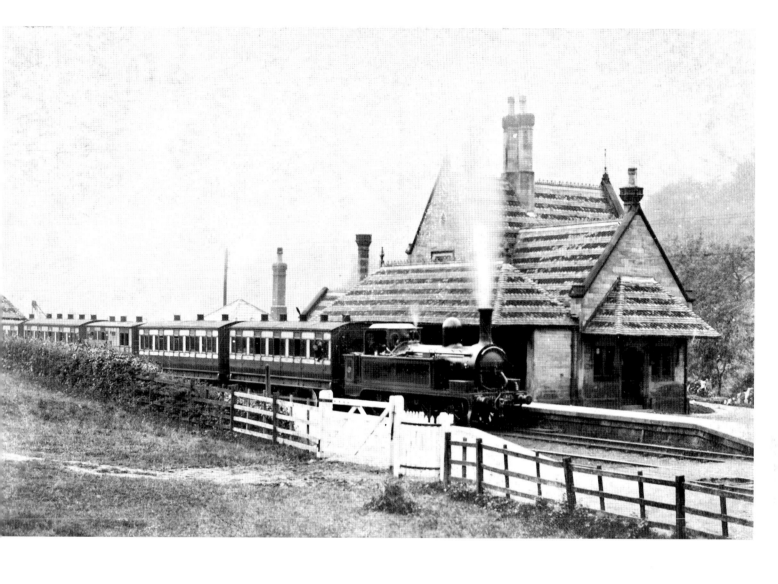

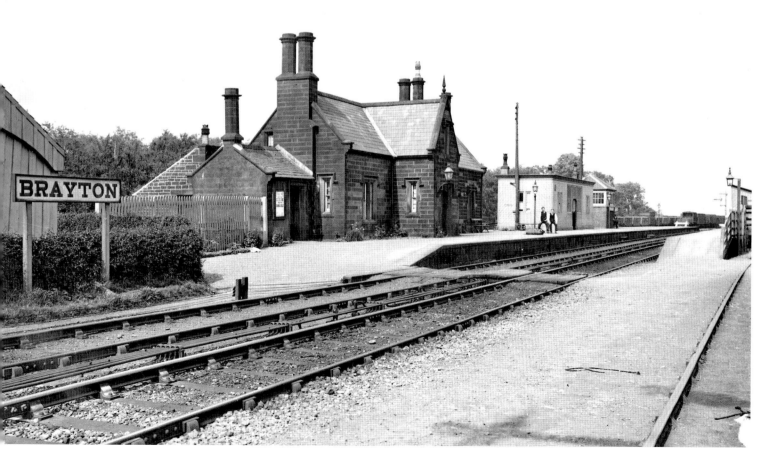

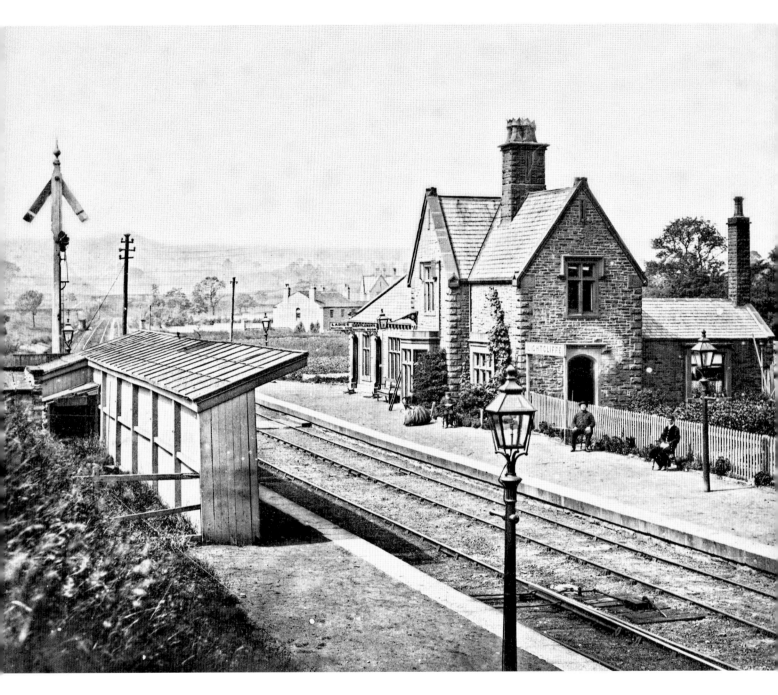

△ LIGHTCLIFFE

The earliest photograph in this book is by Samuel Smith, who became a noted photographer in his adopted town of Wisbech. He was a pioneer in the field of documentary photography. It was taken *c.* 1855 and depicts Lightcliffe station on the Lancashire & Yorkshire Railway between Halifax and Bradford, which opened in 1850. Again the simple neo-Tudor style was favoured and opposite can be seen the rudimentary timber waiting shelter. Lightcliffe was closed in 1965 and all trace of the station has vanished. *Science & Society Picture Library*

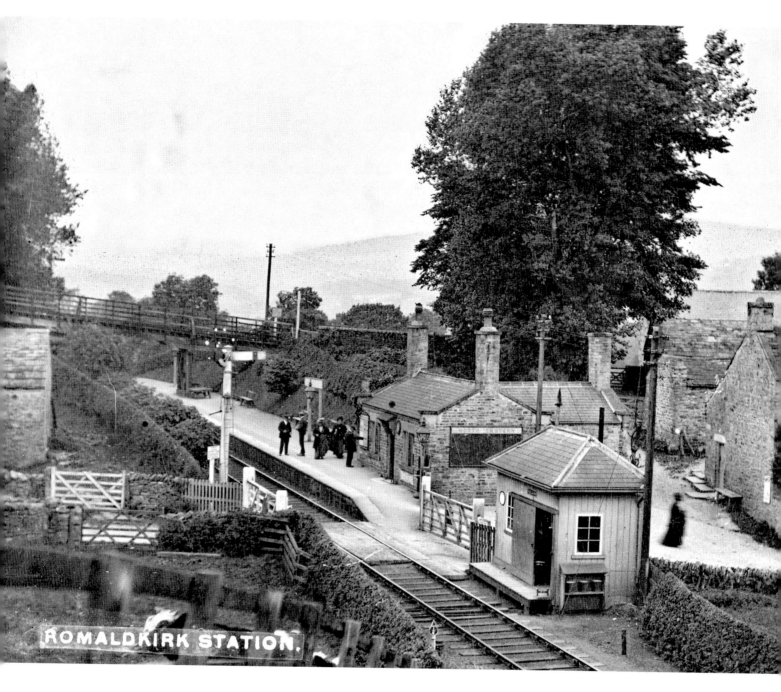

ROMALDKIRK STATION.

△ ROMALDKIRK

Romaldkirk serves to sum up all the stations serving the smallest communities. On the North Eastern Railway branch to Middleton-in-Teesdale, opened in 1868 and closed in 1964, it has no sidings and yet the building is substantially built of stone, seeming almost to be part of the outbuildings of the nearby cottages. The small shed, with its platform, served for such goods as were unloaded here.
John Alsop Collection

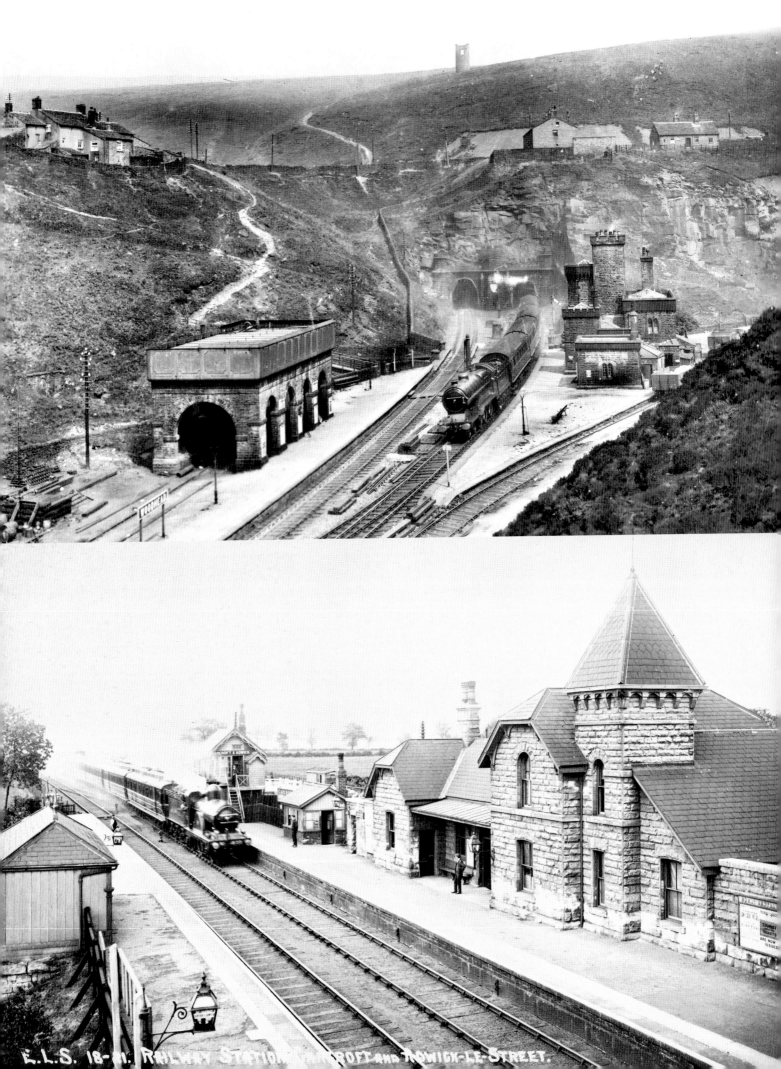

L.L.S. 18-21. RAILWAY STATION WOODCROFT AND ADWICK-LE-STREET.

◁ WOODHEAD

Situated in solitude high in the Pennines, Woodhead station stood at the western end of the then longest tunnel in England. It had been driven through the hills at the expense of twenty-six lives by the Sheffield, Ashton-under-Lyne and Manchester Railway (later the Manchester, Sheffield & Lincolnshire Railway). The station building was unique on the MS&LR, aping a small castle, its crenellations matching those on the tunnel mouth. The water tank on its massive arcaded stone base is equally unusual, as is its position directly at the rear of the Sheffield-bound platform. The locomotive hauling the Marylebone-Manchester express is a member of the 'Sir Sam Fay' class, which dates the photograph to between 1913 and 1923. The building of a second Woodhead Tunnel, as part of Britain's first post-war main line electrification scheme, necessitated the demolition of the station building in 1950 and its replacement by a new station, itself closed in 1964. Now the line itself is no more, the long strings of coal trains finally ceasing in 1981 and the Woodhead area reverting to nature.
John Minnis Collection

▽◁ CARCROFT & ADWICK

Carcroft & Adwick was one of a small number of intermediate stations on the West Riding & Grimsby Joint (Great Northern Railway and Lancashire & Yorkshire Railway) line, opened in 1866, that forms part of the main line between King's Cross and Leeds. All four of the stations were built to this distinctive design with half-hipped gables and a short tower, topped by a pyramidal roof. The coarse cut stone gives the building a robust appearance. The waiting shelter is a simple timber structure of standard GNR design while the signal box is also of GNR pattern. The express for Leeds and Bradford racing through is hauled by a Stirling 2-2-2. *John Alsop Collection*

▽ LONG MARSTON

Although many stations had pointed arches to windows and doors, relatively few had the full Gothic panoply of tracery, shafts and so forth. The best known small Gothic station was Battle, happily still extant, but Long Marston, Warwickshire, had many Gothic details set into a building which, with its ornate bargeboards, was akin to a cottage ornée. It was built in 1859 on the single track Oxford, Worcester & Wolverhampton Railway (later Great Western Railway) branch running through Stratford. The line was doubled in 1907 to form part of the new GWR route from Birmingham to Cheltenham and the photograph was taken shortly after the widening. The row of trefoils of the timber screen echoes those in the dormers, while the principal ground floor room has a large window with plate tracery. The front door to the house had shafts, capitals and a heavily moulded surround. In later years, the tracery was lost and the screen simplified. After passenger services were taken away in 1966, the line to Long Marston survived for freight traffic into the 1980s but the building was demolished. The signal box of 1892 lasted until 1981.
John Alsop Collection

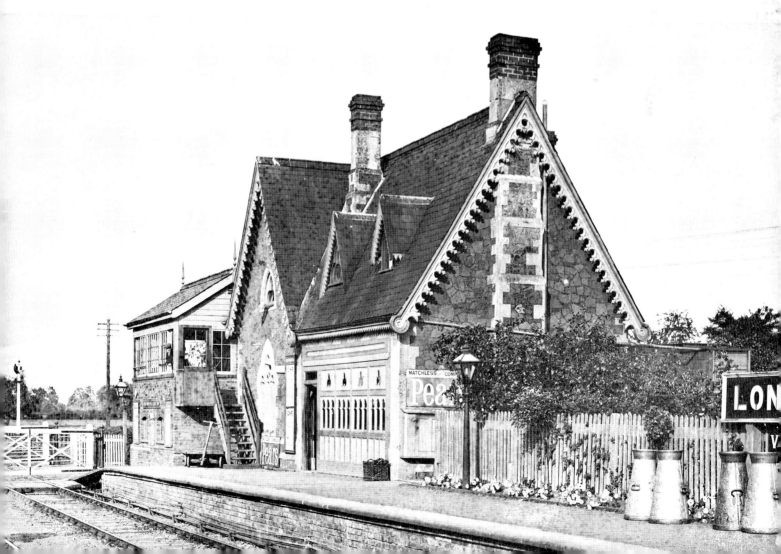

△ TRENTHAM

Some early stations had a romantic quality that enabled them to fit into a picturesque landscape. One such was Trentham, built in 1848, which served the Duke of Sutherland's estate at Trentham Hall and was possibly designed by the Duke's architect, Sir Charles Barry. Its Italianate style and massing was quite similar to the extant station at Alton, the station for Alton Towers. It closed in 1964 and was demolished soon after. *John Minnis Collection*

▷△ ARKSEY

Arksey was where the Great Northern Railway main line ended, in the words of its chairman, Edmund Denison, 'in a ploughed field four miles North of Doncaster'. From there the East Coast main line was in the hands of the North Eastern Railway. The station had timber hipped-roof buildings probably dating from the 1880s, of a type used elsewhere on the system, at Crow Park (opened in 1882) for example. Diagonal boarding was often employed by the GNR in its timber buildings, as were windows with distinctive pointed tops. But what made the station stand out was the picturesque Italianate stationmaster's house. The photograph, taken c. 1905, is looking towards Doncaster. The station was opened in 1854 and just failed to achieve its centenary, being closed in 1952. The signal box dates from 1876 and lasted until 1980. *John Alsop Collection*

▷ ADLESTROP

Adlestrop station was immortalised in Edward Thomas's poem of the same name. Seen here looking towards Moreton-in-Marsh soon after 1907, when the signal box was renewed, it was opened in 1853 as part of the Oxford, Worcester & Wolverhampton Railway's line from Oxford to Worcester. It was built to a neat gable-ended timber design seen at most stations along that line. Equally characteristic are the waiting shelter with its deep valance, which is unusually given decorative treatment at both top and bottom edges, and the timber goods shed with an opening in the end wall for carts to enter as well as an opening for railway wagons. The station house is later, dating from the 1890s, and built to a standard GWR design of the period. It alone survives, following closure of the station in 1966 and demolition the following year. *John Alsop Collection*

STATION ARKSEY

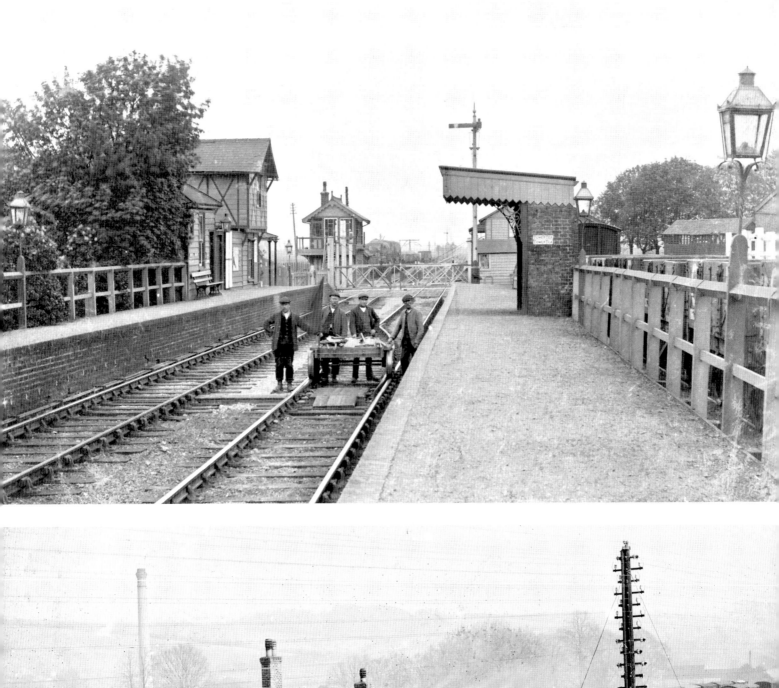

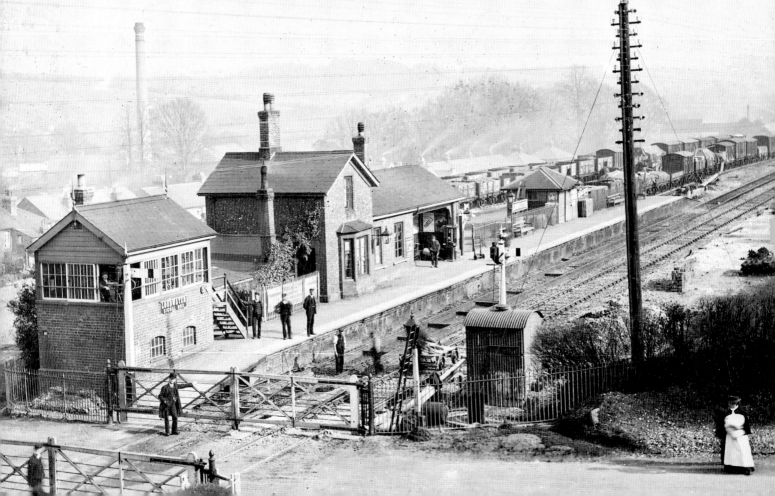

MANEA

In the fens, the Great Eastern Railway found that the nature of the soil was such that conventional buildings would simply sink into the ground. They developed a lightweight timber design, used for stations and crossing keeper's houses, with an exposed frame and much X-bracing. The upper floor was jettied out from the ground floor with beam ends exposed and the result was one of the most distinctive station designs to be built anywhere. Manea was opened in 1847 and others of the type were constructed at Black Bank, Stonea and Coldham. They eventually succumbed to subsidence and in their later years leaned at a variety of angles. None survive. The 1883 signal box is the sole surviving reminder of the station. *John Alsop Collection*

LOUDWATER

Although the Great Western Railway branch line to Marlow via Bourne End is still open, the northern section of the line to High Wycombe, opened in 1854, was closed in 1970 leading to the demolition of Loudwater station, seen here *c.* 1907. The buildings on this line, erected by the Wycombe Railway, made use of local flint and red brick and were of simple design with the stationmaster's house linked to a small booking office. At Loudwater, the latter was extended shortly after this photograph was taken. Similar buildings are still extant at Bourne End and Cookham. The signal box was added in 1892. *John Alsop Collection*

TURRIFF

One of the oddest stations to survive into the post-war period was Turriff, on the Great North of Scotland Railway Macduff branch. Opened in 1857, the station retained its low timber platforms and gabled ends to the platform canopies. The slated roof across the tracks, seen here on 22 June 1937, may be all that was left of a timber footbridge subsequently replaced by the iron structure visible in the background. The station was closed in 1951 and demolished. *L&GRP/John Minnis Collection*

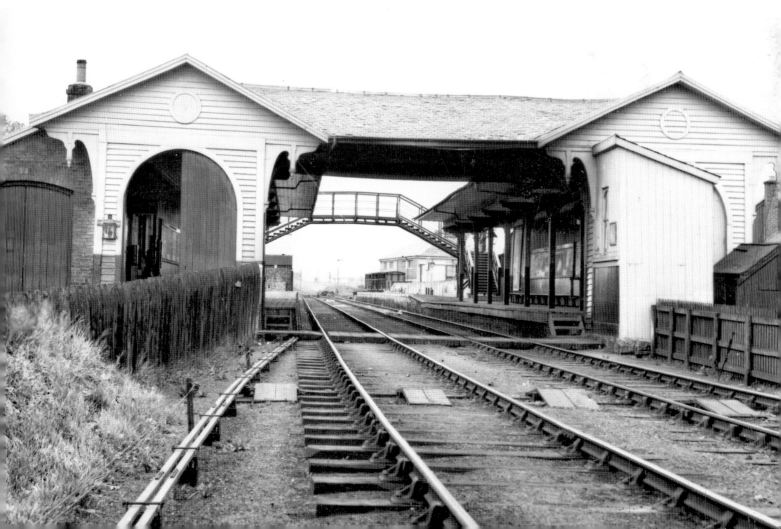

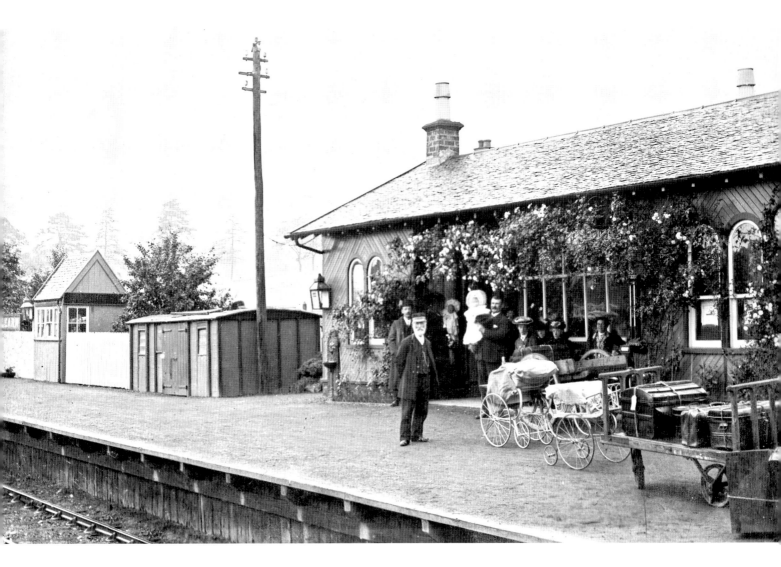

△ KILLEARN

Some Scottish wayside stations could be very picturesque, especially
in tourist areas. This is Killearn, on the Blane Valley branch of the
North British Railway, taking holidaymakers from Glasgow through
the Campsie Fells to the Trossachs at Aberfoyle. The station, opened in
1882, employed diagonal boarding for its walls, an inherently attractive
arrangement, and was of the familiar type with two end pavilions
clasping a narrower central section which in this case is largely glazed.
Climbing roses add to the effect. Drinking fountains were common
at such stations, as was the use of old goods van bodies as stores or
lamp rooms. The mounds of luggage that tourists of the day found
essential are another long absent feature. The station closed in 1951,
along with the line. *John Alsop Collection*

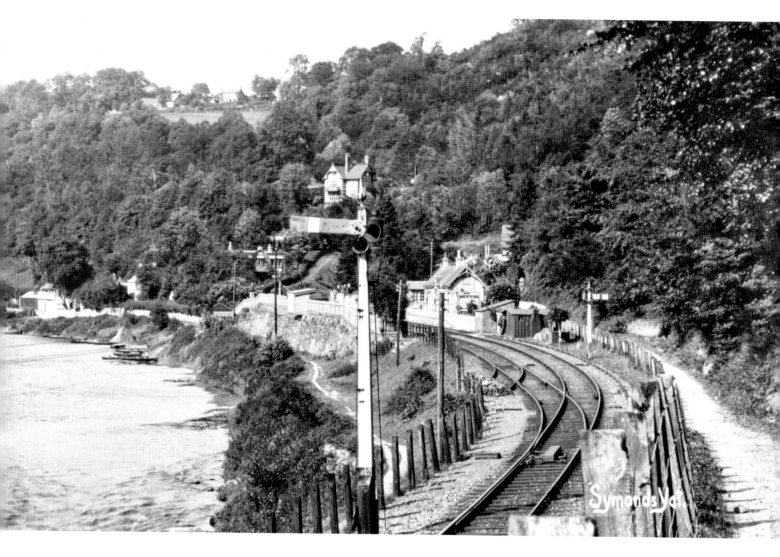

△ SYMONDS YAT

Few stations could have had a more idyllic setting than Symonds Yat, which was located on a ledge beside the river Wye. Above rose the wooded heights of the Wye gorge. Opened in 1873, it was closed with the line in 1959. Not a trace of the station is left and its site is now a car park. *Lens of Sutton Collection*

SOHAM

Soham station illustrates how designs produced by a railway engineer could be replicated in different parts of the country. The engineer of the Ely & Newmarket Railway was George Hopkins, and he produced buildings very similar in appearance to those he would later create for the Maidstone & Ashford Railway in 1884 and for the London Tilbury & Southend Railway new lines of 1885–92. The pointed windows and the unusual arrangement of stepped-out corbelling on the gable ends of the houses were almost identical. Built for the E&NR in 1879, the station building at Soham met an unusual end in that it was totally destroyed by a massive explosion to an ammunition train on 2 June 1944. The heroism of railway workers, several of whom lost their lives, prevented the destruction of the town. The station itself remained open until 1965 and the line still sees constant heavy traffic of containers to and from Felixstowe. The signal box survived the blast to be closed in 1992 and still exists, privately preserved at Prickwillow, Cambridgeshire. *John Alsop Collection*

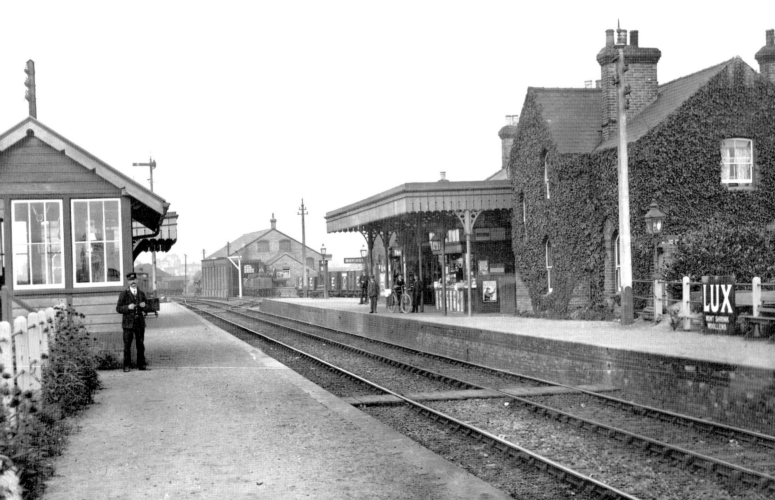

REDMILE

The Great Northern Railway was not noted for the elaboration of its stations, nor indeed was the London & North Western Railway unless there were exceptional circumstances. On the Great Northern and London & North Western Joint Railway, running through sparsely populated High Leicestershire from Bottesford to Market Harborough, was one such exception, Redmile, of 1878–9, which was opened specifically to serve the Duke of Rutland at Belvoir Castle. The station bore his coat of arms on the end gable and possessed a ducal waiting room, wood panelled throughout with a vast oak chimneypiece in sixteenth-century style, allegedly copied from one at Belvoir, with a timber centrepiece of a gamekeeper in a suitably rustic setting. This interior was severely damaged during by troops during the Second World War. The exterior of the building, designed apparently by John Fraser, the GNR engineer for the line, was equally elaborate with much use of cut-brick mouldings, extremely tall chimneys with sunflower motifs in panels and lengthy ridge and furrow awnings with intricate brackets and end screens. In its use of cut-brick and sunflower motifs, the building was an early example of Arts & Crafts style applied to railway buildings, although its execution lacked the delicacy seen in later work on the London, Brighton & South Coast Railway and Great Eastern Railway. The line was never successful financially and Redmile closed in 1953, its awnings long cut back and unglazed. Demolition followed in the 1960s but the chimneypiece is believed to have been removed to Belvoir. *National Railway Museum/Science & Society Picture Library*

SAUGHALL

The Manchester, Sheffield & Lincolnshire Railway and its successor, the Great Central Railway, rarely went in for flights of fancy in their later buildings which makes this Domestic Revival building at Saughall, built in 1890, and its neighbouring station of Blacon, unusual. It was very much on the fringes of the company's system in Cheshire and hence a black and white style may have been thought appropriate. The building has much in common with T.H. Myres' stations for the London, Brighton & South Coast Railway and the treatment, including a jettied first floor on the house portion, shaped brackets and a ventilator disguised as an elaborate flêche, was well-handled. It was closed in 1954 and later demolished. *John Alsop Collection*

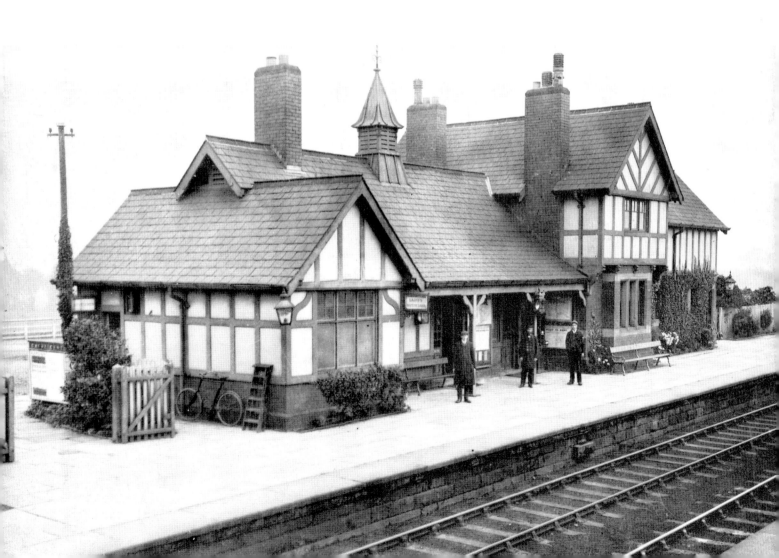

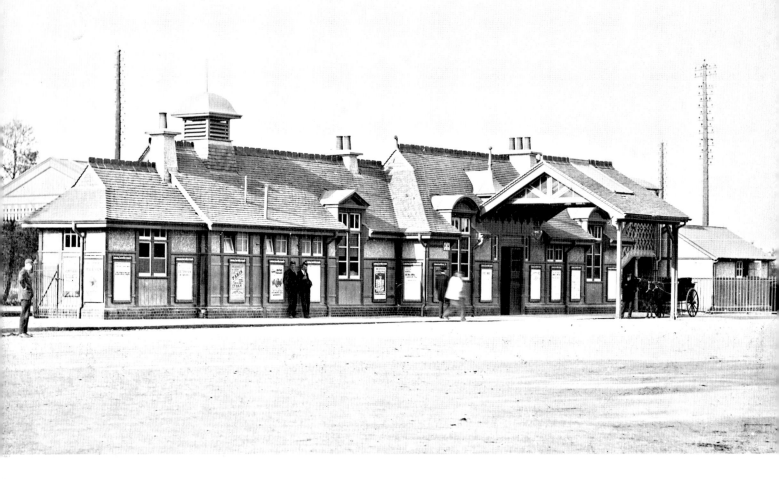

FLEET

Along with several other companies, notably the London, Brighton & South Coast Railway and the Great Eastern Railway, the London & South Western Railway employed a broadly Arts & Crafts style on its new stations from the 1880s to the early twentieth century. Fleet on the main line to Southampton was rebuilt in 1904 following quadrupling of the line. The new building, seen *c.* 1908, had all the hallmarks of the style: steeply pitched tiled roofs, half-hipped gables, asymmetrical elevations with windows cutting through the eaves, battered chimneys and the most dominant architectural motif, the cupola over the louvred ventilator for the gents' lavatories. Wall surfaces were a combination of timber framing, boarding and pebble dash, and the rather busy appearance of the building was heightened by the porte-cochère. The building was the first to be replaced by the Southern Region's drab version of the CLASP system in 1966. *John Alsop Collection*

HIGH WESTWOOD

In the early twentieth century, the North Eastern Railway made much use of timber construction for its new stations. This is High Westwood in Co. Durham under construction in 1909, giving a rare view of how these buildings were put together. High Westwood was an early closure in 1942 and few of the NER's timber buildings are left. *John Alsop Collection*

RYLSTONE

The major railway companies seldom bought buildings off the peg but exceptions were made if a line had been promoted by a local company. One such was the Midland Railway's Grassington branch, promoted by the Yorkshire Dales Railway and opened in 1902, where the prefabricated buildings came from the Portable Buildings Co. and were identical to those purchased by the independent Derwent Valley Light Railway near York. Rylstone was the sole intermediate station on the branch, which although closed as early as 1930 to passengers, remains in use for stone traffic today. *John Alsop Collection*

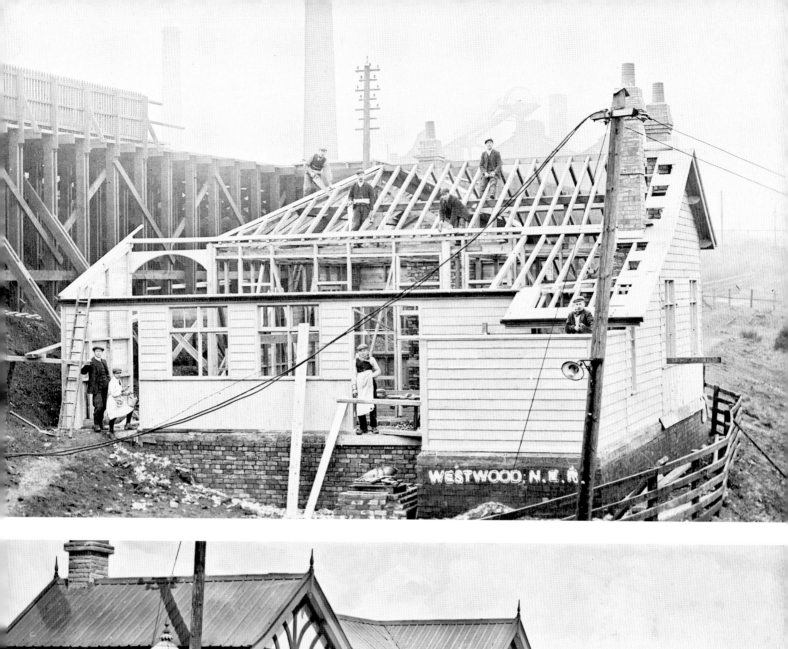

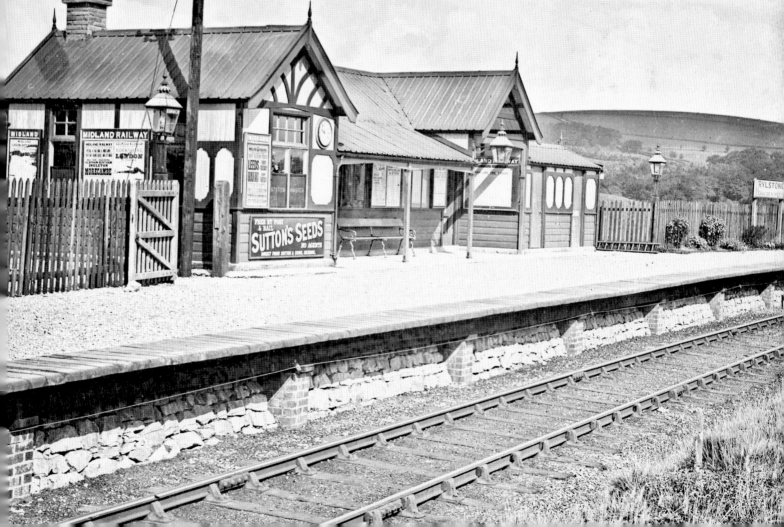

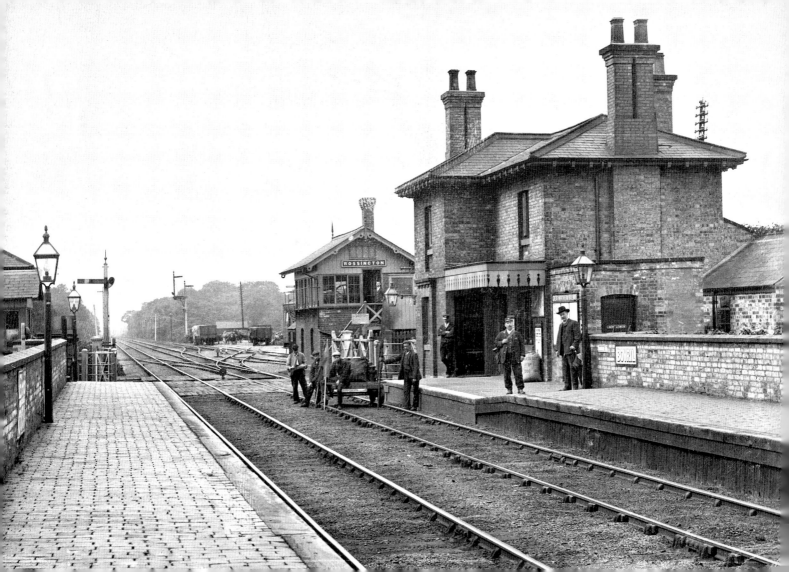

STANDARD DESIGNS

While the buildings of many railway companies bore a resemblance to one another from the start, some companies, such as the South Eastern Railway, quickly developed their own standard designs. 'Line styles' where all the stations on a new line were built to a similar style soon became commonplace. From the 1860s, the railway companies extended the practice to develop styles that were used throughout the system. Standard designs were particularly identified with timber structures, and were extensively used for goods sheds, stables, signal boxes, waiting shelters and a whole array of small huts. But they were also widely developed for station buildings with some companies producing prefabricated timber components, the London & North Western Railway being the best-known exponent. Such buildings were a major contributor to the 'look' of a particular company, to the extent that it was possible to identify the ownership of a stretch of railway even when no train was visible. The imposition of a corporate identity through the use of standard designs, often in 'railway vernacular', was something quite new in the nineteenth century. The practice was not confined to railways: multiple shops, too, began to develop house styles at the same time. The railway buildings, being so widespread in their distribution, provided the most striking instance of this standardisation.

◁ ROSSINGTON

The Great Northern Railway used a very plain Italianate style in gault brick for many of the stations on its main line. Rossington, the first station south of Doncaster, opened in 1849 and seen here *c.* 1910, is typical: two storeys, incorporating the stationmaster's accommodation, a small canopy and positioned next to the level crossing. That part of the platform in front of the station building, which has not been raised, shows the low height prevalent in the mid nineteenth century.
The signal box of 1876 was one of the early GNR standard designs. Closed in 1958, the station was demolished soon afterwards.

◇ CHILHAM

The South Eastern Railway was well-known for its use of simple hip-roofed single-storey buildings for its minor stations from its earliest days until virtually the end of its independent existence. The company was condemned for this practice by a shareholder who argued that 'as foreigners were likely to use the South Eastern line, they ought to honour their country and have becoming stations, not miserable paltry erections ...' Chilham on the line from Ashford to Ramsgate was typical of the earliest design, with casement windows with six large panes per window, and was demolished c. 1970. This view is of c. 1905, looking towards Canterbury. The plain goods shed beyond is another standard SER design, as is the small hut with a gabled roof facing the track; this is the company's earliest form of signal box, used in the 1860s. When replaced, as this one was in 1893 by the box opposite, these were often used as station offices. *John Alsop Collection*

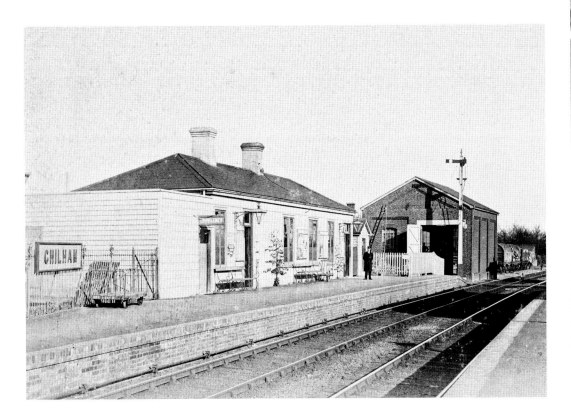

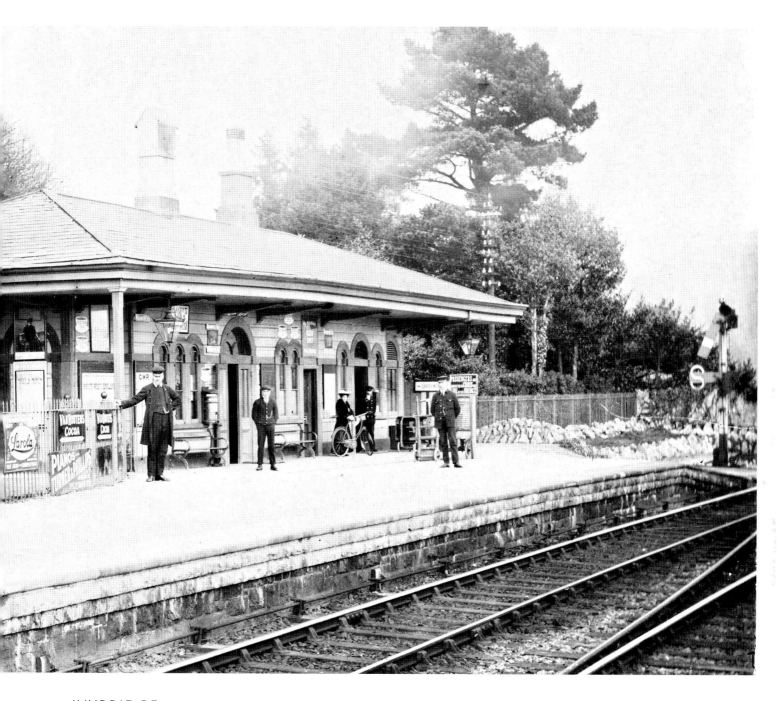

△ IVYBRIDGE

As an alternative to neo-Tudor, Brunel favoured a distinctive hip-roofed design with a very low roof pitch, built in brick or timber having round-headed windows, often grouped in twos or threes. Like the neo-Tudor buildings, great care was taken to protect passengers from the weather and the roof extended on tapering brackets across very broad eaves to form a canopy. One of the larger examples, that at Ivybridge, on the South Devon Railway (later GWR) main line to the east of Plymouth, is seen *c.* 1905 when it was evidently in need of some support. The station was opened in 1848, closed in 1959, but reopened in 1994, although the original buildings had long since gone.
John Alsop Collection

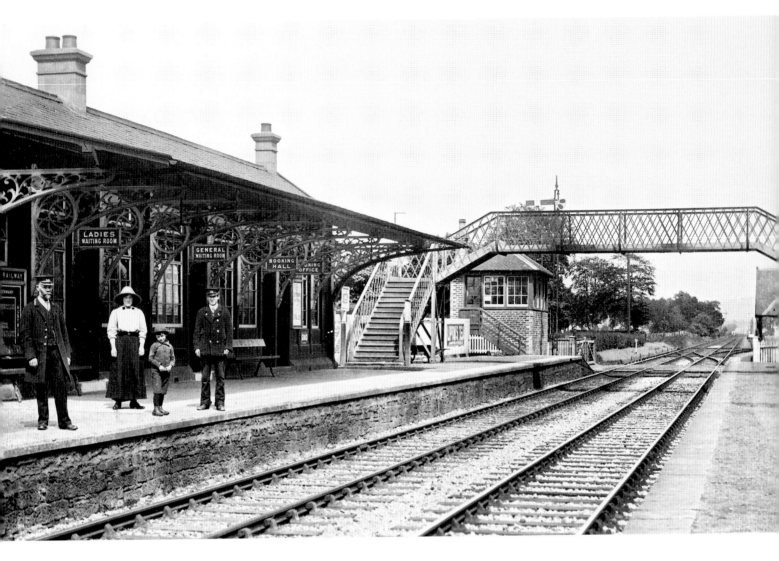

△ ARDLER

The Caledonian Railway favoured particularly elaborate ironwork on many of its stations, even some of the smallest such as Ardler, a wayside station on the now closed CR main line across Angus from Perth to Aberdeen. The Northern and Southern Divisions of the CR had different standard signal box designs, Ardler being of the Northern Division type, notably plainer than that used by the Southern and dating from the 1870s. Ardler was closed in 1956, along with a number of other stations on the CR main line, and the box followed in 1967. *John Alsop Collection*

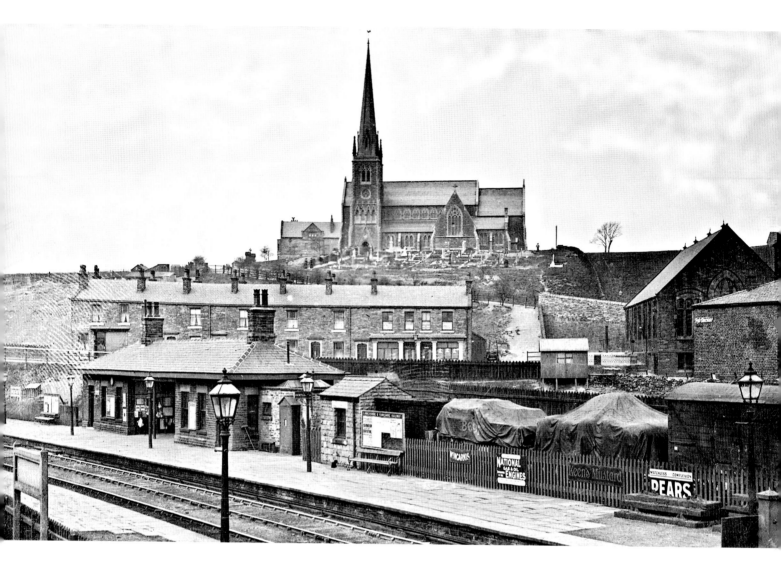

△ NEW HEY

The Lancashire & Yorkshire Railway had a simple twin pavilion design in stone that was widely used in the 1860s. Opened in 1863, New Hey on the Oldham loop line of the L&YR remained in use until recent closure for the extension of the Manchester Metrolink. St Thomas's church (1876–7, H. Lloyd), an imposing structure of local sandstone, and the earlier school below it still survive but the workmanlike buildings which fitted well into their surroundings had gone years earlier. *John Alsop Collection*

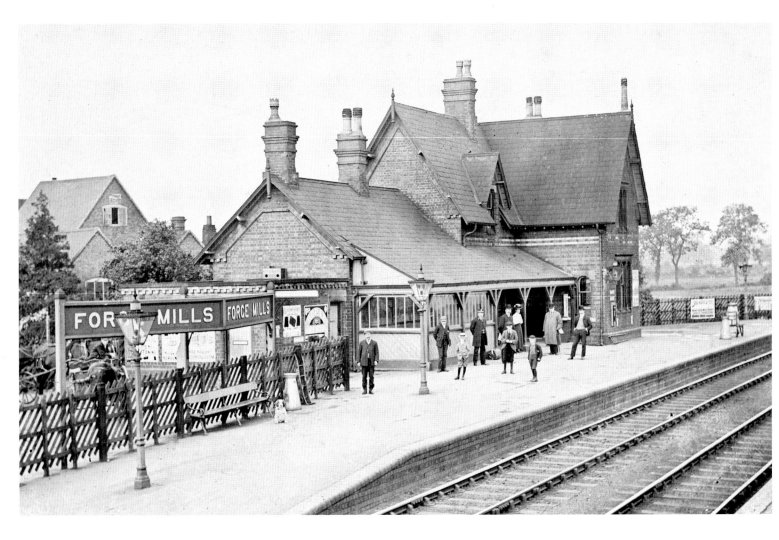

△ FORGE MILLS

An example of a two-storey stationmaster's house combined with single-storey booking hall and offices, Forge Mills was one of a number of stations built to the same design on the Midland Railway's line from Water Orton to Nuneaton in 1864. The canopy is not very sophisticated by comparison with many other MR stations but part has been screened in favoured MR fashion and all the details are typical of that company: the fencing with its angled boards, the station nameboards, canted so they can be clearly seen from either direction, and the proprietary rustic seats. The station was renamed Coleshill in 1923 and closed in 1968. Subsequently, a new Coleshill Parkway station has been opened and its utilitarian vandal-proof buildings could not be a greater contrast to its homely predecessor. *John Alsop Collection*

▷△ PLAWSWORTH

The North Eastern Railway developed a standard style of station in the 1860s with a two-storey station house flanked by single-storey pavilions at each end with a canopy linking them. It was widely used, and this view of Plawsworth (opened in 1868) on the main line to Newcastle *c.* 1910 shows a typical example. It was demolished following closure in 1952. *Lens of Sutton Collection*

▷ HENDON

The Midland Railway's London extension was built on a scale worthy of a company that could commission St Pancras. Hendon, opened in 1868, displays the light ridge and furrow canopies that were so characteristic of the MR, as indeed were the timber platform buildings under them. The station is still open, but the large station house and booking office and all the other buildings went in the late 1960s when the M1 motorway extension ran hard up against the railway at this point. No. 1383 is an 0-4-4T built to the design of S. W. Johnson in 1895 and its train is made up of a four coach London-Bedford suburban set of a type introduced in 1909, enabling us to date the photograph to soon after that date. *John Alsop Collection*

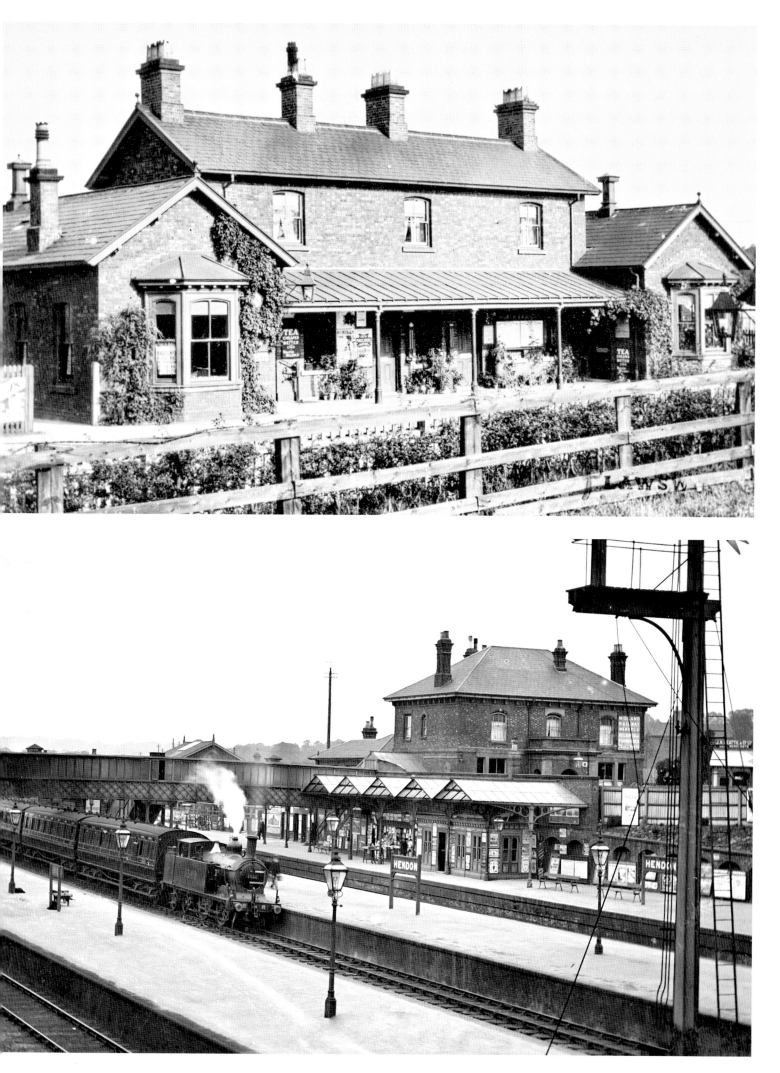

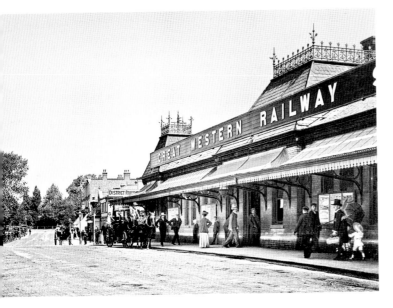

⟨ EALING BROADWAY

In the 1870s, the Great Western Railway favoured steep pitched mansard roofs, topped with ornamental ironwork, very much in the fashionable French Second Empire style, for its larger stations. These mansards were often grouped in threes, like this example at Ealing Broadway, rebuilt following quadrupling of the line in 1877. The style was widely used, e.g. at Ross on Wye, Neath and Wrexham. Ealing was replaced by a large office block in the 1960s, while the District Railway station just visible beyond was rebuilt in 1911 (architect: Harry Ford) and this later station survives. *John Alsop Collection*

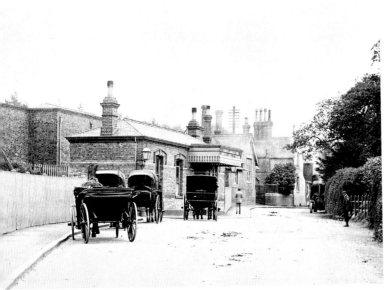

⟨ KING'S LANGLEY

King's Langley, on the London & North Western Railway main line, was rebuilt in the form seen here in the 1870s. The nearer building is in a style used extensively by the LNWR at that time, with segmental arches with hood mouldings above, and decorative brick cogging below the eaves. It is an example of a common arrangement where the platforms were elevated, due to the line being embanked, and the main building located at a slightly lower level. The buildings beyond are much earlier, cottagey in appearance, and may date back to the early days of the London & Birmingham Railway. The photograph is of *c.* 1910. *John Alsop Collection*

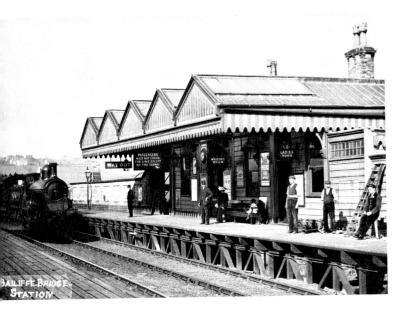

⟨ BAILIFF BRIDGE

Bailiff Bridge is one of many stations that closed during the First World War as part of economy measures. Most reopened but several did not, Bailiff Bridge, which closed in 1917, among them. It had opened only in 1881 on the Lancashire & Yorkshire Railway's line between Wyke & Norwood Green and Cooper Bridge in the West Riding. Located on an embankment, both platform and buildings were of timber. The style employed had the distinctive ridge and furrow awnings with glazing to the gable ends favoured by the company during this period. The L&YR practice, also used by the London & South Western Railway, of painting boards in alternate colours (shades of buff, in this case) is evident. *John Alsop Collection*

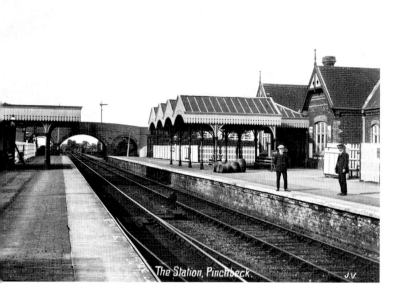

◁ PINCHBECK

The Great Northern and Great Eastern Joint line provided an alternative route from London to the north. Promoted as the Cathedrals Route, because it went through Ely, Lincoln and York, it was primarily a useful alternative to the East Coast main line for goods traffic but intermediate stations were provided. They were built to a standardised design in 1882 with the station buildings set back to allow for any future widening of the line to four tracks – a degree of foresight rare in railway construction. Consequently the canopies at Pinchbeck have a linking section between them and the station building, which is of the twin pavilion type seen in so many locations. Pinchbeck closed in 1961 but others of similar design are still extant. *John Alsop Collection*

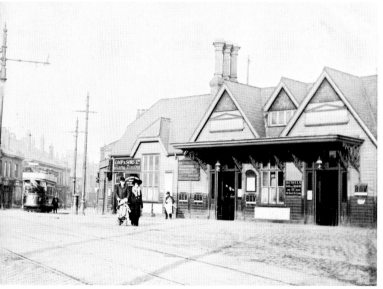

◁ ECCLES

The London & North Western Railway, beyond its liking for prefabricated timber buildings, did not really have a style of its own for stations in the way that some other companies did. It did however go through a stage of putting up buildings with half-hipped roofs and dormers, with tall, picturesquely grouped chimneys. In this example at Eccles, which had been rebuilt in 1881 with the quadrupling of the line, photographed *c.* 1903, the gables are tiled at their apex and bear curious pedimented panels. Although the canopy itself is simple with no bargeboarding, the ornate iron brackets more than make up for it. Similar buildings were put up at Pleck, Loudon Road and Wolverton, all now demolished. The Eccles building was destroyed by fire on 11 January 1971. *John Alsop Collection*

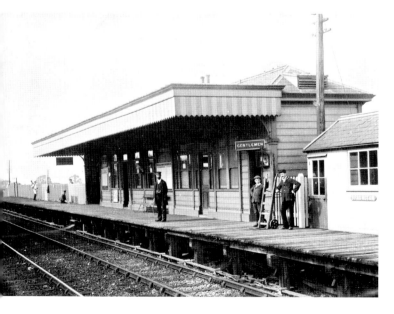

◁ BRAUNSTONE

The London & North Western Railway provided a lead in the use of prefabricated timber buildings. The process started in the 1860s and by the 1880s a highly standard modular system had been devised, found throughout the LNWR. An example is the station at Braunstone on the line between Weedon and Leamington Spa, opened in 1895. It was photographed while undergoing repainting *c.* 1910. The hut next to it is also an example of LNWR standardisation. Always with vertical boarding, built to a standard width but varying in length as required, the huts were used for a variety of purposes – in this case, housing a lever frame. Lamp huts were another use and they could be employed for small stations: Napton and Southam stations on the same line were so equipped and an example at Pentreath is illustrated. Braunstone closed in 1958 and the buildings were subsequently demolished. *John Alsop Collection*

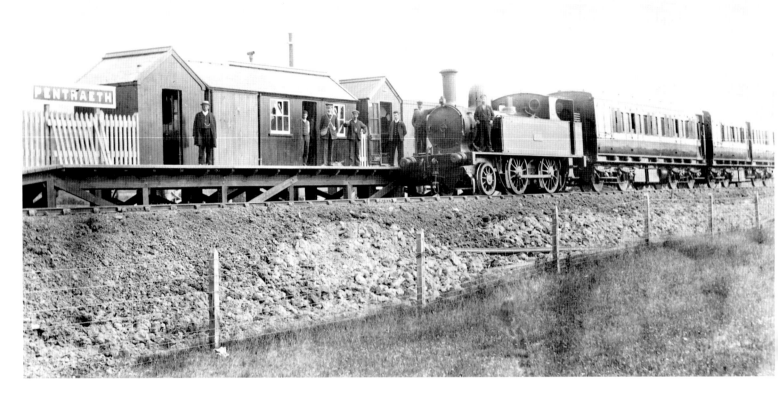

PENTRAETH

Pentraeth was one of the intermediate stations on the London & North Western Railway's Red Wharf Bay branch in Anglesey and was opened in 1908. This view, probably taken on the opening day, shows how the LNWR could be quite parsimonious with its lesser stations in later years, choosing to erect a cluster of the prefabricated 'Webb huts', named after the LNWR's locomotive engineer, to accommodate passengers, a cost-effective solution to a line that was never likely to bring great receipts and indeed closed to passengers in 1930. The locomotive is Webb No. 1000, built in 1884 as a 2-4-2T and cut down to a 2-4-0T in 1908, and the train comprises the pioneer LNWR motor set, consisting of coaches nos 78 and 79, converted from two 42ft restaurant cars in 1908, to enable the train to be worked without the engine running round at each end. *John Minnis Collection*

MERTHYR VALE

Merthyr Vale, opened in 1883, on the Taff Vale Railway line to Merthyr Tydfil is another example of a company's standard design for its later station buildings. The TVR favoured compact single-storey buildings whose plainness was relieved by exuberant polychromy, in this case with brick quoins and edging as a relief to the dark stone, but similar designs could also be found in brick (e.g. Cowbridge of 1892). Platform awnings were frequently omitted, perhaps surprising in view of the dampness of the upper reaches of the valleys. The signal box, with its particularly elaborate bargeboards and ornamental ridge tiles, is also a standard TVR design, built by the McKenzie & Holland company. The station remains open but the buildings were demolished, along with others on the line, in 1972. The 1885 signal box went much earlier, in 1925. *Lens of Sutton Collection*

PONTLOTTYN

Waiting for the train at Pontlottyn on the Rhymney Railway. The Rhymney used a utilitarian but well-proportioned design of stone building at many of its stations. Pontlottyn was opened in 1860 and is still in use today although, like almost all the valleys' stations, it has the most minimal accommodation. The signal box of 1891 was closed in 1970. There are several attractions competing for the children's attention in this photograph! The little girl is fascinated by the chicken on the line, one boy is watching the train coming in while others are looking at the photographer. *Lens of Sutton Collection*

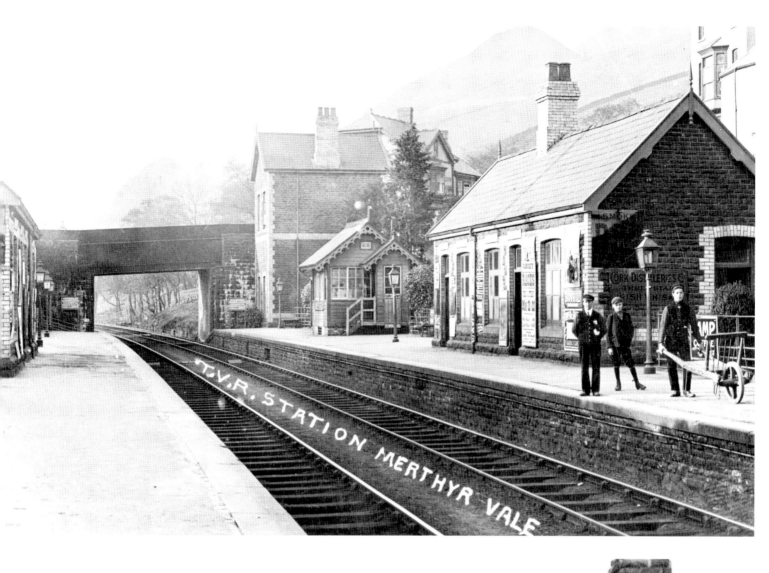

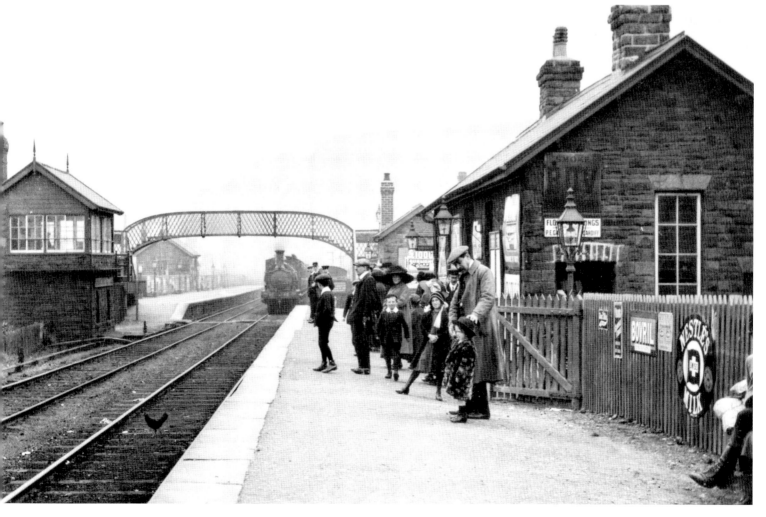

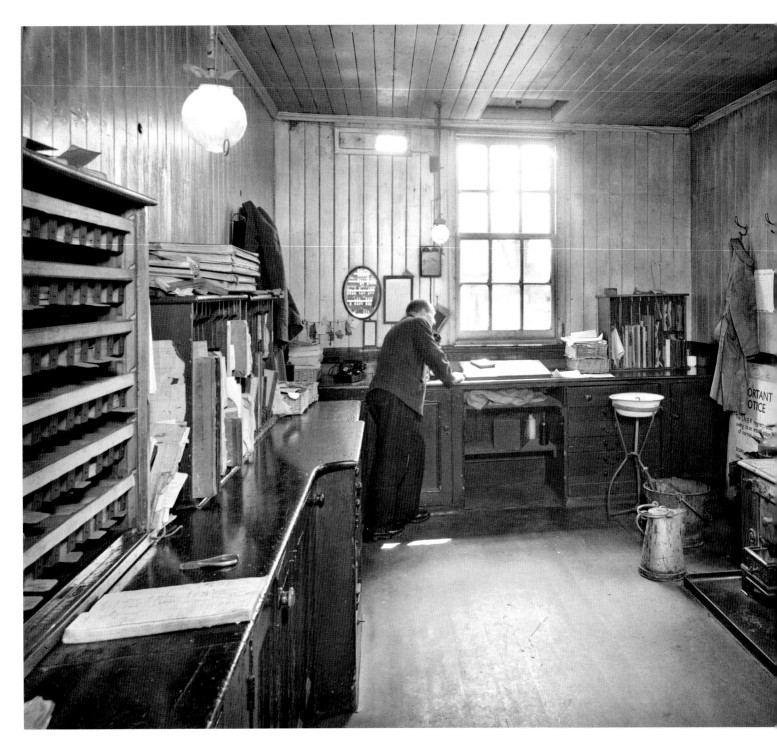

△ BOWES PARK

Bowes Park on the Hertford Loop of the Great Northern Railway
was opened in 1880. Although the photograph was taken in the
early 1950s, the matchboarded walls, the gas lighting, the ticket racks
and the built-in cupboards and drawers are all typical of what one
might find in any small booking office well into the 1960s. Many had
barely changed since the nineteenth century. Bowes Park is still open
today although the booking office, which straddled the tracks, was
demolished in advance of electrification of the line in 1976.

John Minnis Collection

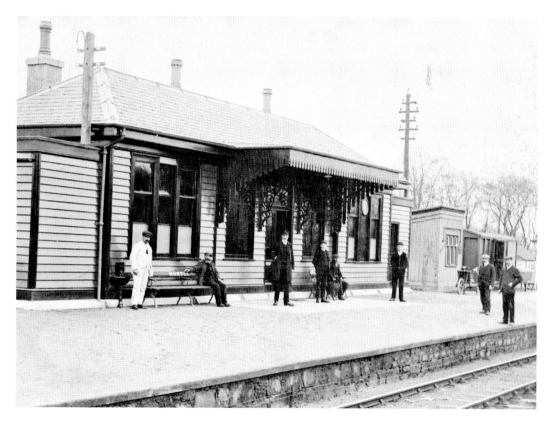

△ MURTLE

The Great North of Scotland Railway's earlier stations were predominantly of stone but, later, neat timber hipped-roof buildings were favoured for wayside stations. Murtle was opened in 1853 but was rebuilt in the form seen here, probably in the 1880s. It was on the company's Deeside branch and formed part of Aberdeen's suburban railway network, which enjoyed a frequent service of trains until it was defeated by competition from municipal trams. Murtle closed in 1937 and was subsequently demolished. *John Alsop Collection*

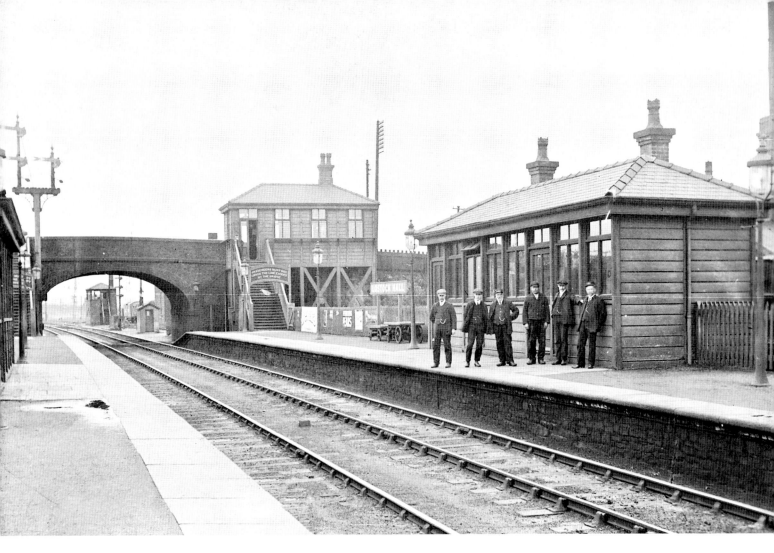

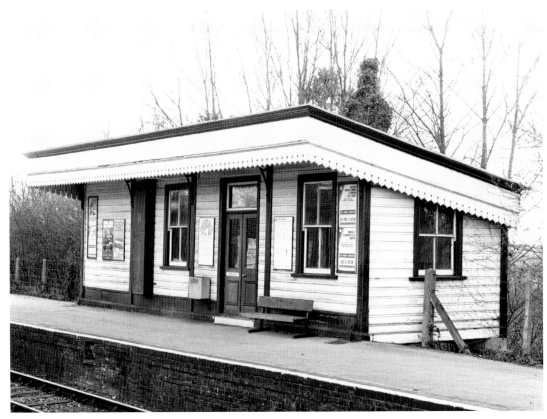

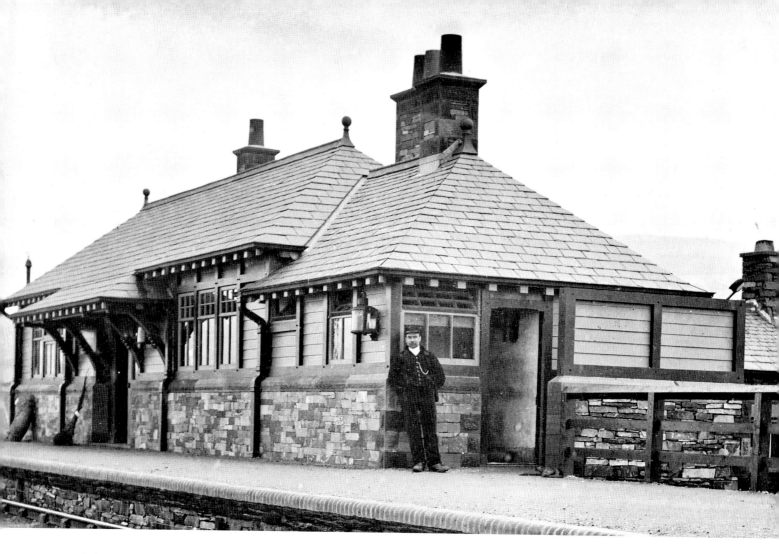

LOSTOCK HALL

Lostock Hall, rebuilt in 1881, is an example of the Lancashire & Yorkshire Railway's modular timber design, used extensively throughout the system for small stations and waiting shelters. It replaced a station opened in 1846 on the other side of the road bridge. Closure came in 1969 and, although reopened in 1984, it suffered the fate of almost all timber stations in the north. The signal box just visible beyond the bridge is an early L&YR designed box of 1873 and just failed to achieve its centenary, being closed in 1972.
Lens of Sutton Collection

BUXTED

The style of architecture that I have termed 'railway vernacular', employing iron and timber, is distinct to the railways, having little obvious connection with period styles and precedents, and, while utilitarian, is not afraid of the odd decorative flourish. Waiting shelters are particularly good instances and this London, Brighton & South Coast Railway waiting shelter at Buxted, built in 1894 and photographed in 1985, is just such a building. Singling of the line in 1990 led to its redundancy and demolition. This was an LB&SCR standard design; other examples include Emsworth and Wivelsfield (extant). *John Minnis*

KIRKBY

An example of the highly distinctive Arts & Crafts Furness Railway designs that owed their inspiration, if not their actual design, to the work of Austin & Paley, one of the few significant architectural practices to have carried out extensive railway work. Kirkby, seen in 1905, is typical of later FR construction with stone base and timber uppers, exposed rafter ends, and a hipped roof of Westmorland slate carried down to form a small canopy supported on elaborate moulded brackets. The company's designs were consistently good, partly due to the aforementioned Austin & Paley influence and partly to the fact it operated in a tourist area and hence went to great pains to ensure its stations fitted harmoniously into the landscape.
John Alsop Collection

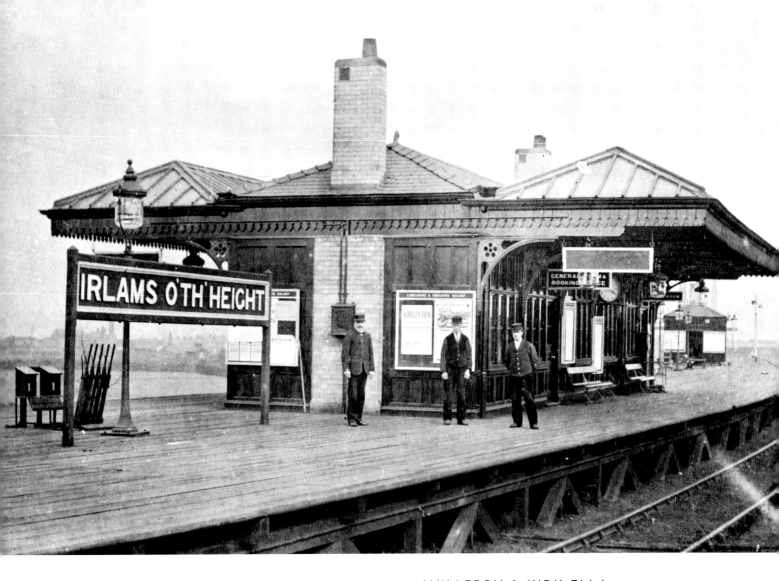

△ IRLAMS O' TH' HEIGHT

At the turn of the twentieth century, the Lancashire & Yorkshire Railway had developed a complex design of timber building with inset panels. It was used at Irlams o' Th' Height, opened in 1901 as an additional station to the west of Pendleton on the L&YR Manchester–Liverpool main line. Irlams o' Th' Height station was closed in 1956 and subsequently demolished. The L&YR colours were often applied in a two colour arrangement, picking out the panelling, but here a monotone application was used. *Lens of Sutton Collection*

▷ WILLERBY & KIRK ELLA

The Hull & Barnsley was a late addition to the railways of Yorkshire, having its origins in the dissatisfaction of Hull's citizens with the monopoly enjoyed by the North Eastern Railway in the city. Its stations were substantial and well-detailed affairs with a definite Domestic Revival feel to them, seen in the tall chimneys, tile-hung gables and windows akin to those of a Board school with the upper sash divided into small panes and the lower sash filled by a single sheet of glass. The buildings appear to be the work of the company's engineer, William Shelford. Willerby & Kirk Ella, opened with the railway in 1885, was located on an embankment with the platforms accessed by a staircase from the booking office. Passenger services on the line ceased in 1955 and Willerby was demolished in 1968, although the generally similar station at North Cave survives. *John Alsop Collection*

⊳ MIDHURST

Thomas Harrison Myres (1859–1910) carried out nineteen stations for the London, Brighton & South Coast Railway. He was born in Preston, was articled to E.M. Barry 1864–6 and remained as his assistant until 1867, before setting up in independent practice in 1869. It is likely he had met the LB&SCR's chief engineer, F.D. Banister, who had been educated and trained in Preston, while based there. He cemented the relationship by marrying Banister's eldest daughter. His designs for the LB&SCR were perhaps the finest stations to be built in the Domestic Revival style. The half timbering, with plaster panels bearing incised sunflower motifs, was found to let in the rain and within a few years, the upper parts of the stations were tile-hung, completely in some places and in others, including Midhurst (built 1881), partially, on those walls most exposed to the weather. Five have been demolished, among them Midhurst, closed to passengers in 1955 and seen here in derelict state in 1969. *John Minnis*

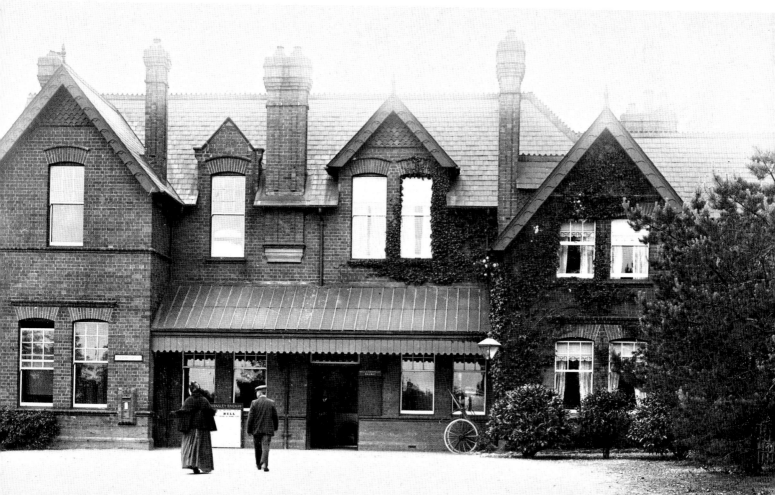

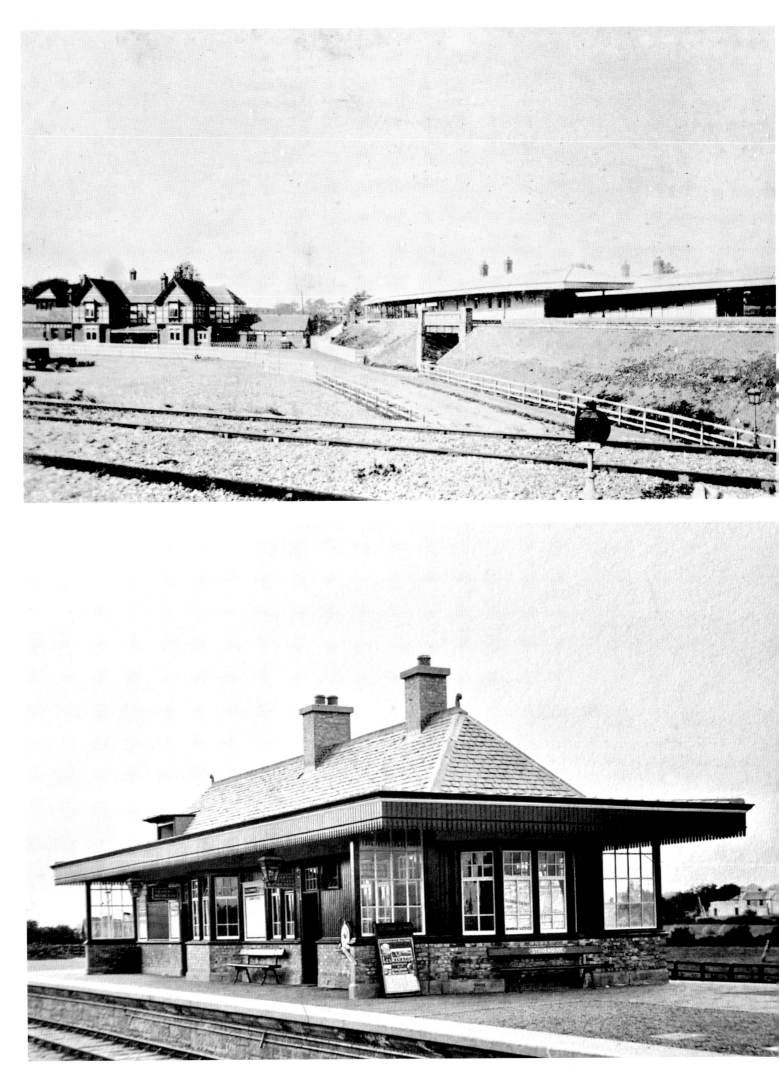

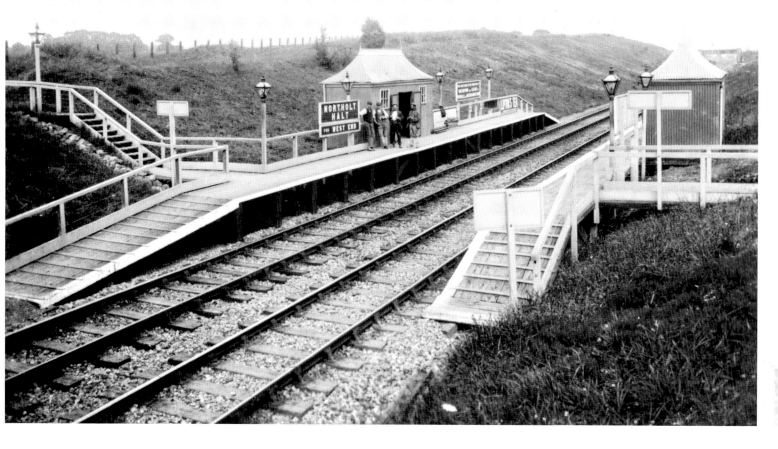

◁ EAST GRINSTEAD

The largest of the Myres stations was the extensive station at East Grinstead, where there were both high level and low level portions. The station was completely rebuilt in 1882 when a new through route from Hurst Green to Lewes via Horsted Keynes was opened, carried under the existing Three Bridges–Tunbridge Wells line. It is seen here looking west in a photograph taken, at about the time of opening, from a spur line that connected the two routes. The accommodation included a refreshment room, lit by a lantern roof, to the left of the twin-gabled main building which here is in its original half-timbered state – it, like most of the other Myres stations, was later tile-hung. The high level platforms, which had extensive awnings and timber station buildings, were closed along with the line to Three Bridges in 1967; the low level buildings were demolished in 1971 and replaced by one of the somewhat mean CLASP structures. *East Grinstead Museum*

◁ STONEHOUSE

At the turn of the twentieth century, the Caledonian Railway adopted a particularly spacious design for some of its smaller stations. Its architecture was derived from the stations designed by James Miller and was distinguished by broad awnings extending around the ends of the building as well as the sides, glazed end screens to give additional protection to the waiting passengers and broad bay windows. These stations were some of the most agreeable ever offered to the travelling public but this opulence was often the cause of their downfall as, with their very extensive use of timber, they proved costly to maintain. The station at Stonehouse was rebuilt in 1905 in connection with the opening of a new line from Larkhall, as part of the CR's expansion in Mid-Lanark. The secondary island platform building is seen here soon after construction. Stonehouse was closed in 1965 and its site now lies under the town's bypass. *John Paton Collection*

△ NORTHOLT HALT

In the first decade of the twentieth century, the Great Western Railway, in common with numerous other companies, opened many halts, most of which were unstaffed with passengers buying their tickets on the train. Northolt Halt, seen here soon after opening in 1907 to serve what was then a largely rural part of Middlesex, was typical with its simple timber platforms, post and rail fencing and highly distinctive corrugated iron shelters with their 'pagoda' roofs, capped by metal ridge decoration. These buildings were to be seen throughout the company's territory, serving a variety of purposes. Very few are left today, Appleford Halt, south of Oxford, one of the last survivors, being replaced in the last few years. An example is preserved at the Great Western Society's museum at Didcot. *Lens of Sutton Collection*

△ HASTINGS

The Southern Railway was the grouped company most willing to
undertake full scale station rebuilds, predominantly at major suburban
stations or at seaside resorts. In the 1920s and early '30s, the
company's architect, J.R. Scott, favoured a heavy neo-classical style
which drew some of its inspiration from the American stations of the
period, with the booking offices given much natural daylight through
the use of large lunettes. Red brick and Portland stone combined to
give them an appropriate civic dignity. The 1851 terminus at Hastings
was replaced in 1931 with a building that was moving towards
moderne. The building retained its original Southern Railway lettering
when photographed in 1970. While the two best examples of Scott's
early stations, Ramsgate (in fact, probably the work of Maxwell Fry)
and Margate, both of 1926, were listed, the booking office at Hastings
was demolished and replaced with a new station in 2004. *John Minnis*

MODERN STATIONS

Taking a definition of modernity to include those stations constructed since 1918, there have been relatively few losses. Most were soundly built and the emphasis during the 1960s and '70s was in dealing with the enormous legacy of nineteenth-century buildings bequeathed to British Railways. However, some of the relatively small number of branch and wayside stations that were built in this period have gone, due to redundancy, such as those at Beningbrough and Bourton on the Water. Larger stations, too, have been replaced, sometimes due to their being too large for present-day requirements, such as Lytham's station of 1925, but more often due to opportunities for town centre redevelopment such as Welwyn Garden City. Another factor now in evidence is the rebuilding of stations as part of a town's overall regeneration scheme, such as at Hastings, where an imposing station building of 1931 was demolished to be replaced by an equally impressive new one in 2004. A phenomenon becoming increasingly noticeable is that stations built in the 1960s and '70s, as opposed to inter-war ones, are being replaced. Many, such as the CLASP stations on the former Southern Region, are now showing their age and do not provide the facilities that customers expect today – Ashtead, last rebuilt in 1969, is currently being rebuilt for a second time. In urban areas, the extensively glazed buildings put up as part of the 1960s London Midland electrification programme are not faring well in an era of reduced staffing and increasing vandalism. Sometimes, the facilities put up in the economy-minded 1970s are simply inadequate for the vast growth in passenger numbers today, hence the short life of Oxford station, rebuilt in 1970 and again in the 1990s.

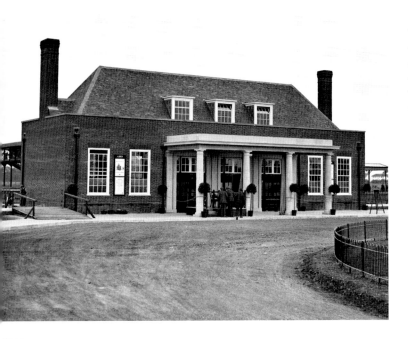

◁ WELWYN GARDEN CITY

Welwyn Garden City was opened in 1926, replacing a halt of 1920, to cater for the nascent garden city. It is seen about the time of its opening with what appears to be a podium either awaiting or left over from the opening ceremony. The neo-Georgian style reflected that being employed throughout the garden city by its architect Louis de Soissons and was of modest proportions. It survived unaltered until the station became submerged within the Howard Centre development in the 1990s. *Getty Images*

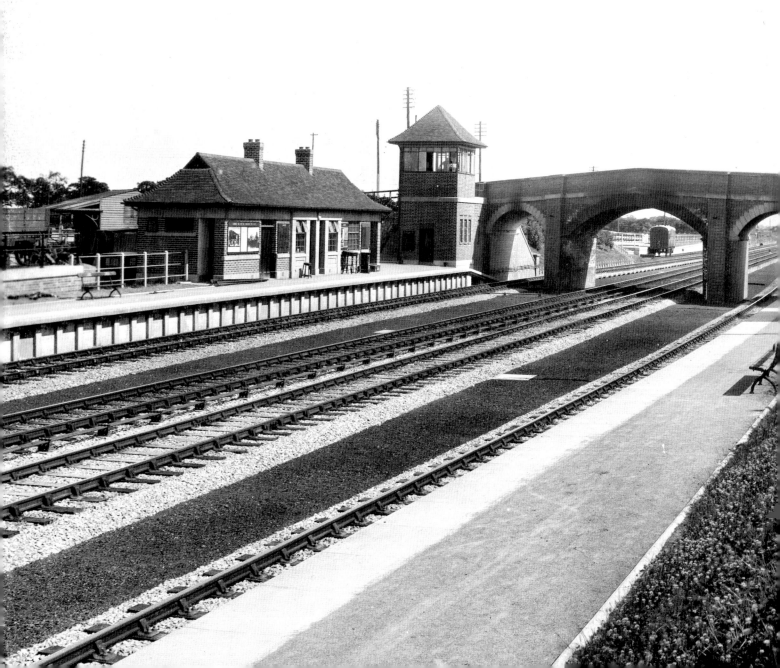

BENINGBROUGH

Few rural stations were rebuilt in the inter-war period unless, as was the case here at Beningbrough, as a result of operational necessity. The East Coast main line between York and Northallerton was widened to four tracks in 1932–3, which entailed the rebuilding of four minor stations. Each was rebuilt in brick and tile, broadly neo-Georgian in style, with half-hipped roofs and steel-framed windows. A feature of these rebuildings was the way in which station building, signal box and waiting shelter were all carefully designed to harmonise with each other, an integrated approach to design relatively rare in railway architecture. Beningbrough, photographed on 22 July 1933, immediately after completion, was closed in 1958 and subsequently demolished, although Otterington, rebuilt at the same time, retains both station building and signal box. *LNER/Robert Humm Collection*

BOURTON-ON-THE-WATER

Bourton-on-the-Water, along with its neighbouring station of Stow-on-the-Wold, was rebuilt by the Great Western Railway in 1935 in local stone , its design a simplified version of the Cotswold vernacular style. This photograph was taken just after the station was completed. Both places were extensively promoted by the company and received many tourists, hence the building of stations that were highly sympathetic to local tradition. Both stations were closed along with the Banbury–Cheltenham line in 1962. Stow was soon demolished but Bourton remained as a depot until 2009, when it was demolished following calls from local councillors who regarded it as an eyesore. It was offered to a preservation society who did not want it as it did not fit in with their buildings, which were turn of the century GWR brick designs. So this rare example of a railway company building a new branch line station of sympathetic design to its locality was regrettably lost. *GWR/John Minnis Collection*

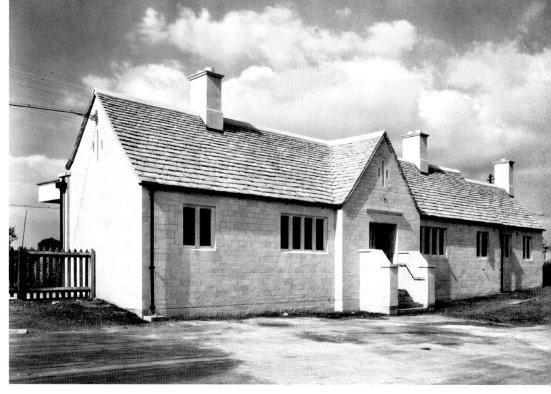

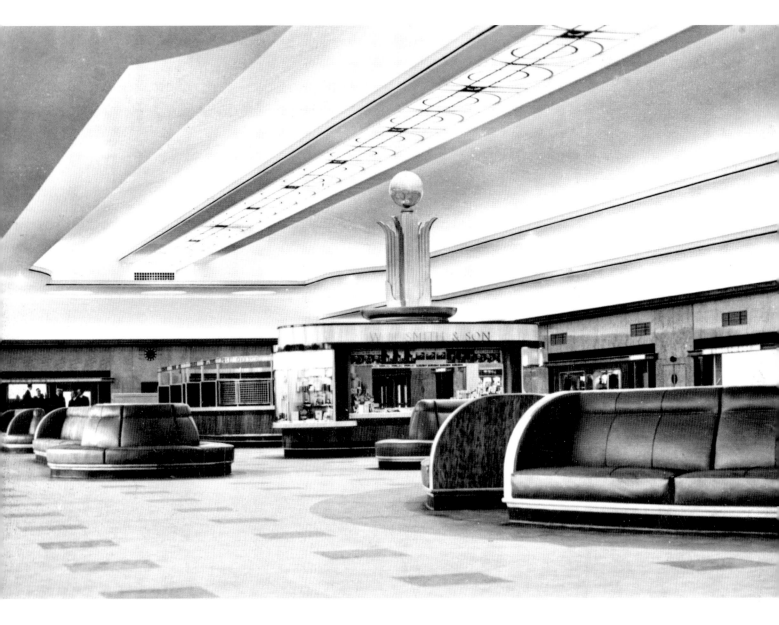

◁ SOUTHAMPTON OCEAN TERMINAL

Although redolent of the 1930s, Southampton Ocean Terminal was
not opened until 1950, its construction having been delayed because
of the war. Its interior was the epitome of Art Deco style, fully
capturing the glamour of ocean travel. But it was too late: it thrived
throughout the 1950s but its decline was rapid with the move to
transatlantic air travel. Closed in 1980, it was demolished soon after.
John Alsop Collection

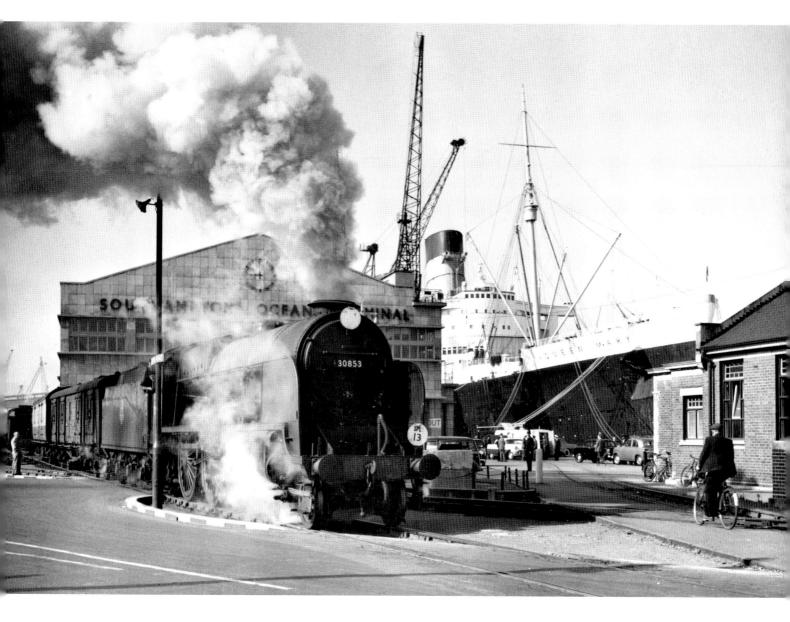

△ SOUTHAMPTON OCEAN TERMINAL

The exterior of the Ocean Terminal on 15 May 1956 with a boat train, hauled by No. 30853 'Sir Richard Grenville' of the 'Lord Nelson' class with the Queen Mary in the background. *B.A.Butt/Robert Humm Collection*

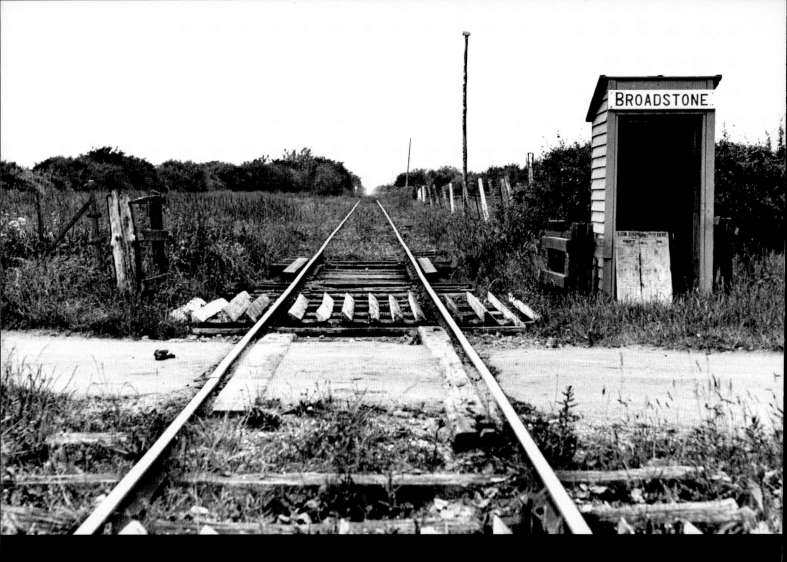

LIGHT RAILWAYS

Facilities for the passenger on light railways were a very mixed bag indeed. At best, one might find a substantial prefabricated building such as those employed on the Derwent Valley Light Railway, or less welcoming, the corrugated iron buildings favoured by Colonel Holman F. Stephens on the light railways he managed. At worst, it was a tumbledown shed, an old carriage body, in one case a former bus body, a night watchman's shelter or even nothing at all. Whether these offered less discomfort than the bus shelters that have sufficed for far too many English stations from the 1960s to this day is debatable.

◁ BROADSTONE

Some halts on the minor railways could be of the simplest description, frequently having no raised platforms. Broadstone on the Weston, Cleveden & Portishead Light Railway was perhaps one of the most basic of all with something resembling a watchman's hut for shelter, its sole contents a torn timetable. Some however consisted of a nameboard and little else. Beyond the halt, an expanse of grass-grown track stretches into the distance. Broadstone was opened in 1918 and is seen here in June 1937, three years before the closure of the unfortunately named WC&P in 1940. *L&GRP/Robert Humm Collection*

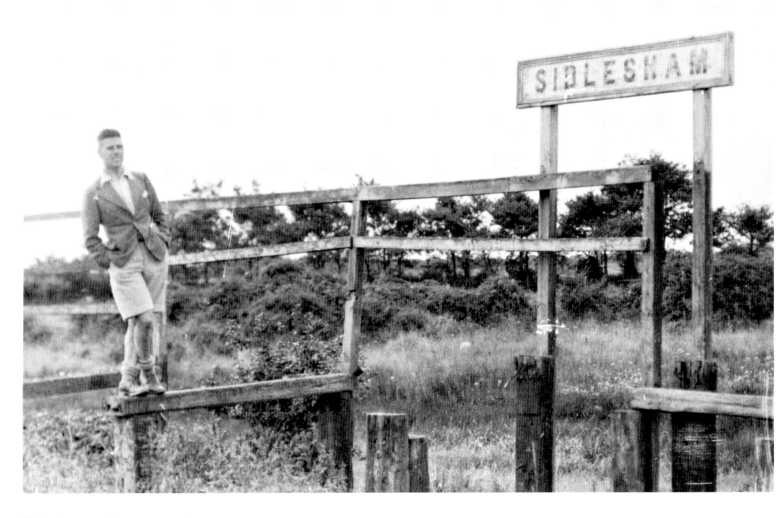

▵ SIDLESHAM

The flimsy Selsey Tramway structures soon deteriorated after the line was closed, as seen at Sidlesham where an intrepid walker gingerly poses on the decaying remains of the platform. *A.W. Croughton/Lens of Sutton Collection*

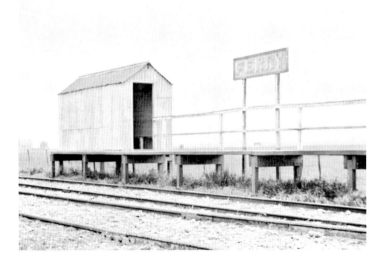

◁ FERRY

The Hundred of Manhood & Selsey Tramway (which ran between Chichester and Selsey), like many light railways, had a short life, from 1897 to 1935. Its stations were typical of those built by its engineer, Col. Holman F. Stephens, in being constructed of corrugated iron. One of the most rudimentary was that at Ferry, with nothing more than an iron shack and a lightly built timber platform. *Lens of Sutton Collection*

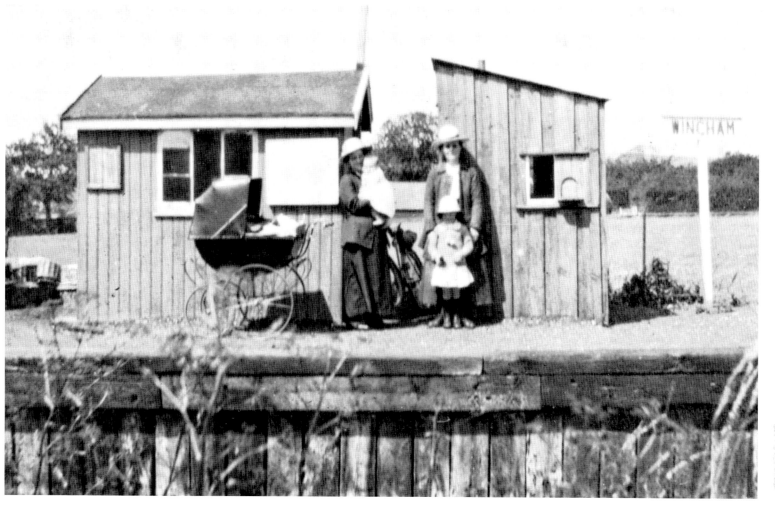

△ WINGHAM

A snapshot of Wingham Town on the East Kent Light Railway, another of Col. Stephens' lines. A latecomer, with passenger services to Wingham only being laid on in 1920, the services never reached more than three a day and were down to two from 1931 before being withdrawn altogether in 1948. The timber buildings are almost dwarfed by the pram. Such stations were doomed almost before they opened. *Lens of Sutton Collection*

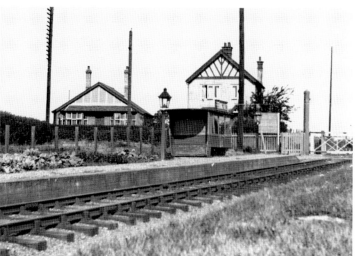

◁ FEERING HALT

Although light railways are generally associated with independent concerns, there were several operated by the major companies that rivalled the independents for quaintness. One such was the Kelveden & Tollesbury Light Railway, opened in 1904 to serve the fruit-growing trade around Tiptree and the fishing and oyster trade of the Blackwater estuary. A late addition to the railway was Feering Halt, opened in 1934. The ash platforms had a timber facing and, of all things, the body of a former London General Omnibus Co. B type bus (a type that achieved immortality as many of them went to the Western Front during the First World War) was provided as a shelter for waiting passengers. *A.W. Croughton/Lens of Sutton Collection*

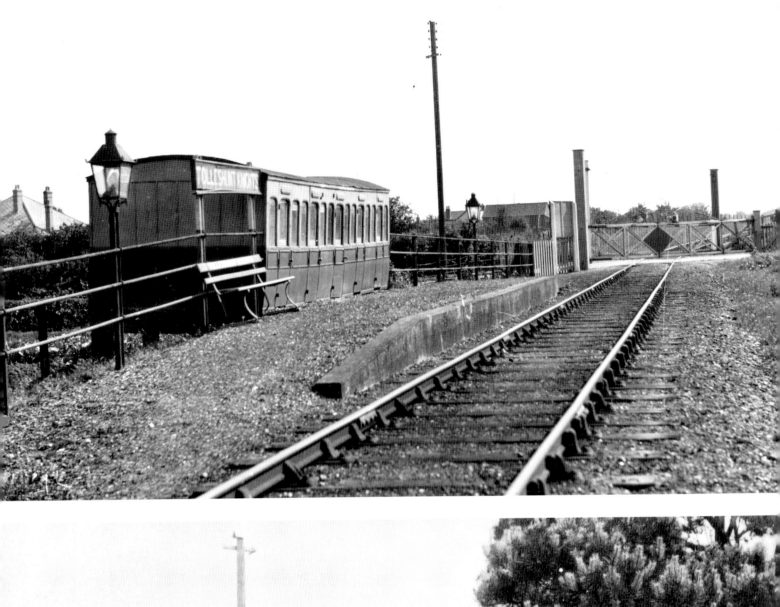

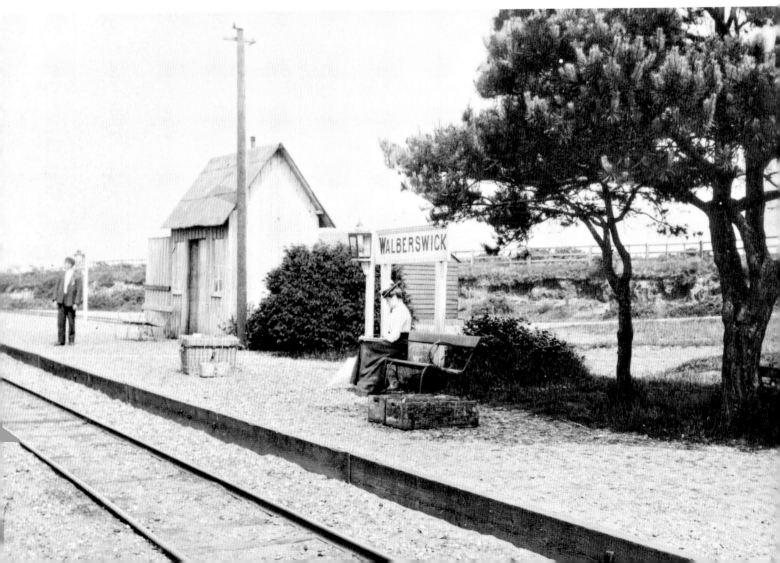

◁ TOLLESHUNT KNIGHTS

Tolleshunt Knights was opened in 1910. Carriage bodies were frequently used as shelters on minor railways, and often as lamp rooms or parcels accommodation on smaller stations belonging to the major companies. This coach is a Great Eastern Railway third of the 1880s and has developed a pronounced sag in the middle. Its decay is matched by the seat, which leans at an alarming angle in this photograph taken in September 1935. The Kelvedon & Tollesbury closed to passengers in 1951 and to goods in 1962. *A.W. Croughton/Lens of Sutton Collection*

◁▽ WALBERSWICK

The 3ft gauge Southwold Railway provided a service from the Great Eastern Railway East Suffolk line at Halesworth to the now fashionable resort of Southwold between 1879 and 1929. The intermediate station at Walberswick had for a station building a tiny timber hut which is seen in the background of this view of c. 1910. *Lens of Sutton Collection*

▽ BLAENAU FFESTINIOG

When the London & North Western Railway completed its line through the Conwy valley to Blaenau Ffestiniog in 1881, the narrow gauge Festiniog Railway opened a new station opposite to enable easy interchange. Both stations are seen here in 1923 with trains of both railways present, that of the Festiniog being hauled by the single Fairlie (an articulated design well suited to the tight curves of the FR), 'Taliesin', of 1876. The Festiniog station was of simple design, a shelter using, as its rear wall, the boundary wall of North Western Road which separated the two stations. That of the LNWR was of the timber construction much favoured by that company. It was perhaps an unfortunate choice in view of the particularly heavy rainfall suffered by the town, surrounded by mountains, and the building deteriorated to the point where it had to be replaced in 1952, initially by temporary huts and then by a new permanent structure in 1956. Meanwhile, the Festiniog station also disappeared after the closure of the line to all traffic in 1947. In 1982 the Festiniog returned to Blaenau, using a new station built on the site of the former GWR station closer to the centre of the town, and the LNWR station was closed on the same day, both British Rail and the Festiniog sharing the new Central station. *Getty Images*

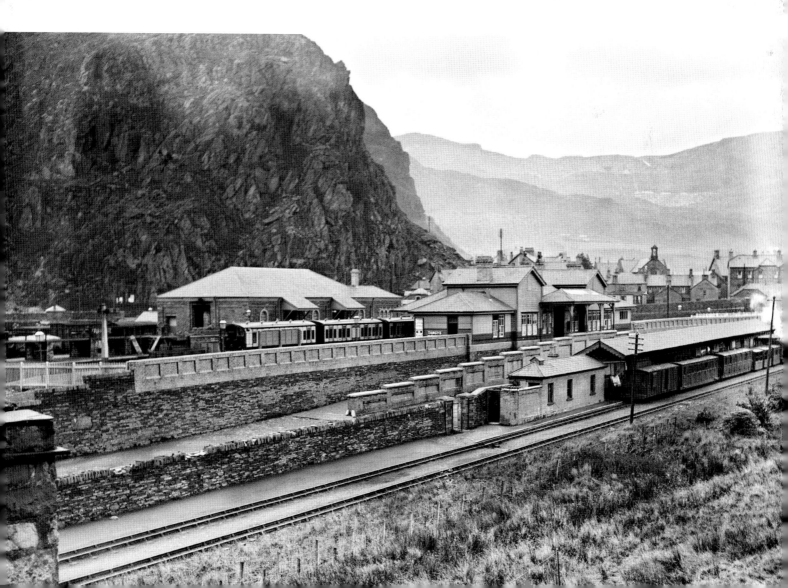

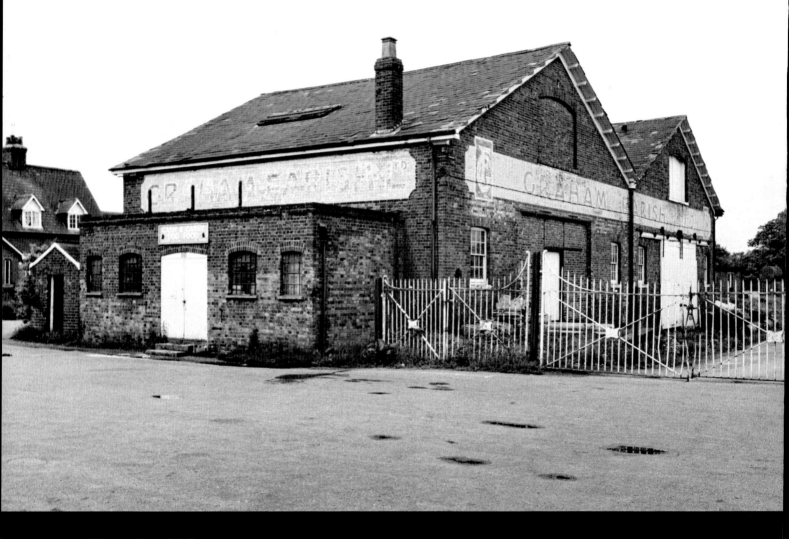

△ STAPLEHURST

The South Eastern Railway spent £500 on a hop warehouse at Staplehurst in 1846. Identical structures were built at Tonbridge and Ashford but Staplehurst was the final survivor by many years, being demolished a few years after this photograph was taken in 1984. With its exposed rafter ends and sliding doors, it is typical of industrial buildings of the time, utilitarian but with good proportions. On the left is a group of four cottages. The SER put up several groups of cottages to this design, following a decision of the board in March 1848, their otherwise plain exteriors enlivened by diaper decoration in the brickwork and ocular windows in the end elevations. The cottages were pulled down about the same time as the warehouse. *John Minnis*

GOODS SHEDS

Very much the poor relations in terms of the attention devoted to them as compared to that paid to passenger stations, goods warehouses and sheds (terms virtually interchangeable) nevertheless were probably of greater financial significance to the companies that constructed them. Their purpose was to enable the transshipment of goods from road to rail or vice versa under cover, often providing some measure of accommodation for a goods clerk and, in the larger examples, space for warehousing goods. Like passenger stations, there was a wide range of buildings to suit the varying traffic needs of the railway. The smallest in scale were hut-like structures where goods could be stored before loading, then the common type of shed found in most country goods yards where a track ran through the shed alongside an internal platform, usually equipped with a jib crane. On the road side would be one or more openings with hinged or sliding doors, often protected with canopies where goods could be loaded or unloaded into drays. These sheds could be greatly enlarged, if required, with external office blocks provided at one end. Alternatives could include sheds where the rails did not run through the shed but served a platform outside, often under an awning. Some goods yards had multi-storey sheds with the upper floor used for warehousing goods, culminating in the multi-storey warehouses, often of fireproof construction, seen in the major cities. Although they were essentially utilitarian structures, goods sheds varied greatly in appearance. The majority were of brick, their elevations generally broken up by panelling. Stone was frequently employed in areas of good building stone and some companies favoured timber, particularly for smaller structures: the Highland Railway used it almost exclusively. Each company developed its own style, some intended to match the station buildings that accompanied them; for example the goods sheds of the London, Brighton & South Coast Railway accompanying the T.H. Myres stations had tiled roofs with ornamental ridge tiles and half timbering, and incised flower motifs in the panelled areas of their walls. The London & South Western Railway had pointed arches to the blind arcading in the goods sheds of its Yeovil–Exeter main line, matching the Gothic detailing of the station buildings. Most companies developed their own house style, as recognisable as that of their passenger stations.

▽ AMBERLEY

Three examples from the London, Brighton & South Coast Railway illustrate how one company approached the provision of goods facilities at different locations. Amberley here is an example of the classic country goods shed built in 1863. The track running through it, an internal platform and a door providing cart access, are all features commonly found. The interior is lit by semi-circular iron windows set within recessed panels, used widely on the LB&SCR. This was in contrast to many companies who used roof lights to illuminate the interior. The excellent proportions of the building are evident. Seen here in 1970, Amberley was demolished later in that decade. *John Minnis*

▷▽ SEAFORD

The LB&SCR put up a number of two-storey warehouses to serve towns within its territory, using many of the same stylistic features, notably the round-headed windows, but with their effect heightened by the increased scale of the building. This is Seaford (1864), photographed in 1984, after it had served for many years as a local authority depot, which caused a number of crude minor alterations to be made to the structure. The position of the taking-in door for the upper floor, subsequently boarded and glazed, and which would have originally had a hoist, is evident under the central gable while the single-storey office block is in the foreground. The goods shed was demolished in the late 1980s and while others of broadly similar design at East Grinstead, Tunbridge Wells West and Steyning were also pulled down between the 1960s and '80s, one at Arundel was listed Grade II and survives. *John Minnis*

▷ BERWICK

In the late nineteenth century, a number of railway companies began to provide purpose-built structures, known as 'goods lock-ups', to store goods at smaller country stations. Prior to this, there was a reliance on old van or carriage bodies which were separated from their underframes and set down on the platform or in the goods yard. Some companies provided substantial buildings, such as the London & South Western Railway which introduced a brick hip-roofed design. Others used lighter construction, such as the Great Western Railway which employed corrugated iron, while the South Eastern and London, Brighton & South Coast companies favoured timber structures. The LB&SCR is known to have put up at least thirty-two lock-ups between 1888 and 1900, all with monopitch roofs and generally two doors, one on the rail side for goods to be transferred from railway wagons and one on the road side for it to be loaded on to a dray. This is the lock-up at Berwick on the main line to Eastbourne, photographed on 20 August 1970. Built in 1889, it was demolished in the 1970s, the only building to have gone at what is otherwise one of the most complete country railway stations in Sussex. Only three of the LB&SCR lock-ups are known to exist today. *John Minnis*

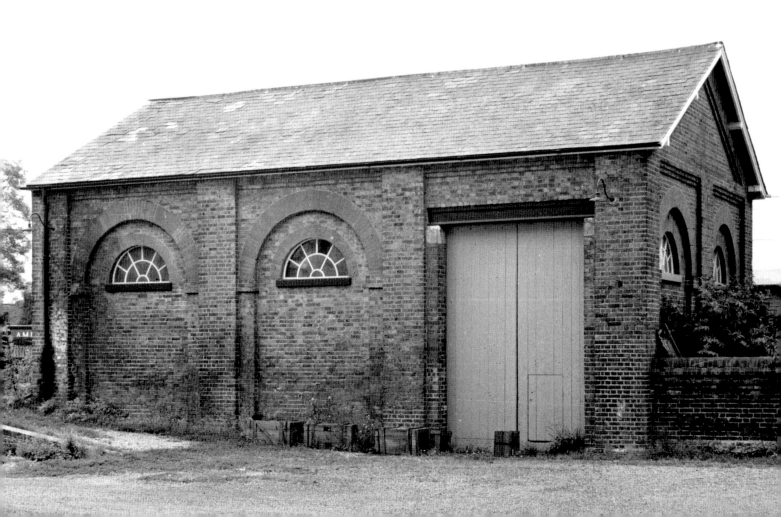

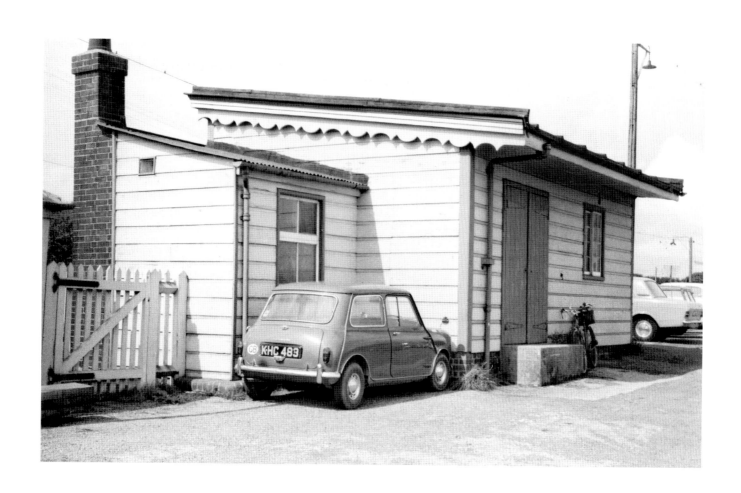

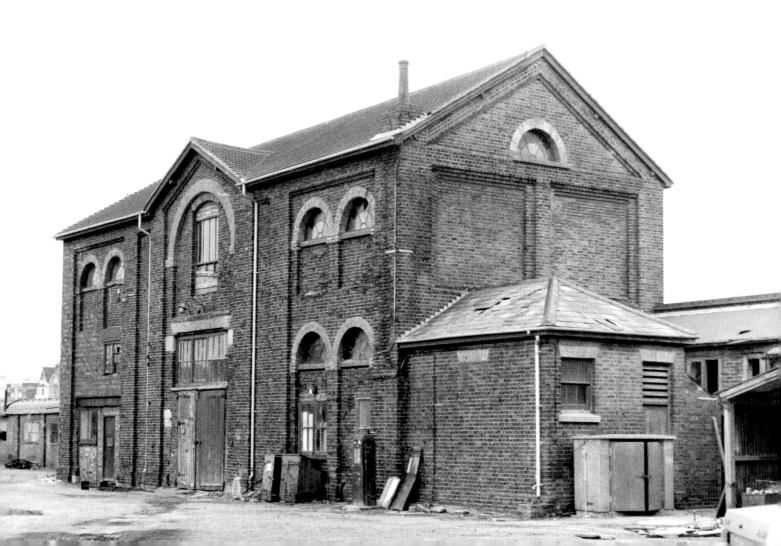

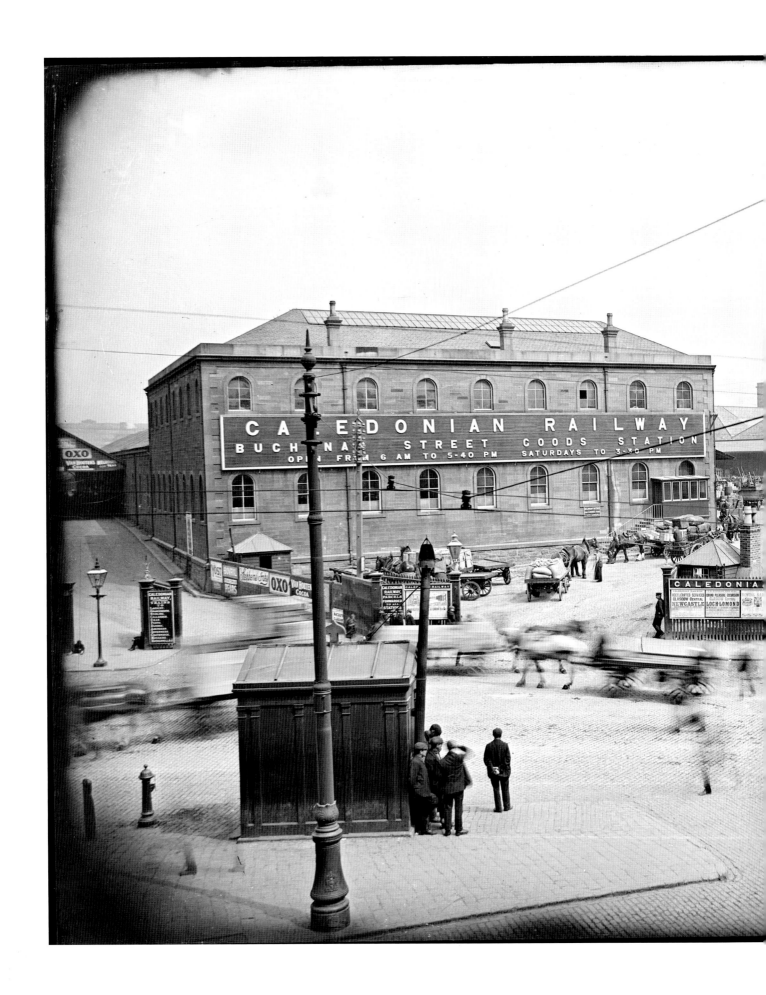

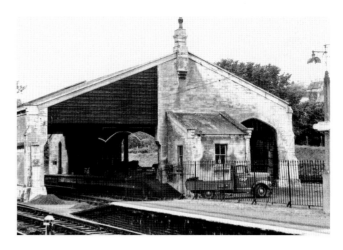

△ BRADFORD ON AVON

Bradford on Avon, on the Wilts, Somerset & Weymouth line of the Great Western Railway, was built in 1857, when the line opened. The line was engineered by Brunel and the goods shed has many of the characteristics associated with his designs; the four-centred arch above the cart entrance, the heavy corner buttresses, the monopitch roof to the lean-to office and the timbered section of the end elevation above the tracks. The plan of the building is shown well in this photograph of 12 July 1963 with a central loading platform flanked by track on one side and access for carts to pass through the building on the other. The building, constructed of local stone, was built for the broad gauge and lasted into the 1970s. *P.J. Garland*

◁ GLASGOW BUCHANAN STREET

Buchanan Street was the Caledonian Railway's principal goods station for general traffic in Glasgow. It was somewhat more distinguished architecturally (at least it was constructed of ashlar) than the adjacent timber-built passenger terminus, uncharacteristic of the CR, a company usually noted for the excellence of its stations. In fact, the station was so bad that, according to a Glasgow newspaper, 'a chemical works or a charnel house is cheerful by comparison'. The CR might have been expected to build something far more impressive for the station from which ran the expresses to Perth, Aberdeen and the tourist destinations of the north. This view c. 1905 by the CR's official photographer is of remarkably high quality and gives an impression of the scale of these depots located close to a city centre. Taken from Port Dundas Road, it shows in the centre the general offices with a shed used for English forwarding traffic behind. Beyond it is a larger shed dealing with goods from Scottish stations and a five-storey granary. The passenger station closed in 1966 and the whole site was cleared shortly thereafter. *National Railway Museum/Science & Society Picture Library*

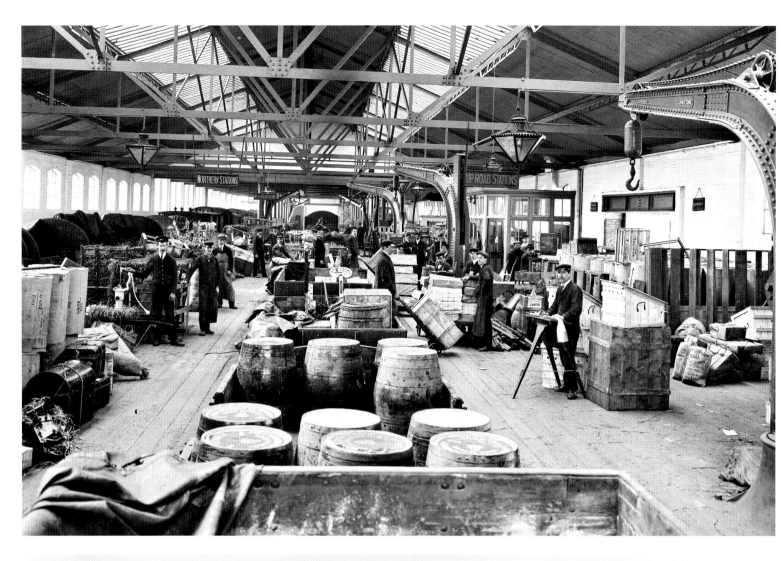

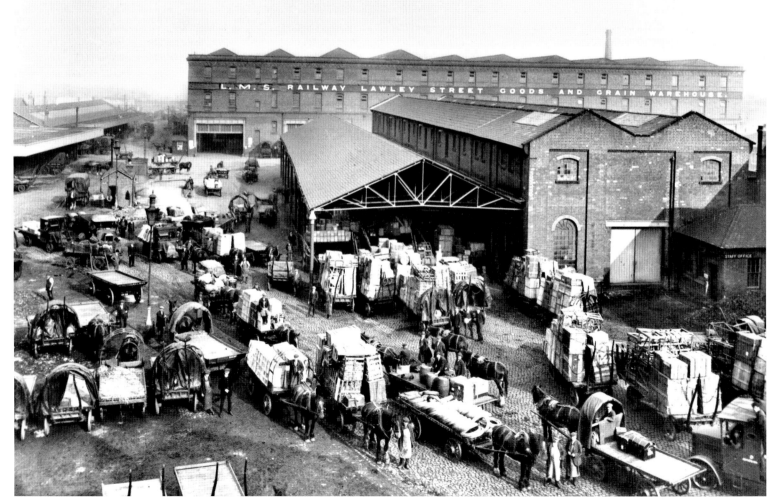

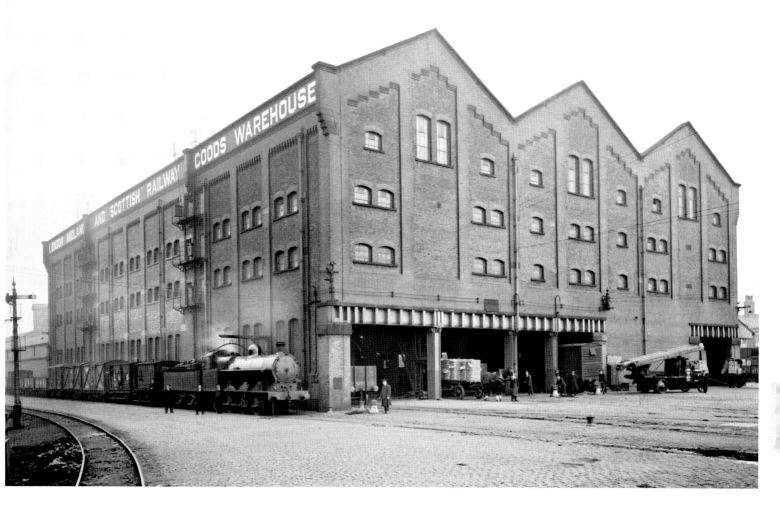

◁ READING

The interior of the Great Western Railway's Reading goods shed, photographed on 21 November 1919, gives a good idea of how such places functioned. The apparent chaos, with a great miscellany of different types of product handled in barrels, sacks, wooden packing cases, trunks and metal containers, is an illusion. The situation is, in fact, perfectly under control. The wooden platforms are divided into sections, depending on the outward destination, with staff using fold-up tripod tables on which to balance ledgers recording the details. The goods shed dates from 1896 and was located to the north of the main line, at a lower level alongside King's Meadow road. The goods depot was closed in 1969 and the goods shed demolished in 1987, its site now forming part of an office park. *GWR/Robert Humm Collection*

◁ BIRMINGHAM LAWLEY STREET

Lawley Street, the Midland Railway's principal goods depot in Birmingham, had a three-storey warehouse occupying an area of 2½ acres built in 1895 as the culmination of a series of improvements to the goods station. Seen in the background of this photograph taken in the mid 1920s, it was completely destroyed by fire on 26 May 1937. It was replaced during the war by a much more utilitarian steel-framed, single-storey structure, clad in corrugated sheeting. The building in the centre of the view, known as the 'Empties' shed, was considerably older and is visible in an engraving of the mid 1870s. In its later years, Lawley Street was transformed into an inland port, finally closing in 1987. *John Minnis Collection*

△ BOLTON

The Lancashire & Yorkshire Railway had many large warehouses to cater for the traffic of the industrial centres it served. Some were solely used for cotton; others were for general merchandise. One of the largest was this triple-gabled example at Bolton, built in 1904 as an addition to an earlier structure of 1885 to the north of it. The lettering along the top of the side elevation is typical of the way many railway companies advertised themselves on their warehouses, either in white paint, or less commonly in coloured bricks. The warehouse was badly damaged by fire in 1918 and the central portion was rebuilt, hence the new looking brickwork. The photograph was taken on 15 January 1932 and shows how the London, Midland & Scottish Railway replaced the L&YR lettering with its own. Demolition took place between 1983 and 1986. Few of these very large scale warehouses survive; their location on large sites close to city centres makes them attractive redevelopment targets while most went between the 1960s and 1980s, before the vogue for loft living took hold. *National Railway Museum/Science & Society Picture Library*

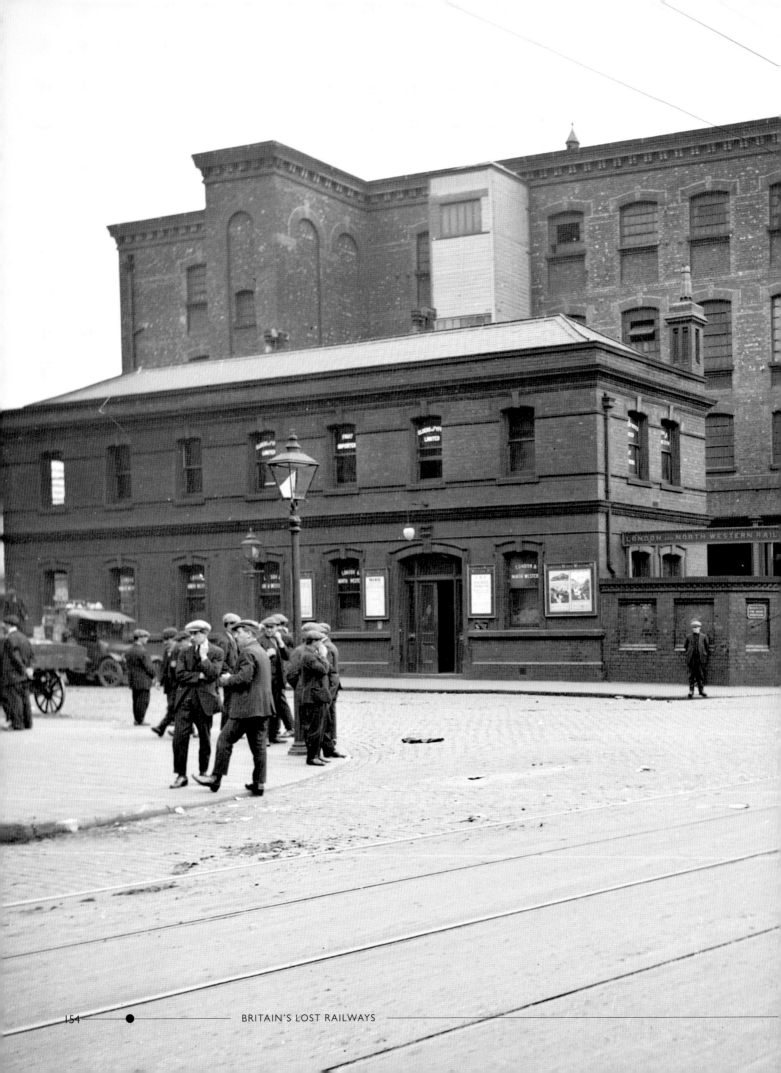

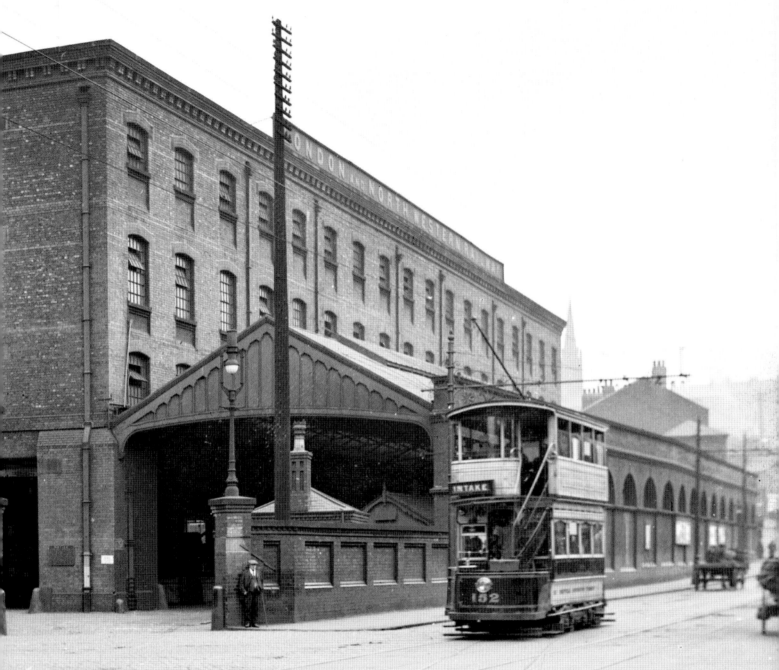

SHEFFIELD CITY GOODS

Competition between railway companies had many consequences
in terms of infrastructure. The London & North Western Railway
managed to gain a foothold in Sheffield, a city dominated by the Great
Central and Midland companies, when in 1903 it opened its City
Goods Station in Broad Street and Wharf Street, a stone's throw
from its rivals. The facilities were impressive: a warehouse on three
levels and a floor area of 94,260 sq ft, typical of LNWR practice with
much use of blue engineering bricks and a glazed canopy protecting
the loading bay. The depot was raised up so that the wagons entered
at the top level and descended to the lower levels by means of two
hydraulic wagon lifts. British Rail carried out a major rationalisation
of its goods handling at Sheffield in the mid 1960s, culminating in the
opening of the state of the art marshalling yard at Tinsley (itself
now closed), and City Goods was closed, the warehouse being
demolished *c.* 1969. This photograph was taken on 28 August 1925.
National Railway Museum/Science & Society Picture Library

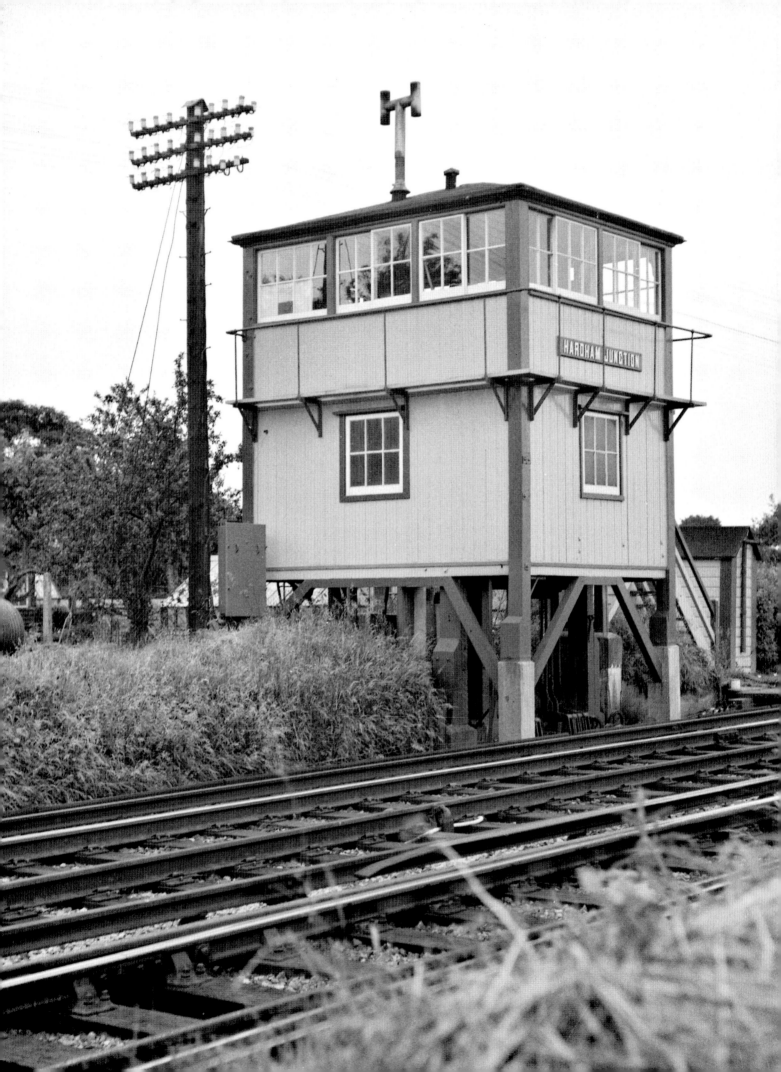

SIGNAL BOXES

Signal boxes were one of the most characteristic building types born of the railway age. They combined form and function in a highly satisfying manner, employing a limited range of elements – large windows, lighting a first floor operating room, a lower locking room and an external staircase – in a quite remarkable variety of different architectural treatments. The mixture of designs produced by the railway companies themselves, added to those that were the products of the railway signalling contractors, such as Saxby & Farmer or McKenzie & Holland, left an extraordinary legacy. The variations possible in such areas as the height and length of the boxes, roof pitch, hipped or gabled roofs, proportion of window frames, forms of timber cladding, patterns of bargeboarding, the use of toplights and eaves brackets and the size and shape of locking room windows are almost inexhaustible. What was at first sight a standard style could in practice encompass a great many minor variations. The first structures for the operation of signals comprised platforms of levers exposed in the open air with huts behind them in which the signalman could take shelter; the signal box, in the form that we know it today, emerged at the end of the 1850s. Signal boxes, more than any other railway building, were particularly susceptible to continual replacement as trackwork alterations were carried out and signalling technology evolved, but a surprising number of boxes from the 1870s lasted more than a hundred years and a few are still in use today, while many more survive from 1880 onwards.

◁ HARDHAM JUNCTION

Hardham Junction signal box, on the London, Brighton & South Coast Railway's Mid-Sussex line, controlled the junction with the branch line to Midhurst. At the time of its closure in 1967, it was the last survivor of a type introduced by John Saxby in 1859 which was raised high above the ground on timber struts to enable the signalman to obtain a good view. Originally, the signal arms passed right through the roof of the box which is actually deeper than it is wide, in contrast to most signal boxes that followed it. Hardham Junction was built in 1863 and was probably the oldest box still in use at the time of closure. Photographed in the 1960s by D.J.W. Brough. *John Minnis Collection*

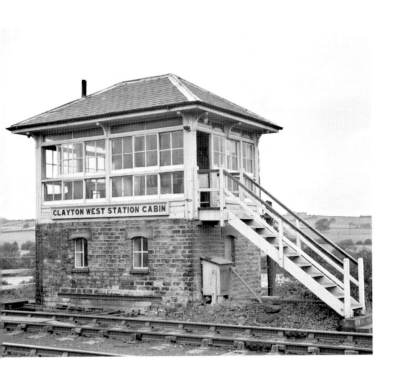

◁ CLAYTON WEST

The Lancashire & Yorkshire Railway used signalling contractors for its signal boxes until it established its own signalling department in 1889. Saxby & Farmer built this box at Clayton West, the terminus of a branch from Shepley & Shelley on the Huddersfield–Penistone line, in 1878. It displays the distinctive eaves brackets favoured by Saxby & Farmer and an original L&YR nameboard. Local materials in the form of coursed stone are used for the base, brick being much more commonly employed, even in areas where building stone was freely available. It lasted in this form until closure in 1983. Photographed in the 1960s by D.J.W. Brough. *John Minnis Collection*

▽ WESTWOOD

The Manchester, Sheffield & Lincolnshire Railway had a most distinctive type of signal box used from 1873 to 1880. It had vertical boarding, a hipped roof with a prominent finial at its apex and windows arranged with double height sashes on the front elevation, carrying round to the sides. Westwood station on the Sheffield–Barnsley line had an elevated box, the framework of which was exposed below the locking room in the manner of the early Saxby & Farmer boxes of the 1860s. A nice touch was the ornamental valance applied to the bottom of the boarding, something unique to the MS&LR. *John Alsop Collection*

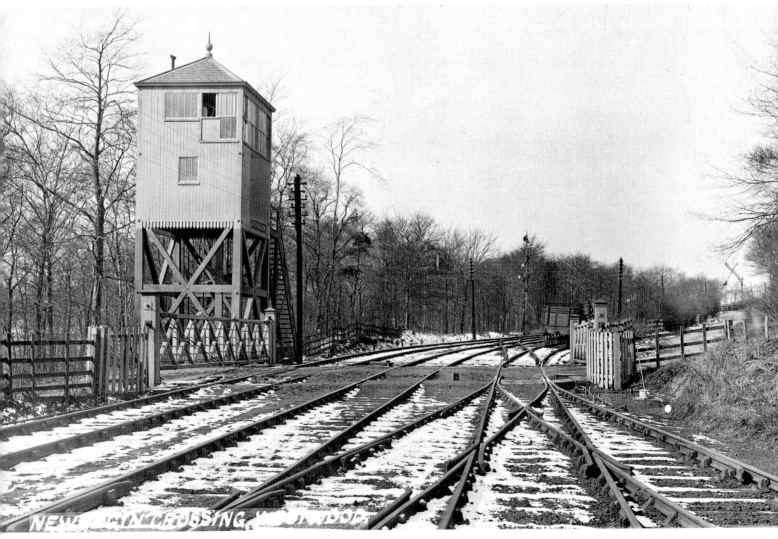

◁ MELTON

The love of ornament is again evident in the eaves valance and the ridge tiles of Melton signal box on the Great Eastern Railway. Platform-mounted boxes often had elaborate floral displays, either in window boxes or, as in this case, in pots. It was quite common for the base of the box to be almost covered by creeper although when it began to obscure the windows, it is likely management would have complained. It is typical of the way in which railway staff would seek to personalise and make homely their surroundings and the tradition is not entirely dead. Melton box opened in 1881 and was demolished as part of the East Suffolk line resignalling in 1986. *John Alsop Collection*

▽ BALQUHIDDER

The Caledonian Railway had quite distinct styles for its Northern and Southern Division boxes. While those of the Northern Division were relatively plain structures, from the 1870s the Southern Division used a design that became ubiquitous in the 1880s. It had broad overhanging eaves and very distinctive curved eaves brackets as seen in this view of Balquhidder East box, opened in 1905 and closed in 1965. *Historical Model Railway Society*

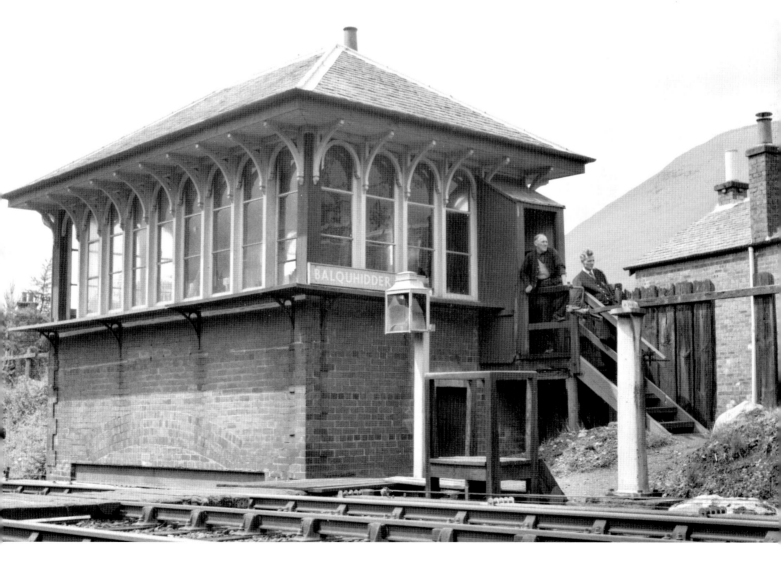

KINNABER JUNCTION

What is otherwise a fairly undistinguished looking North British Railway signal box, Kinnaber Junction occupies a unique place in British railway history. It marked the 'winning post' of what became known as the Railway Race to the North. In 1888 and again in 1895, the East Coast and West Coast routes were locked in an unofficial contest to determine which was the fastest route from London to Aberdeen. The two routes converged at Kinnaber Junction, just to the north of Montrose, and whichever train was the first to reach it went forward first to Aberdeen. The second phase of the race was occasioned by the opening of the Forth Bridge in 1890.

The races became a major story in the press, the second seeing the West Coast route as the victors at an average speed of 63.3 mph, a record not broken until more than seventy years later. The signal box, built in 1880 and of typical NBR design, using more brick than most other companies, was closed in 1982 and demolished, despite its historical significance and amid calls for its preservation. *C.E.J. Fordyce/Lens of Sutton Collection*

MELTON MOWBRAY

Some boxes continued to be elevated in special circumstances. This otherwise standard London & North Western Railway box of 1914 at Melton Mowbray was raised on a steel substructure to give a good view along the line. The box tended to sway in anything more than a light breeze, which used to stop the wall clock inside. Photographed by D.J.W. Brough, it was demolished when the line closed to all traffic in 1964. *John Minnis Collection*

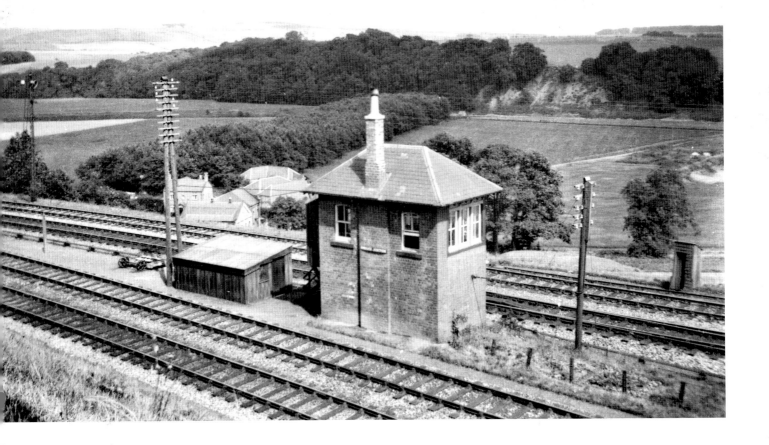

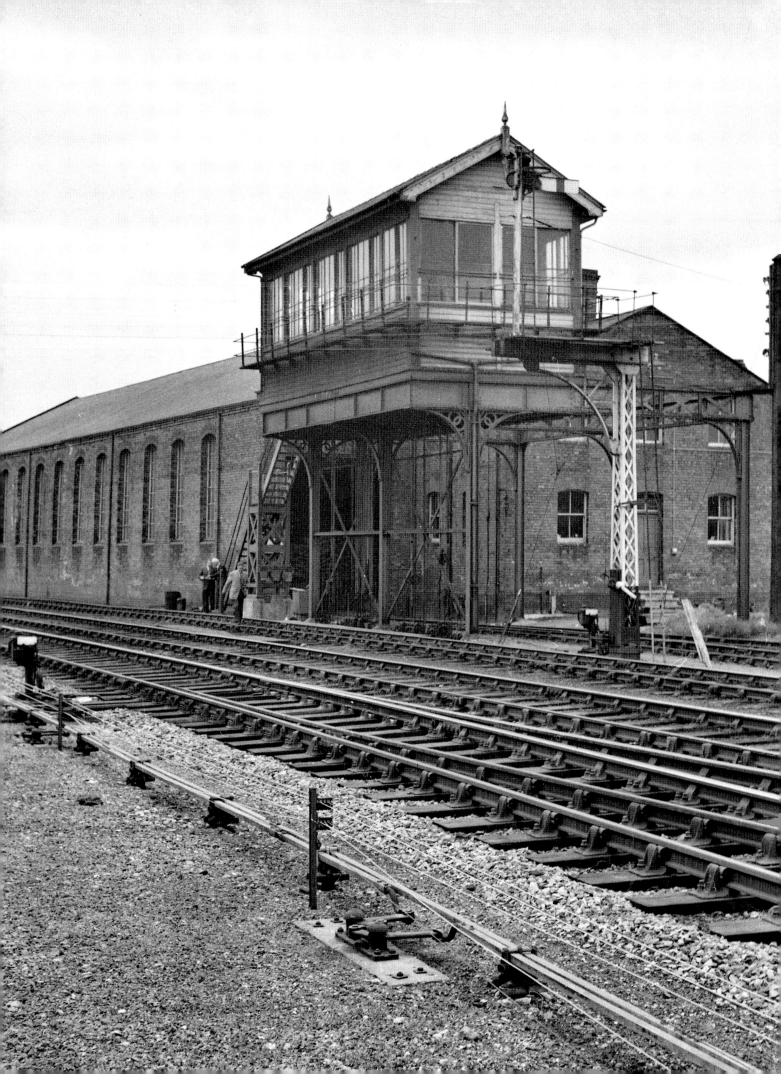

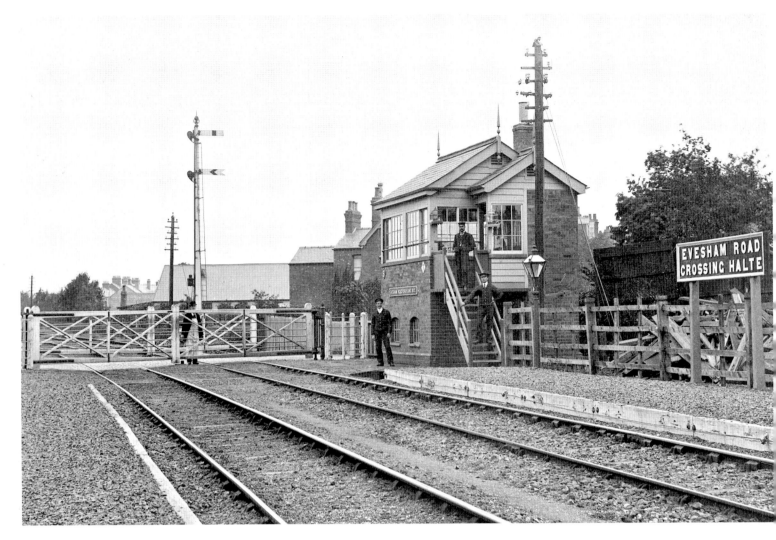

△ EVESHAM ROAD

Evesham Road box is of a characteristic Great Western Railway design, the first to be used system-wide and employed between 1889 and 1897. It dates from 1891. The halt (note the spelling variation favoured by the GWR), located a short distance south of Stratford-upon-Avon, has the most rudimentary form of construction possible, simply a slightly raised bed of packed cinders with a timber board to hold it in place. It was one of many opened in connection with the introduction of steam railmotors, this one opening after the 1904 service was introduced. Like many, it had a short life, closing in 1916 with the box going in 1960. *John Alsop Collection*

▷ BLUE BELL CROSSING

Where space was at a premium, signal boxes cantilevered out from narrow brick bases were often found. The North Eastern Railway was particularly fond of the arrangement and this example, Blue Bell Crossing, also has a bay window to the side to give the signalman a better view down the road crossing he is controlling. As always with signal boxes, the interest lies in the detailing, the ornamental brackets to the window cleaning platform around the box, the two large brackets supporting the upper part of the box and the diagonal boarding. The particularly chunky posts for the crossing gates are also uncommon. The box was demolished after closure in 1984. *John Alsop Collection*

△ CRAIGELLACHIE

One of six signal boxes built to this attractive design by the Great North of Scotland Railway, Craigellachie dates from 1900. The earliest appeared in 1898 and the last in 1914; one of the type at Inverurie (1902) is still in use. The decorative panels, the ornamental ridge tiles and finials helped to complete an attractive ensemble, an effect heightened by the British Railways cream and brown colour scheme it carried when photographed in the 1950s. The line closed in 1968. *Historical Model Railway Society*

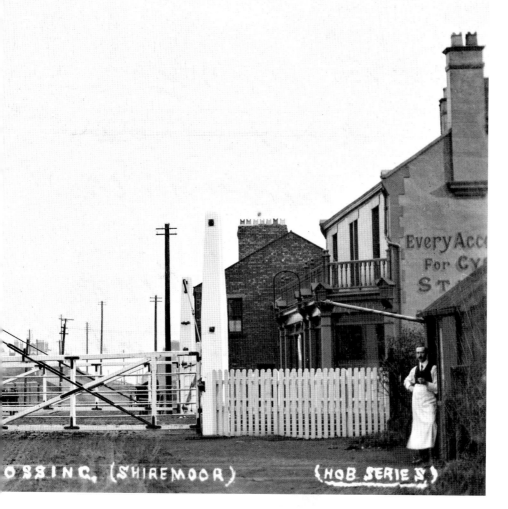

OSSING. (SHIREMOOR) (HOB SERIES)

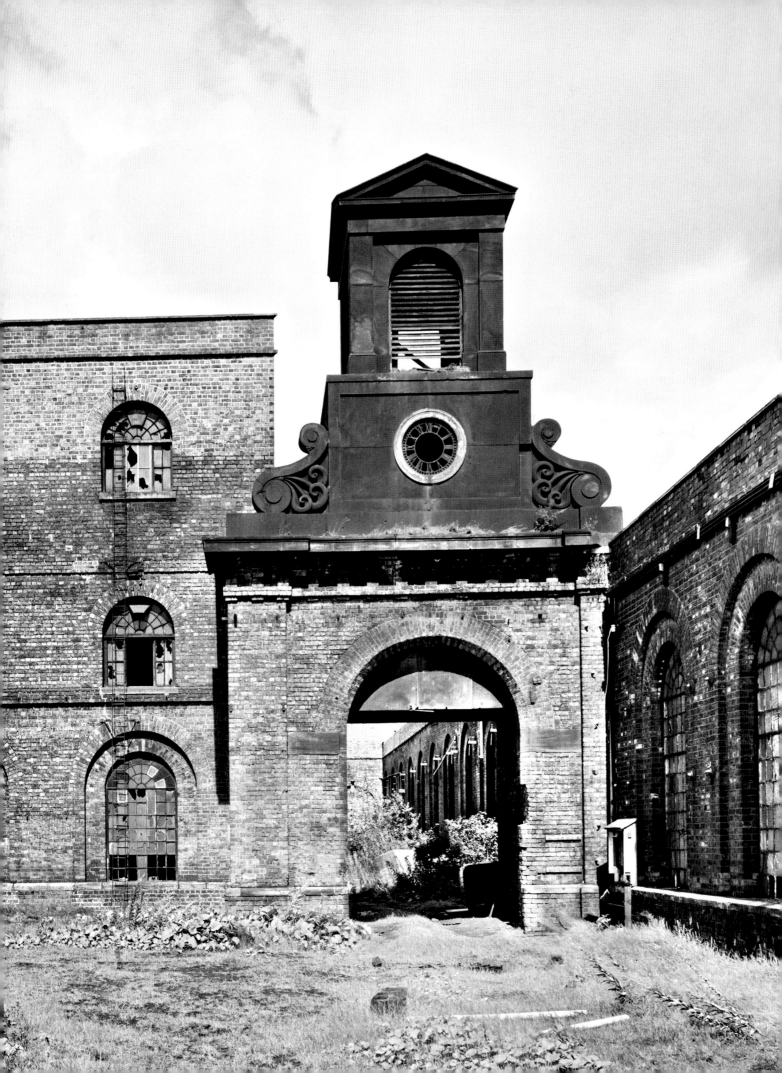

RAILWAY WORKS, ENGINE SHEDS AND ENGINE HANDLING

The change from steam to diesel and electric traction resulted in the disappearance of most of the infrastructure catering for the earlier form of motive power. Although some steam sheds were converted to house the new locomotives, the vast majority were closed, a handful to see out a further existence in industrial use or continuing employment by the railways as wagon repair shops or the like, but most were demolished leaving no trace. Also removed were all the facilities that serviced the steam locomotive – inspection pits, water softening plants, ash plants, coaling stages, both manual and mechanical. The latter, some of the most striking building types that emerged in the latter part of the steam age, are now represented by just one survivor at Carnforth, now listed Grade II. All the rest are now lost. Gone too are many of the vast railway works complexes. The majority survived intact into the 1960s, Darlington, Gorton, Stoke, Stratford among them, but the effect of successive rationalisations and the privatisation of the industry in the 1990s decimated their ranks. Even where substantial parts remain, the losses are significant such as at Swindon where, while the earlier parts of the works survive re-used as offices, retail and a museum, the great 'A' shop of 1902, extended in 1921, where the engines were built, was demolished soon after closure in 1986. At Crewe, the core of the Old Works with its celebrated clock tower, dating from 1843, which formed the background for so many early locomotive portraits, was demolished by 1976.

◁ CREWE WORKS

The entrance to the Crewe Works of the Grand Junction Railway was marked by a handsome clock tower. The GJR chairman, John Moss, declared before the works was opened in 1843 that 'This grand manufactory will be the finest and most extensive railway workshop in the world.' To the left are the stores and general offices block, to the right what was built as the engine-in-stem shop, later the No. 1 erecting shop. The former gained an additional storey c. 1864–5, evident from the change in brickwork. The overall scheme was in the hands of Joseph Locke and the architect was John Cunningham, who created a complex that had a monumental character, owing much of its inspiration to public works such as naval dockyards. Subsequent enlargement at Crewe under the London & North Western Railway, which turned it into the largest railway-owned works, took place to the south and west, leaving the Old Works, as it became known, largely intact until its closure in the late 1960s and complete demolition by 1976. *English Heritage NMR*

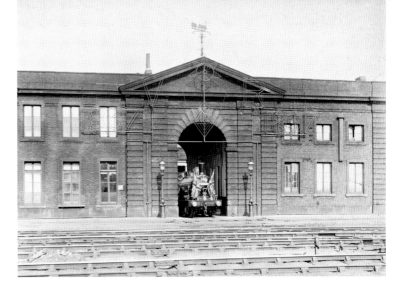

▷ STRATFORD WORKS

The General Offices at Stratford Works were built by the Eastern
Counties Railway in 1847–8 when the company enlarged the original
works of the Northern & Eastern Railway, enabling it to close its works
at Romford. In the centre of the building was an archway, flanked by
paired pilasters of rusticated brick, through which engines entered
the erecting shop. The General Offices were extensively rebuilt in
1920, when a third storey was added and the building extended. The
complex, which was one of the largest of all, gradually declined and
demolition took place over a long period, the General Offices lasting
into the 1980s, with the last part going in the preparations for the
2012 Olympic Games. The building has been decorated for the Golden
Jubilee of Queen Victoria, as has locomotive No. 1006, a D27 class 2-2-2
designed by J. Holden, which had a relatively short life: built in 1893, it
was scrapped in 1904. The lettering is intended to light up – note the
gas pipes running to the ground. *John Minnis Collection*

▷ LONGHEDGE WORKS

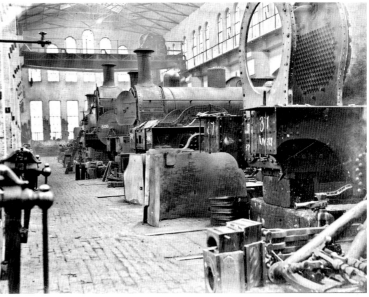

The erecting shop at the Longhedge Works of the London, Chatham
& Dover Railway in 1902. The works were commenced in 1862 and
were built in a distinctive, broadly Italianate style with tall grouped
round-headed windows and pronounced overhanging eaves on the
end gables. Fifty locomotives were constructed in the erecting shop
between 1869 and 1904. Following the working union with the South
Eastern Railway in 1899, locomotive building at Longhedge ceased and
heavy repairs were concentrated at the Ashford Works of the latter
company from 1912. Part of the works was leased but the erecting
shop was used as a railway store for many years. It had been extended
in 1881 and, although the 1860s portion was demolished in 1979, the
extension survived and was used as a flooring warehouse in its later
years. The erecting shop was the last remaining building of its kind in
London, and the demolition of the remaining section as recently as
2010 exemplifies how little appreciation there is of railway buildings
that lack the glamour of stations. It was fully recorded by the Survey of
London before demolition took place. *John Minnis Collection*

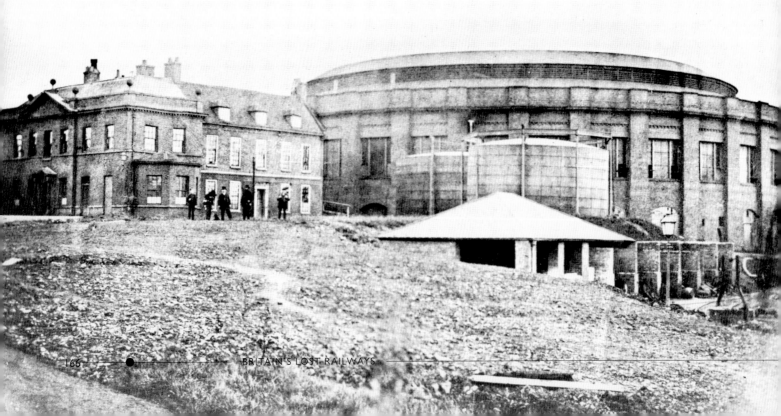

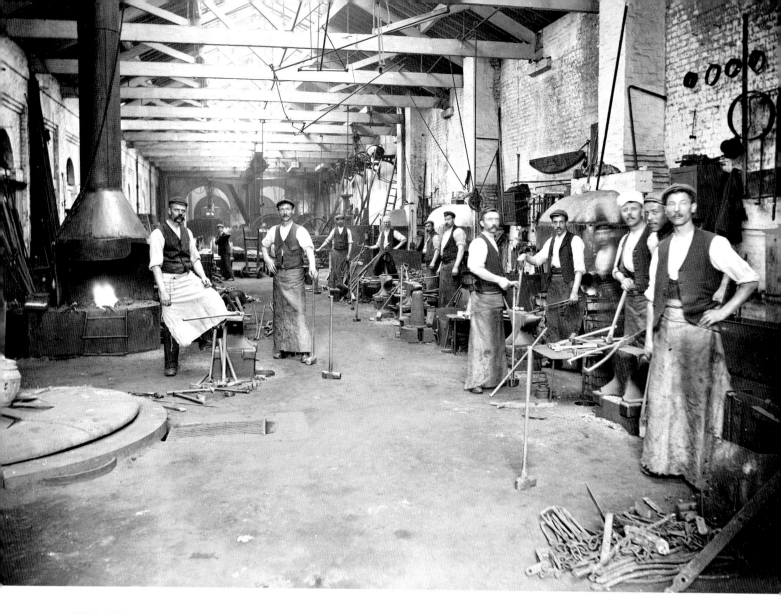

STOKE WORKS

At Stoke, the North Staffordshire Railway built its works in the grounds of an eighteenth-century house and incorporated it into the complex as its general stores. Adjoining it, they constructed a vast roundhouse c. 1852 to house locomotives. It was of a great height and the basement incorporated the tinsmiths' shops and the iron store of the works. The building, its construction on a scale rivalling that of the Camden roundhouse, remained derelict into the 1970s, seemingly unrecognised outside the local area. In this photo dating from c. 1870, a gas works is visible in front of the roundhouse. *John Minnis Collection*

BRIGHTON WORKS

The London, Brighton & South Coast Railway opened its locomotive works at Brighton in the 1840s. It always seemed slightly incongruous in a seaside resort, perched on a tight site between the main line running into Brighton station and the lines running into the Lower Goods station, which allowed little scope for expansion. Although some rebuilding was undertaken in the early twentieth century, many of the original buildings, with their low roofs, survived to the end which came in 1958. After a period in the early 1960s when part of the works was used for assembling Isetta bubble cars, the entire complex was demolished in 1969. This is the Smiths' Shop, with the leather-aproned blacksmiths posing for the photographer in one of a series of views taken of the works c. 1905. *John Minnis Collection*

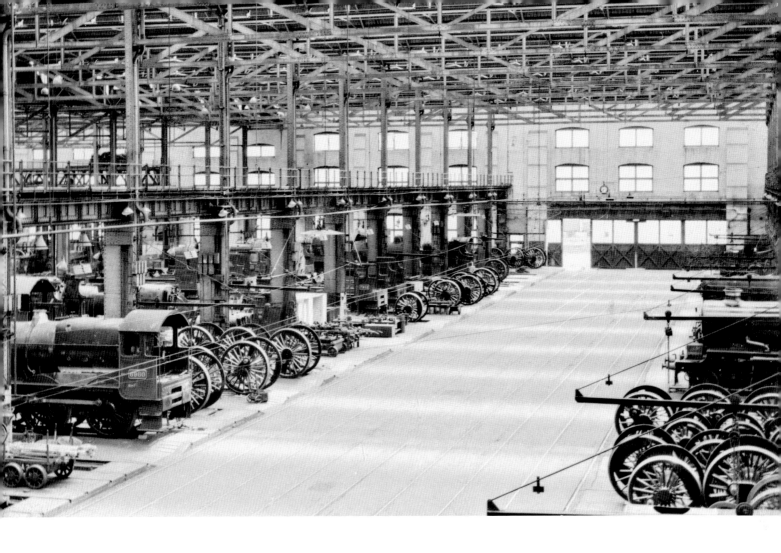

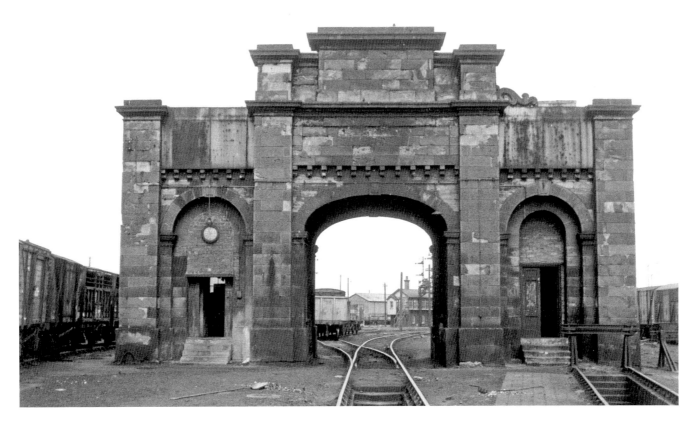

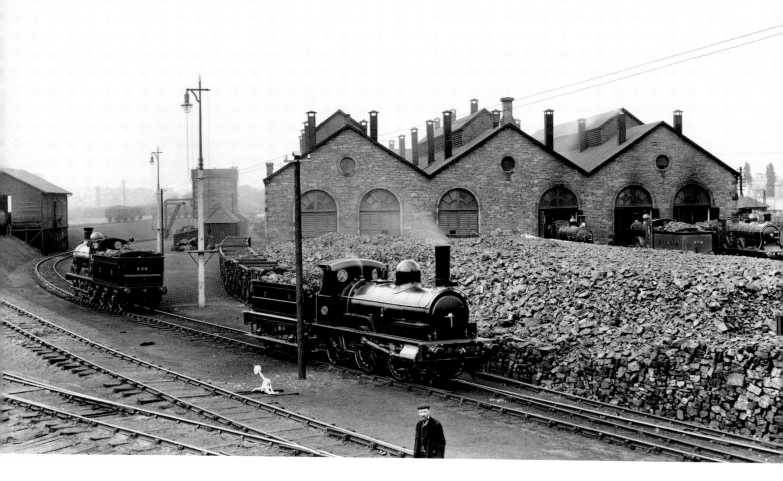

SWINDON 'A' SHOP

The vast interior of 'A' shop at Swindon, where the Great Western Railway built its locomotives from 1902. The view is looking southwards across the 1921 extension to the 1902 erecting shop and gives some idea of the sheer scale of the steel-framed structure. To many people, this great building, austere as it was, with none of the architectural flourishes of the Brunel buildings, was nonetheless the heart of the railway works and the failure to preserve it on the closure of the works in 1986 took away much of the satisfaction gained from the retention of the earlier works buildings at the east end of the site. Photographed on 15 August 1954. *W. Potter*

INVERNESS

Extravagant display was quite rare where locomotive sheds were concerned by 1864, when this triumphal arch leading to the roundhouse at Inverness was constructed by the Inverness & Nairn Railway, which merged with the Inverness & Aberdeen Junction Railway the following year to form the Highland Railway. It was practical in that it housed a 45,000 gallon water tank but its deeply modelled façade lent an element of splendour unequalled by any other locomotive shed in Great Britain. It may be attributed to Joseph Mitchell, the engineer of the company. The arch and the shed that lay beyond it were demolished in the 1960s. *The Transport Treasury*

PERTH SHED

Many locomotive sheds had few architectural pretensions and their hard use, subject to constant pollution from the engines they housed, often resulted in their premature demise. This is the shed at Perth, one of the Caledonian Railway's principal depots, c. 1905. Tenders for it were invited in 1854 and it was completed before the end of the decade. Constructed of stone and extended in the latter part of the nineteenth century, it was a through shed with doors at both ends, some 200ft long and about 140ft wide. The smoke ventilators are very prominent in this view, which also shows the timber coaling stage to a standard CR design on the left with the water tower beyond. The shed was replaced by the LMS in 1938 with a new structure, itself now demolished. Besides the stacks of coal stands No. 324, the first of a class of 0-4-2 mixed traffic locomotives, built by Neilson & Co. in 1872 and scrapped in 1907. To the right are some of the impressive McIntosh Dunalastair II express engines, No. 779 'Breadalbane' the nearest. *Robert Humm Collection*

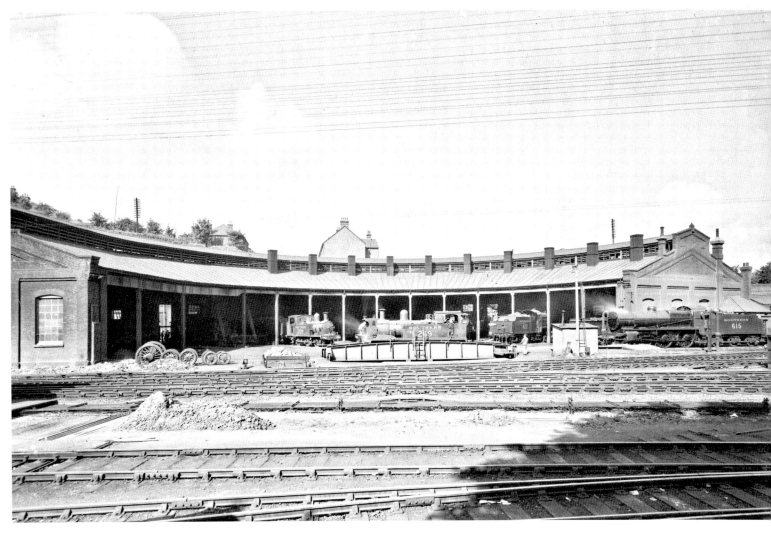

◁ GUILDFORD SHED

A wide angle lens exaggerates the width of Guildford shed, a half-roundhouse built into a cramped site excavated from a chalk hill at the south end of the station. The shed replaced an earlier structure, closer to the station, in 1887. The original roof, seen in this photograph of *c.* 1930, was replaced in the early 1950s. The shed lasted to the end of steam on the Southern Region in July 1967 and, like many other steam sheds, was demolished within a few months to be replaced with car parking for the station. *D.E.H. Box/John Minnis Collection*

▷ OLD OAK COMMON

The Great Western Railway was, with the Midland Railway, the greatest user of the roundhouse type of locomotive shed and continued to develop the design into the twentieth century. The massive rectangular structure at Old Oak Common, built in 1903–6, had four interconnected electrically operated 65ft turntables and housed 112 locomotives. In this photograph, taken from one of the turntables, the wooden smoke hoods to draw steam out of the building are very prominent. The locomotives to the rear are grouped around a second turntable. The locomotive on the right is one of Churchward's 'Star' class 4-6-0s. *John Alsop Collection*

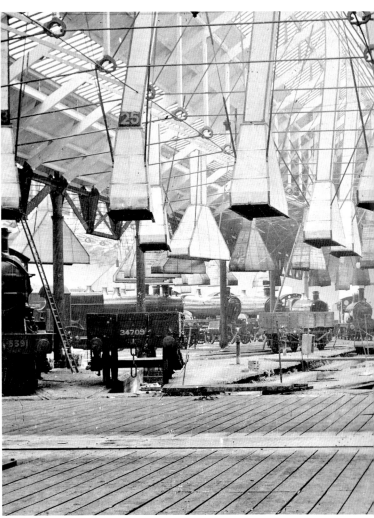

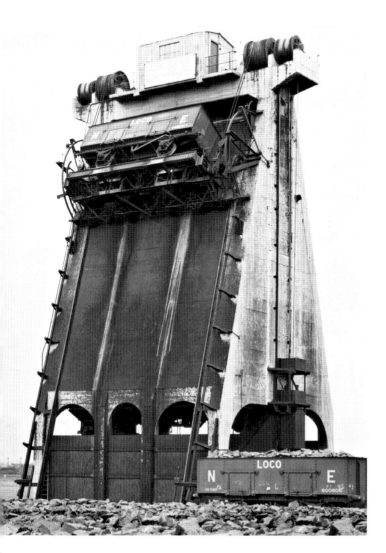

◁ WHITEMOOR

By the late 1920s, the traditional means of coaling locomotives at a coaling stage, either by hand or by crane, were increasingly seen as being outdated and the London, Midland & Scottish and London & North Eastern Railway both introduced mechanical coaling towers where wagons were lifted to the top of the tower and their contents then tipped into the locomotive tender below. The tall reinforced concrete towers were some of the most impressive structures designed to accommodate the steam locomotive. This is the 500 ton hopper at Whitemoor, photographed on 8 May 1928, soon after construction, although it has inevitably already become covered in coal dust. Only one mechanical coaling plant, that at Carnforth, survives. *Robert Humm Collection*

▽ RUGBY

The London & North Western Railway, as always an advocate of standardisation, devised a distinctive form of coaling stage for its locomotives with panelled brick walls supporting a water tank. Rugby, built in 1878, is typical with, on the left, a timber platform which could be lowered so as to enable wheelbarrows to be pushed across it and tip their loads into the engine's tender. By the 1930s, these methods of hand coaling were seen as increasingly slow and labour-intensive and, at many of the busiest engine sheds, were replaced by mechanical coal tipplers. This happened at Rugby in 1934, soon after this photograph was taken. No. 5244 'Tubal' is a member of the 'Precursor' class, built 1906 and scrapped in 1935. *John Alsop Collection*

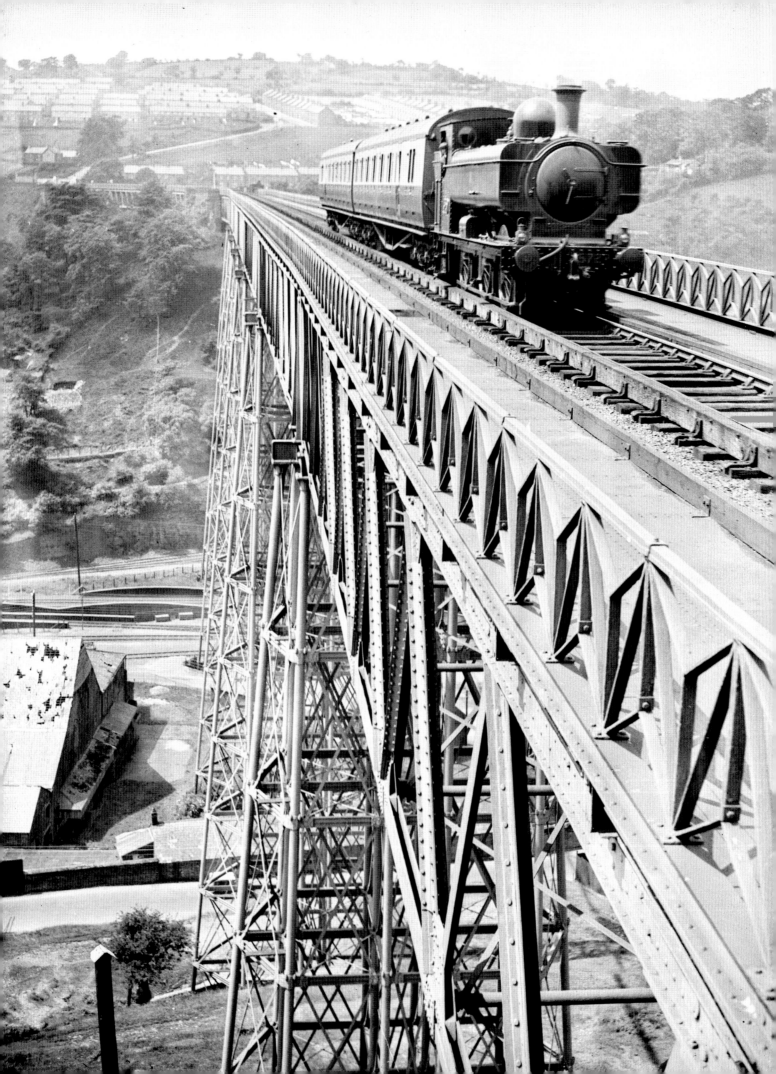

VIADUCTS AND BRIDGES

Viaducts are among the most resilient of railway structures. Even where lines have closed, masonry viaducts tend to remain, either because of their aesthetic qualities (many are listed), their role as part of the increasing number of long distance footpaths or cycleways, or simply the sheer cost of demolishing them. A number have gone when the costs of maintaining the structure have become excessive: some, such as that at Crowhurst on the South Eastern & Chatham Railway Bexhill West branch, blown up in a spectacular manner. But they are the exception. What have gone are the great iron and steel viaducts where the scrap value of the material makes demolition economically viable. Bouch's great viaducts at Belah and Deepdale and the steel viaducts of the Barry Railway's unsuccessful competitive routes across the South Wales valleys are but the most impressive examples of a host of bridges that have gone. In a different category altogether are the many timber viaducts designed by Brunel, principally located in Devon and Cornwall and in South Wales. They were demolished as repairs to the timbers became prohibitively expensive, the last in the west going in 1934 and in South Wales in 1947, and not one is left – their remarkable appearance may be appreciated only in the form of models and drawings or by the fortunately large number of photographs that were taken of them.

◁ CRUMLIN

The great iron viaduct at Crumlin on the Vale of Neath line was, at the time of construction in 1853-7, one of the highest railway bridges in the world, at over 200 ft above the floor of the Ebbw valley. Comprising ten spans, of seven and three spans with a hill between them, it was the work of Charles Liddell and Tom Kennard. They employed a combination of cast iron pipes, grouped into a hexagonal shape to form the piers and wrought iron Warren trusses between them. This was an early use of the Warren truss, only a few years after its introduction at London Bridge station in 1850 and the major Great Northern Railway bridge over the Trent at Newark the following year. Described in 1870 as 'light and delicate as if it were the work of the fairy Ariel', it was demolished in 1965, following the closure of the line the previous year. A Great Western Railway 5700 Class Pannier tank (possibly No. 5729, the number is indistinct) makes its way across the viaduct hauling a 'B' set in the late 1930s.
Science & Society Picture Library

▽ BROTHERTON

Robert Stephenson designed the tubular bridge over the River Aire at
Brotherton on the Knottingley branch of the North Eastern Railway
(originally York & North Midland Railway). It opened in 1851, replacing
a temporary wooden viaduct, put up when the line was opened in
1850. It followed the design of Stephenson's other tubular bridges on
the Chester & Holyhead Railway, the Royal Britannia Bridge and the
Conway Bridge, with two tubes 20ft 1in high. In 1900, it was replaced
with a girder bridge. *Robert Humm Collection*

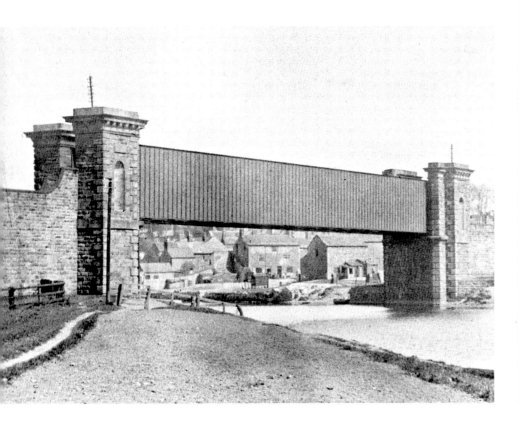

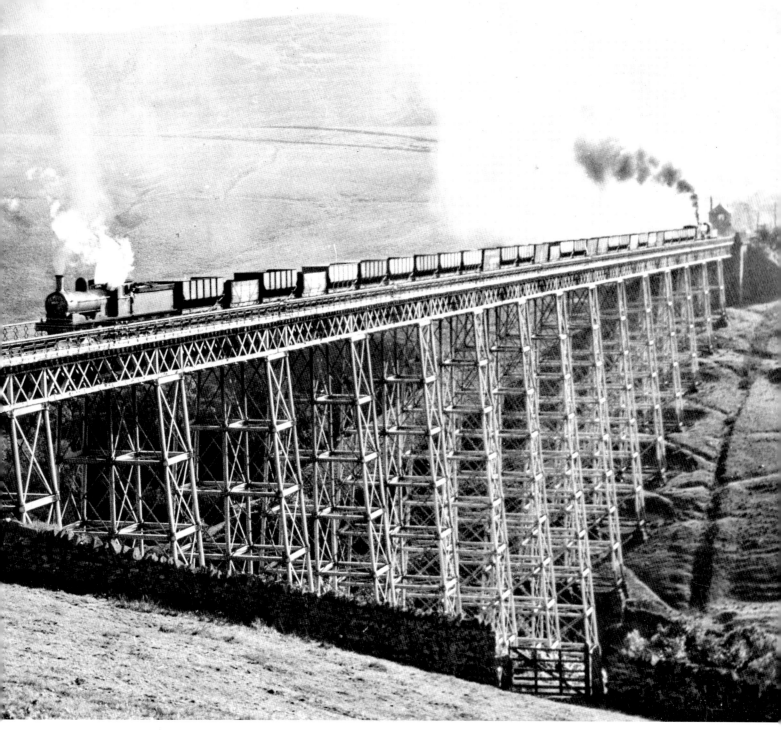

△ BELAH

Some of the most significant casualties of the 1960s were the two great iron viaducts at Belah and Deepdale on the Stainmore line of the North Eastern Railway, closed in 1962. Their light and graceful spans were the work of Thomas Bouch, later to achieve infamy as the designer of the Tay Bridge. Belah, seen here from the north-west in the mid 1950s – in a photograph by J. W. Armstrong, a noted recorder of the railways of the north-east – was commenced in 1858, the foundation stone having been laid the previous November. Two hundred feet high and 1000ft long, it was put up without scaffolding by the contractors, Gilkes, Wilson & Co. of Middlesbrough, and was completed within two years. Both Belah and Deepdale were demolished with almost indecent haste, Belah being felled in 1963.
J. W. Armstrong Trust

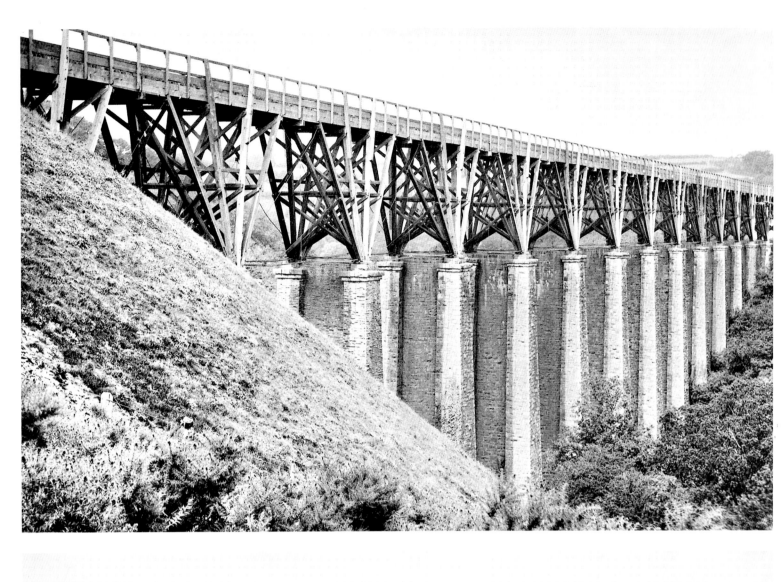

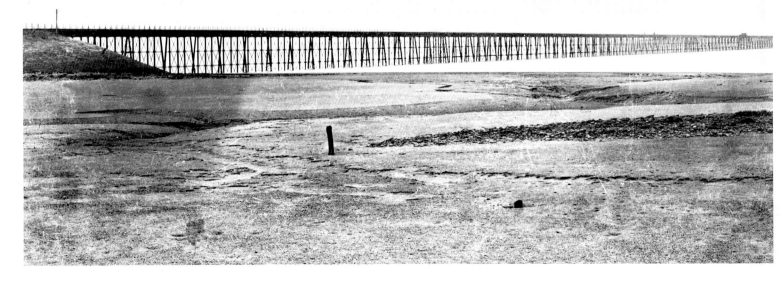

◁ WALKHAM VIADUCT

Brunel's timber viaducts are yet more evidence of his engineering genius. Those in Cornwall were the best known but there were numerous examples in Devon and in South Wales. This, Walkham on the South Devon & Tavistock Railway, is one of the tallest and longest at 132ft high and 1101ft long, constructed in 1859 and replaced by steel girders on the original piers in 1910. The second bridge was in turn completely demolished following the closure of the Launceston branch in 1965. The photograph was taken in 1898. *R&CHS Jeoffry Spence Collection*

◁▽ SOLWAY VIADUCT

The Solway Viaduct was part of a doomed enterprise for an alternative link between England and Scotland to carry hematite ore directly from the Whitehaven area to ironworks in Ayrshire, Lanarkshire and Perthshire. The 1,950 yard long viaduct (the distance from shore to shore was 2,544 yards), the longest in Great Britain until the Tay Bridge was built, was designed by Sir James Brunlees. Construction started in March 1865 and took three and a half years to complete. It consisted of four wrought iron longitudinal girders on 12in diameter cast iron columns. Traffic on the Solway Junction Railway (operated and later purchased by the Caledonian Railway) never came up to expectations. Trains ceased to run across the viaduct in 1921, due to its deteriorating condition, and it was dismantled in 1934–5. In its latter days, it was much used by locals as a short cut. *John Alsop Collection*

▽ LLANBRADACH

The Barry Railway was a relative latecomer to the railways of South Wales. It was intended to capture the coal traffic from other companies and divert it to its own docks at Barry. The Llanbradach viaduct was its greatest structure, spanning the whole of the Rhymney valley, and carrying its main line to a junction with the Brecon & Merthyr company in an attempt to obtain business from the Eastern Valleys collieries – it never carried regular passenger traffic. With a length of 2400ft and rising up 125ft above the valley floor, it was, with the neighbouring Walnut Tree viaduct across the Taff Vale, one of the most magnificent railway bridges to be built. Constructed in 1904–5, it had a working life of only twenty-two years, being closed in 1926, the year after this photograph was taken, and demolished in 1937–8, a fate shared later by Walnut Tree. *R&CHS Jeoffry Spence Collection*

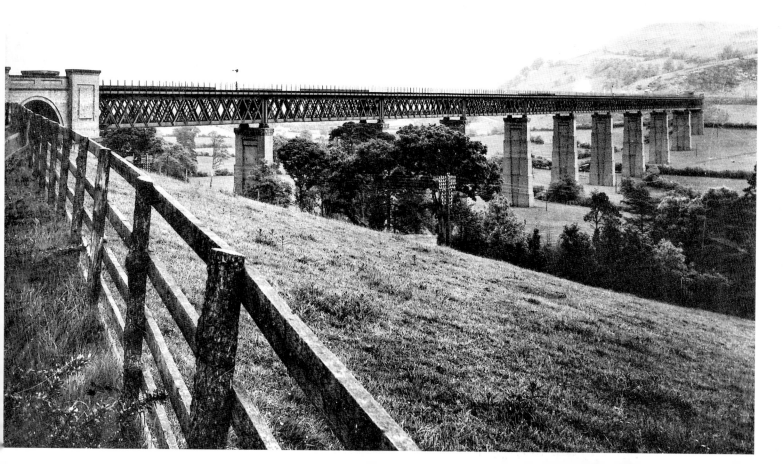

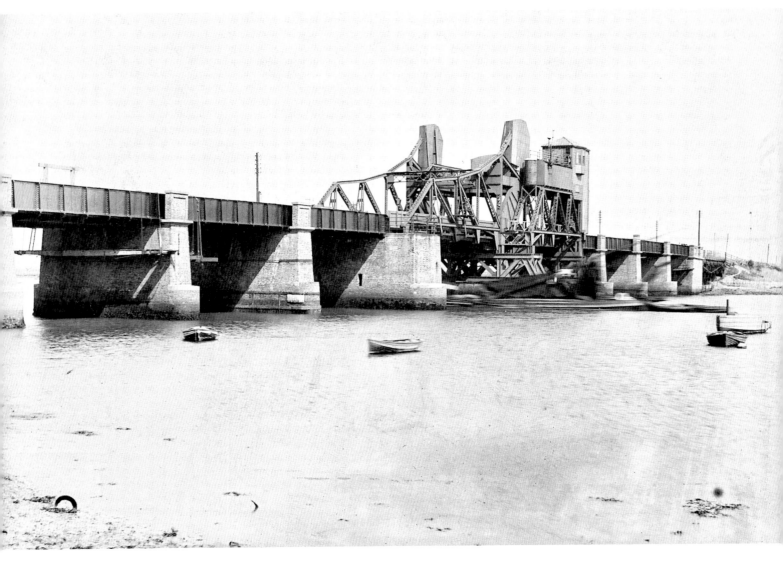

◁ KING'S FERRY BRIDGE

The London, Chatham & Dover Railway opened a branch from
Faversham to Sheerness Dockyard on the Isle of Sheppey in 1860.
Prior to the opening of the railway, access to the island across the
Swale had been by ferry but a bridge was built to carry both road and
rail traffic with an opening span for shipping. This bridge was replaced
in 1904 with the Scherzer rolling-lift bridge seen here. Scherzer
bridges were never common in Britain, the best known being that at
Keadby on the Great Central Railway, opened in 1916. King's Ferry
was replaced in 1960 by a new bridge with a lifting portion that rose
between four concrete towers. *R&CHS Jeoffry Spence Collection*

▷ LIVERPOOL OVERHEAD RAILWAY

The Liverpool Overhead Railway was the only true example in
Great Britain of an elevated railway of American pattern. It ran along
the waterfront giving unrivalled views of the shipping along almost
the whole length of the Liverpool docks. The LOR was the first full
size standard gauge electric railway in the country, its initial section
opening in 1893. This slightly retouched view shows the ironwork for
the viaduct under construction. *Chambre Hardman Collection/Liverpool
Record Office*

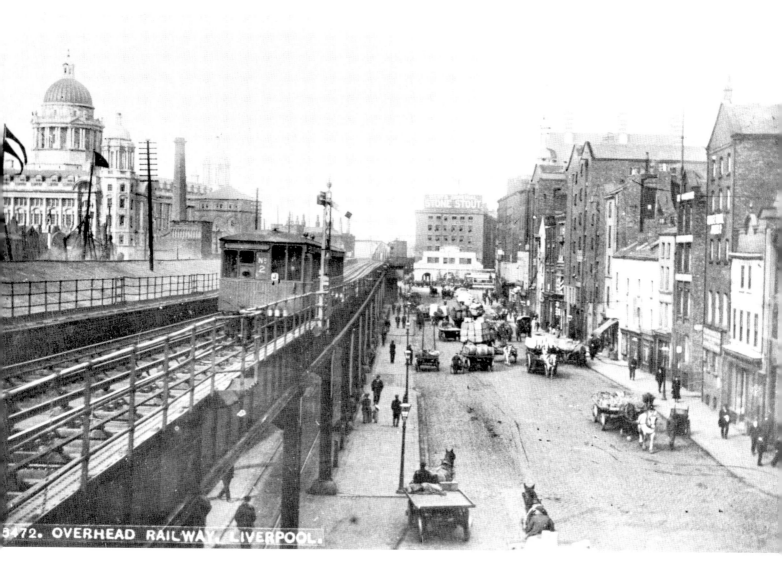

5472. OVERHEAD RAILWAY. LIVERPOOL.

IVES & BARKER. LONDON.

△ LIVERPOOL OVERHEAD RAILWAY

An impression of the views to be had is gained in this photograph taken just south of Pier Head. In the background is the Mersey Docks & Harbour Board Building, completed in 1907. There is no sign yet of the Royal Liver Building beyond it, constructed between 1908 and 1911, enabling the photograph to be dated within a year or so of 1908. The closure of the LOR in 1956 and its subsequent removal robbed Liverpool of something unique to the city that could have been a great tourist attraction. The Overhead Railway is still recalled with much affection in the city and although little tangible remains of it, a short length of the viaduct has been reconstructed at the new Liverpool Museum where a remaining carriage is exhibited.
John Minnis Collection

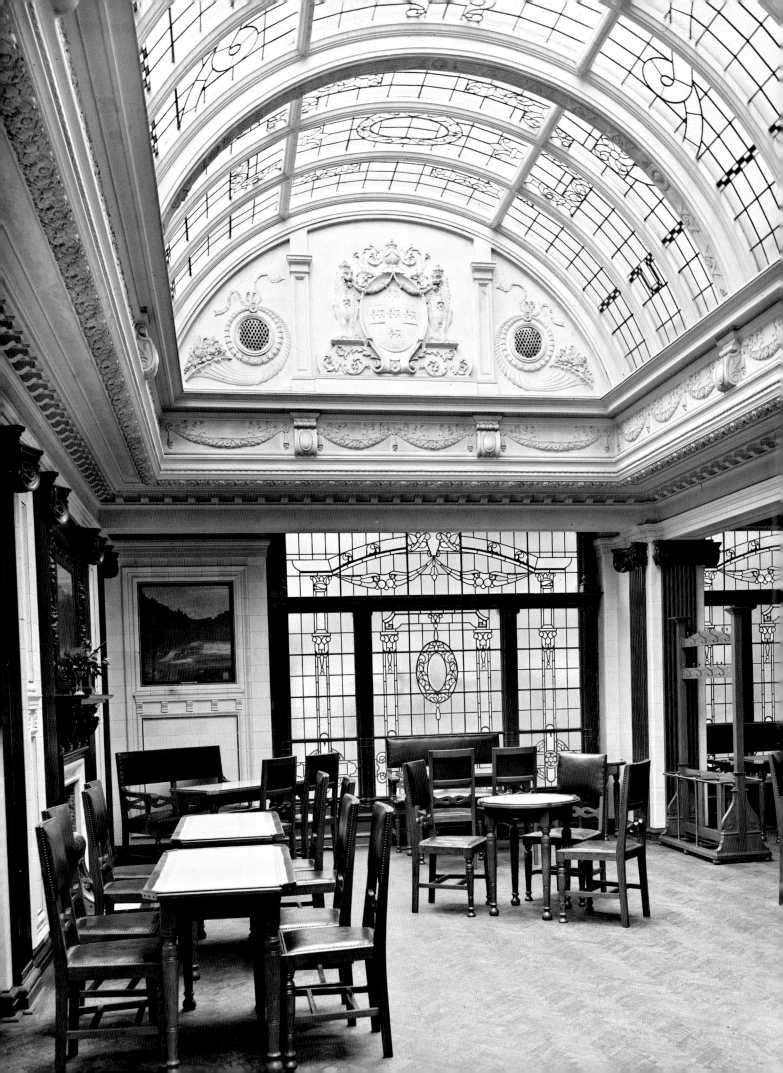

THE RAILWAY ENVIRONMENT

Besides the structures that have gone, the most obvious difference when looking at the railway of fifty years ago and comparing it to the position today is that there was just so much more of it. The reduction in the amount of track, due largely to the great reduction in local freight services, is almost incredible. The amount of space occupied by the great railway marshalling yards such as those at Whitemoor, Temple Mills, Mottram or Tinsley was enormous. Now much of it has reverted to scrub or been taken over by warehousing or redeveloped for housing. Semaphore signals are much reduced in numbers, especially the great clusters of them on gantries that used to stand outside major stations: the last of them, at Scarborough, has just been removed (fortunately for re-use on a preserved railway). Quirky features such as lineside gardens, once the pride of railway gangers, have largely gone, as have many railway cottages, although quite a few are left, often well disguised behind layers of render and uPVC windows. Even the railway refreshment room is now privatised and changed beyond recognition – perhaps thankfully in some cases.

◁ SOUTHPORT REFRESHMENT ROOM

The Lancashire & Yorkshire Railway took trouble in looking after its passengers with what would have been called a dainty tea room, built in 1914, at the fashionable resort of Southport. There was clearly considerable business to be had and the L&YR were determined to invest in it. The fine plaster work with horns of plenty and swags among its motifs, the decorative patterns in coloured glass and the extensive use of faience all attain the level of decoration expected for such a use at the time. The shield bears the arms of York, which were combined with those of Lancaster in the L&YR's coat of arms. The refreshment room was demolished along with the station buildings in 1970. *National Railway Museum/Science & Society Picture Library*

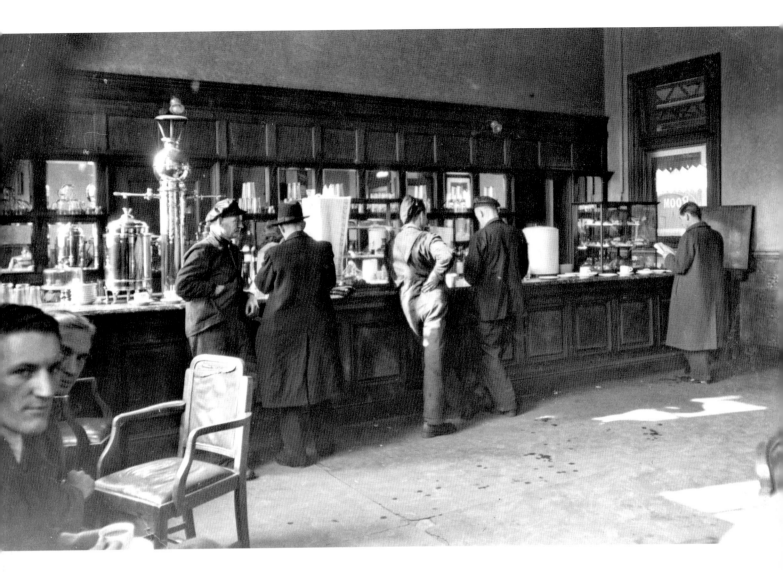

COLCHESTER

Nostalgia about station refreshment rooms, aided by constant showings of *Brief Encounter*, is rife. The reality was a little different. This view of the down side facilities at Colchester in 1948, while not of the greatest quality, seems to sum up the seediness of many of them. *R&CHS Jeoffry Spence Collection*

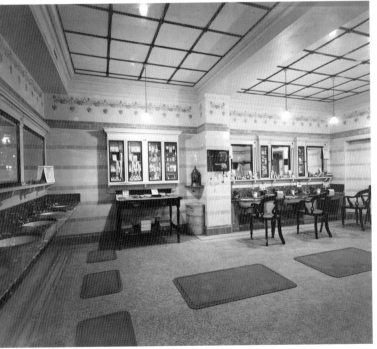

EUSTON HAIRDRESSING SALOON

Hairdressing saloons, usually located close to lavatories, were once a feature of major terminal stations. They may have had their origins in the need for businessmen to spruce themselves up in advance of important meetings at a time when journeys took much longer. The saloon (or 'Hairdressing Rooms' as it is styled on the tariff card) at Euston was photographed *c.* 1911 and, with its elegant frieze, is in the height of contemporary taste. Hair cutting, shampooing and singeing are 6d each while hot or cold baths are 1s. *Science & Society Picture Library/Getty Images*

WINDSOR BAR, WATERLOO

A charming reflection of a bygone age in rail travel that survived into the 1960s was the Windsor bar, a tea room dating from the rebuilding of Waterloo in the early twentieth century. It originally had an American soda fountain. These are the cashier's kiosks, very much in the style of pay booths in a theatre. *Science & Society Picture Library/Getty Images*

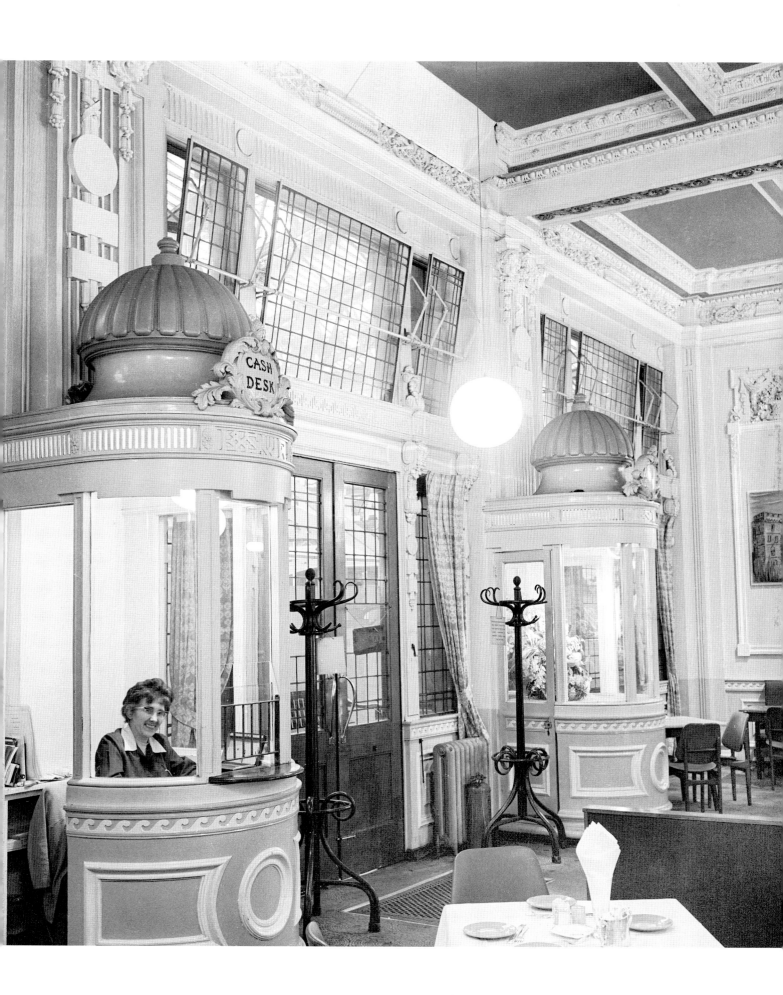

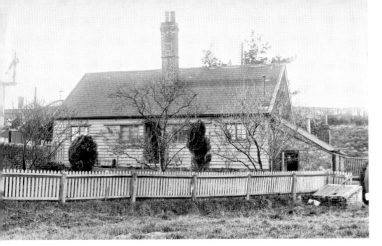

△ POLEGATE

The London, Brighton & South Coast Railway erected large numbers of highly distinctive paired cottages for its staff all over its system in the early 1850s. These were, if anything, even smaller than those of the South Eastern Railway. All were stuccoed and had the first floor windows carried up through the eaves. Decorative bargeboards on the gables and porches were standard. This pair at Polegate were located close to the old station there, replaced in 1881 by one slightly to the east but retained as staff accommodation until 1969 when it and the cottages were swept away, fortunately being recorded by John Hoare just before demolition. Their condition indicates the very poor state of repair that many railway buildings were allowed to get into in the post-war period. *John Hoare/Sussex Industrial Archaeology Society*

◁ YEOFORD JUNCTION

Yeoford Junction on the London & South Western Railway line to north Devon had a collection of somewhat rudimentary timber structures, dating from the station's opening in 1854. The station buildings were single-storey and did not have accommodation for the stationmaster, who lived in a house at the rear of the up platform. It too was of timber and, with its small-paned casement windows, had more in common with a navvies' hut than a conventional stationmaster's house. Pictured here *c.* 1900, it was demolished although the station remains open with just small glass shelters for passengers. *John Minnis Collection*

◁ BROOKWOOD NECROPOLIS

One of the most extraordinary train services in the country was that run by the London Necropolis Company from its private station near Waterloo to Brookwood Cemetery. The cemetery was opened in 1854 in response to the lack of space for interments in the capital. Regular train services between London and the cemetery were provided by the London & South Western Railway with special hearse vans and with first and third class appropriately segregated. At Brookwood, stations were provided both in the nonconformist part of the cemetery (the North station) and in the Anglican (the South station). This is the South station, which was designed, together with the Anglican chapel in the foreground (which survives), by Sydney Smirke. The rail services ceased following the destruction of much of the London station by bombing in 1941 although the track survived in the cemetery until after the war. South station remained in use as a refreshment room and later a store before a fire in 1972 resulted in its demolition. North station had gone some years earlier. *Lens of Sutton Collection*

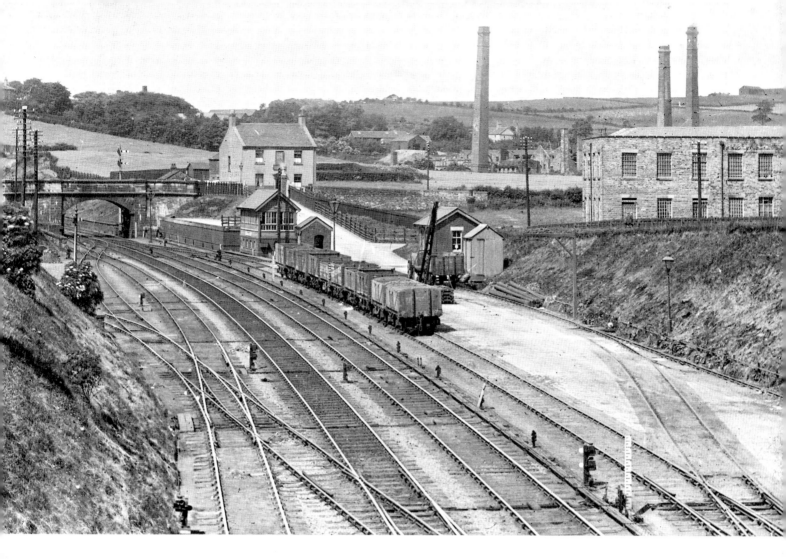

▵ ORRELL

The wayside goods yard is another aspect of railways that has now almost completely disappeared. This is Orrell on the Lancashire & Yorkshire Railway main line from Manchester to Liverpool. Surrounded by mills set in a semi-rural landscape, the view reveals the sidings, loading gauge, crane, lamps, huts and a bank for loading vans through roof doors – something characteristic of the L&YR, which was one of the few companies to use roof doors in its vans. The Orrell West signal box is of Railway Signal Co. pattern. *John Alsop Collection*

◁ FERME PARK YARD

One aspect of the railways that has almost entirely vanished since the 1960s is the marshalling yard where thousands of wagons were dispatched or received. The sheer scale of such yards is difficult to comprehend today. This is Ferme Park, to the north of Harringay on the Great Northern Railway main line, at which vast numbers of wagons, many carrying coal from the West Riding coal field, ended their journeys from the north. From here, they would be made up into local goods trains, bound for the many suburban goods yards of London. We are looking northwards *c.* 1920 with the down yard, opened in 1887, in the foreground and the up yard, opened the following year, half hidden by the smoky haze emanating from Hornsey locomotive shed. The viaduct, which is still there, was added in 1893. The up yard is full of empty coal wagons awaiting the return trip northwards. The site of both yards is now used for carriage servicing and Hornsey electric traction depot stands on the east side.
H. Gordon Tidey/John Minnis Collection

◁ CRICKLEWOOD

The Midland Railway's Brent sidings at Cricklewood from the air, looking south with the North Circular Road in the foreground. This was where much traffic was interchanged with railway companies to the south of the Thames. Land for sidings here was acquired at the time of the land purchase for the Midland Railway's London Extension and the sidings were laid out over a long period of time. Those on the left were laid out from 1885 onwards. The photograph, taken in the 1950s, gives an idea of the sheer scale of the traffic, much of it domestic coal, which has now almost completely vanished together with the facilities provided for it. The line curving sharply from left to right is the Brent Engine line, opened in 1905, which allowed engines from the east side of the line to reach the west and the nearby engine sheds (visible on the right) without obstructing the main line. *Science & Society Picture Library*

△ WHITEMOOR

Whitemoor, at March in the heart of the Fens, became the site of a massive marshalling yard in 1929 to deal with coal traffic from Yorkshire and Nottinghamshire to London and sugar beet from East Anglia. It was the first yard in England to rely not just on gravity to sort the wagons but on rail-brakes to automatically retard the wagons as they moved from the hump into the various sorting sidings. It cost £285,000 and was joined in 1933 by similar equipment in the down yard. Here the control cabin with its large windows and the hump is seen when new. With the reduction in goods traffic and the closure of the line northwards from March to Spalding, March became redundant and most of the tracks were taken up. Part of the site was used for the high security Whitemoor prison while some of the remainder was reopened as a freight terminal. Many similar yards, constructed in the late 1950s, were redundant within twenty years of construction. *John Alsop Collection*

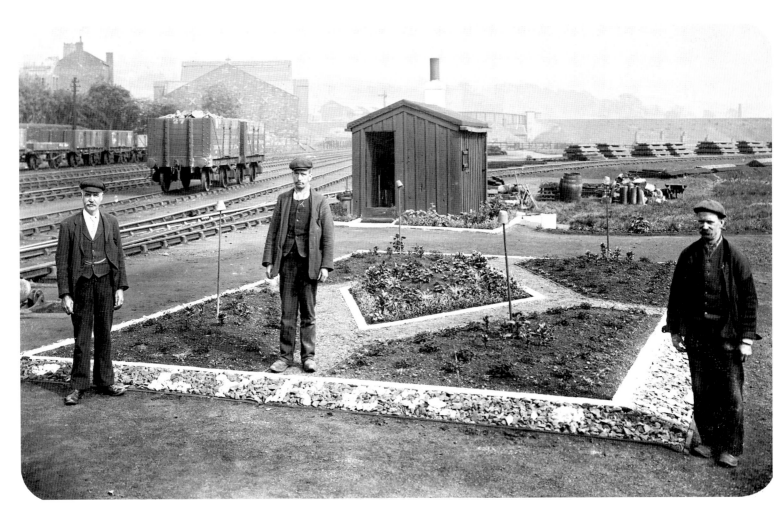

◁ HECKMONDWYKE

Railwaymen would often cultivate any spare patch of land available, and this garden by a group who were probably gangers on the Lancashire & Yorkshire Railway (note the initials in the border) at Heckmondwyke is typical of something that has largely disappeared with the demise of gangers allocated to maintaining a short stretch of line. Gone too are the majority of their huts, many, like this one, roughly built out of sleepers, and also gone is the line through Heckmondwyke itself, closed in 1965. *John Alsop Collection*

▷△ NORTHALLERTON

In the mid 1930s, the London & North Eastern Railway inaugurated a campaign to improve the appearance of its stations and lineside locations by introducing concrete edging which could be used to enclose grass or flower beds and encouraging platelayers to carry out planting. The idea was enthusiastically taken up and little gardens of striking formality grew up all over the system. Often, they were fitted into the space between tracks at junctions or odd bits of waste land, as here at Northallerton where something approaching a small park has been created with gravel paths, lawns and a plantation of shrubs. The gardens waned as platelayers ceased to be allocated to a particular stretch of line but remnants of the concrete edging are still to be seen here and there. *Robert Humm Collection*

▷ RUGBY GANTRY

In 1895, the Manchester, Sheffield & Lincolnshire Railway built its London Extension across the main line of the London & North Western Railway just south of Rugby station on a girder bridge. The new bridge obstructed the view northwards and the LNWR put up, at the MS&LR's expense, a massive forty-four arm signal gantry, nicknamed 'The Bedstead', 87ft wide and almost 60ft high. The lower signals were provided for when the trains were close, the higher for early sight. The gantry, together with its signals, was replaced by colour light signals in 1939. This view was taken by the LNWR soon after construction. Rugby station is visible in the distance, as rebuilt in 1885–6 with the locomotive shed on the right. It too has largely been rebuilt in the last few years as part of the West Coast modernisation programme, losing its overall roof. The girder bridge survived the closure of the Great Central Railway by many years, finally going in the 1990s. *LNWR/Robert Humm Collection*

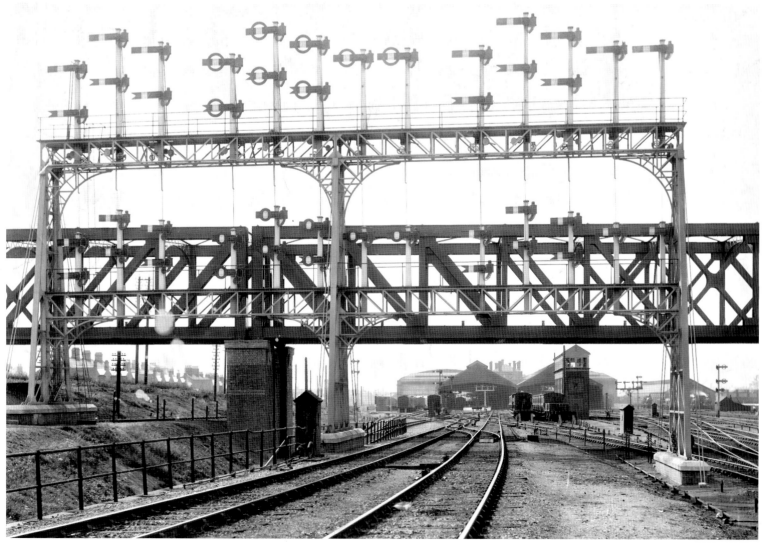

NOTES

1 N. Pevsner, Foreword to Alison and Peter Smithson, *The Euston Arch and the Growth of the London Midland & Scottish Railway*, Thames & Hudson, London, 1968, n.p.

2 J.M. Richards, 'The Euston Murder', *The Architectural Review*, April 1962, pp. 234-8.

3 G.K. Chesterton, *Tremendous Trifles*, London, 1909, pp. 219-224.

4 Peter Walton, *The Stainmore & Eden Valley Railways*, Oxford Publishing Co., Sparkford, 1992, p. 216.

5 Trevor Dannatt, *Modern Architecture in Britain*, B.T. Batsford, London, 1959, p. 26.

6 *The Builder*, 28 April 1939, p. 791.

7 Christian Barman, *An Introduction to Railway Architecture*, Art & Technics, London, 1950, p. 9.

8 Christian Barman in *British Transport Review* 1 (1950-1) quoted in Jack Simmons, *The Railways of Britain*, Routledge, London, 1961, p. 100.

9 LB&SCR Board Minutes 15 March 1860, National Archives RAIL 414/71.

10 Barman, 1950, p. 9.

11 *The Railway Magazine*, November 1975, p. 567; September 1976, p. 482.

12 John Ruskin, *The Seven Lamps of Architecture*, 3rd edition, George Allen, London, 1891, pp. 219-22.

13 'Railway Structures', *The Building News*, 3 April 1891, p. 487.

14 LB&SCR Board Minutes 7 September 1850, National Archives RAIL 414/67.

15 Built by the well-known Crawley builders, James Longley. LB&SCR Engineering Committee Minutes 11 December 1894, National Archives RAIL 414/156.

16 These figures relate to mechanical signal boxes on the national railway network; a further 300 boxes exist, either out of use, preserved or re-used for other purposes.

17 Peter Kay, *The London Tilbury & Southend Railway* Vol. 2, Author, Dawlish, 1997, p. 140.

18 The Signalling Study Group, *The Signal Box, A Pictorial History*, Oxford Publishing Co., Poole, 1986, p. 18.

19 Michael Nevell, 'The Archaeology of the Rural Railway Warehouse in North-West England', *Industrial Archaeology Review*, Vol. XXXII No. 2, November 2010, p. 113.

20 Ian Nairn and Nikolaus Pevsner, *The Buildings of England: Sussex*, Penguin, Harmondsworth, 1965, p. 341.

21 See John Minnis, 'Forest Hill', *British Railway Journal*, No. 71, pp. 222-40.

22 Bill Fawcett, *A History of North Eastern Railway Architecture*, 3 vols., North Eastern Railway Association, Hull, 2001-5.

23 Peter Mathias, review of G.R. Hawke, *Railways and Economic Growth in England and Wales 1840-1870*, *English Historical Review* No. 87 (1972) p. 582.

24 Neil Cossons, 'Railway Preservation: Whither or wither?', *Steam Railway* No. 165, January 1994, p. 26.

25 Paul Karau, 'Common Light Railway Architecture', *British Railway Journal* No. 1, October 1983, pp. 25-31.

26 P.A. Brown, 'Architectural Design on Captain Moorsom's Railways', *Historical Model Railway Society Journal* Vol. 17 No. 1, January–March 2000, pp. 13–18.

27 Kay, 1997, p. 138.

28 See Tom Wray, *The Middleton Branch*, The Lancashire & Yorkshire Railway Society, 1999.

29 *The Railway Magazine*, December 1969, p. 705.

30 'Welsh Stations Change', *The Railway Magazine*, January 1976, pp. 14–15.

31 H.P. White, *Forgotten Railways*, David St John Thomas, Newton Abbot, 1986, p. 41.

32 White, 1986, covers the process and gives numerous examples of how it worked in practice.

33 George Pring, 'Railway Architecture of East Anglia, A GERS 20th Anniversary Review', *Great Eastern Journal*, No. 76, October 1993, pp. 15–23.

34 David Pearce and Marcus Binney, *Off the Rails, saving railway architecture*, Save Britain's Heritage, London, 1977, p. 4.

BIBLIOGRAPHY

The bibliography is designed to provide an overview of what has been published on railway architecture. It makes no claim to completeness. In particular, there is much to be found in the large numbers of histories of individual branch lines and routes and in works on particular localities such as the 'Rail Centres' series published by Ian Allan. For these George Ottley's *Bibliography of British Railway History* is invaluable. There is no equivalent for journal articles but G. C. Lewthwaite, *Branch Line Index* (Third edition), Branch Line Society, Bristol, 1991, is helpful as are the annual bibliographies of transport publications compiled by the Railway & Canal Historical Society. There is, in particular a wealth of material in the journals published by the historical societies covering each of the principal pre-grouping companies, those of the Caledonian Railway Association, the Great Eastern Society and the Lancashire & Yorkshire Railway Society being especially rewarding. I have attempted to list recent articles of particular significance below.

GENERAL WORKS – CHRONOLOGY

Butt, R.J.V., *The Directory of Railway Stations*, Patrick Stephens, London, 1995.

Quick, Michael, *Railway Passenger Stations in Great Britain: a chronology*, Railway & Canal Historical Society, London, 2009.

GENERAL WORKS – ARCHITECTURE

Barman, Christian, *An Introduction to Railway Architecture*, Art and Technics, London, 1950.

Betjeman, John & Gay, James, *London's Historic Railway Stations*, John Murray, London 1972.

Biddle, Gordon, *Victorian Stations*, David & Charles, Newton Abbot, 1973.

Biddle, Gordon & Spence, Jeoffry, *Railway History in Pictures: The British Railway Station*, David & Charles, Newton Abbot, 1977.

Biddle, Gordon, *Great Railway Stations of Britain*, David & Charles, Newton Abbot, 1986.

Biddle, Gordon & Nock, O.S., *The Railway Heritage of Britain*, Michael Joseph, London, 1983.

Biddle, Gordon, 'Goods Sheds and Warehouses', *Journal of the Railway & Canal Historical Society*, Vol. 32 Part 4 No. 166, March 1997, 293-299.

Biddle, Gordon, *Britain's Historic Railway Buildings*, Oxford University Press, Oxford, 2003, Revised edition, Ian Allan, Shepperton, 2011.

Binney, Marcus & Pearce, David (eds.), *Railway Architecture*, Orbis, London, 1979.

Bowers, Michael, *Railway Styles in Building*, Almark, New Malden, 1975.

British Railways Board, *Aspects of Railway Architecture*, British Railways Board, London, 1985.

Buck, Gordon A., *A Pictorial Survey of Railway Stations*, Oxford Publishing Co, Sparkford, 1992.

Burman, Peter & Stratton, Michael (eds.), *Conserving the Railway Heritage*, Spon, London, 1997.

Carter, O., *An Illustrated History of British Railway Hotels 1838-1983*, Silver Link, St Michael's, 1990.

Denton, J. Horsley, *British Railway Stations*, Ian Allan, London, 1965.

Hendry, Robert, *British Railway Station Architecture in Colour*, Ian Allan, Shepperton, 2007.

Jardine, Nick, *British Railway Stations in Colour*, Midland, Hinckley, 2002.

Kay, Peter, *Signalling Atlas and Signal Box Directory (Third Edition)*, Signalling Record Society, Wallasey, 2010.

Larkin, E., *The Railway Workshops of Britain 1823-1986*, Macmillan, Basingstoke, 1988.

Lloyd, David & Insall, Donald, *Railway Station Architecture*, David & Charles, Newton Abbot, 1967.

Meeks, Carroll L.V., *The Railway Station: An Architectural History*, Architectural Press, London, 1957.

Parissien, Steven, *Station to Station*, Phaidon, London, 1997.

Pearce, D. & Binney, M. (eds), *Off the Rails*, SAVE Britain's Heritage, London, 1977.

Richards, Jeffrey & MacKenzie, John M., *The Railway Station: A Social History*, Oxford University Press, 1986.

RSA-Cubitt Trust Panel, *The Future of the Railway Heritage*, Royal Society of Arts-Cubitt Trust Panel, 1985.

Rhodes, M., *The Illustrated History of British Marshalling Yards*, Oxford Publishing Co, Sparkford, 1988.

Signalling Study Group, *The Signal Box, a Pictorial History*, Oxford Publishing Co, Poole, 1986.

Vanns, Michael A., *ABC Signalboxes*, Ian Allan, Shepperton, 1997.

SPECIFIC ARCHITECTS

Beale, Gerry, 'The 'Standard' Buildings of William Clarke', *British Railway Journal*, No. 8, Summer 1985, 266-276.

Biddle, Gordon, 'The Railway Stations of John Livock and T. M. Penson', *Journal of the Railway & Canal Historical Society*, Vol. 31 Part 2 No. 154, May 1993, 61-71.

Biddle, Gordon, 'Sancton Wood, railway architect', *Backtrack*, Vol. 21, No. 9 (September 2007), 551-56, No. 11 (November 2007), 696-700.

Brown, P. A., Architectural Design on Captain Moorsom's Railway, *Historical Model Railway Society Journal*, (Jan-March 2000).

Carter, O., 'Francis Thompson, 1808-95, an architectural mystery solved', *Backtrack*, Vol. 9, No. 4, (April 1995), 213-8.

Cole, David, 'Mocatta's Stations for the Brighton Railway', *Journal of Transport History*, 1st series, Vol. 3, No. 3, May 1958, 149-57.

Dixey, S. John, 'Charles Trubshaw, A Victorian Railway Architect' in Jenkinson, David (ed.), *Bedside Backtrack: Aspects of Britain's Railway History*, Atlantic, Penryn, 1993.

Fawcett, Bill, *George Townsend Andrews of York 'The Railway Architect'*, Yorkshire Architectural

& York Archaeological Society/ North Eastern Railway Association, York, 2011.

Lawrence, David, *Bright Underground Spaces: The Railway Stations of Charles Holden*, Capital, Harrow Weald, 2008.

Leboff, David, *The Underground Stations of Leslie Green*, Capital, Harrow Weald, 2002.

Lewis, Christopher, 'William Henry Barlow 1812-1902', *Backtrack*, Vol. 20, No. 7 (July 2006), 404-10.

Surry, Andrew & Howard, Ian, 'Stations by Francis Thompson: a comparison of British and Canadian examples', *Midland Railway Society Journal*, No. 44 (Autumn 2010), 8-15.

SPECIFIC COMPANIES AND REGIONAL STUDIES

Anderson, V.R. & Fox, G K., *A Pictorial Record of LMS Architecture*, Oxford Publishing Co, Oxford, 1981.

Anderson, V.R. & Fox, G K, *A Pictorial Record of Midland Railway Architecture*, Oxford Publishing Co, Poole, 1985.

Anderson, V.R. & Fox, G K., *Stations and Structures of the Settle & Carlisle Railway*, Oxford Publishing Co, Poole, 1986.

Antell, Robert, *Southern Country Stations, Vol. 1, LSWR*, Ian Allan, Shepperton, 1984.

Biddle, Gordon, *Railway Stations in the North West: a Pictorial History*, Dalesman, Clapham, 1981.

Bolger, Paul, *Merseyside & District Railway Stations*, Bluecoat Press, Liverpool, 1994.

Brodribb, John., *LNER Country Stations*, Ian Allan, Shepperton, 1988.

Cattell, John & Falconer, Keith, *Swindon: the Legacy of a Railway Town*, Royal Commission on the Historical Monuments of England, Swindon, 1995.

Clark, R. H., *A Southern Region Chronology and Record 1803-1965*, Oakwood Press, Lingfield, 1964.

Clark, R. H., *An Historical Survey of Selected Great Western Stations Vols. 1-3*, Oxford Publishing Co, Oxford, 1976-1981.

Fawcett, Bill, *A History of North Eastern Railway Architecture*, Vols. 1-3, North Eastern Railway Association, Hull, 2001-2005.

Gough, John, *The Midland Railway: a chronology*, Railway & Canal Historical Society, Leicester, 1989.

Hawkins, Chris & Reeve, George, *An Historical Survey of Southern Sheds*, Oxford Publishing Co, Oxford, 1979.

Hawkins, Chris & Reeves, George, *LMS Engine Sheds* Vols. 1-5, Wild Swan, Upper Bucklebury, 1981-7, Vols. 6-7, Irwell, Oldham, 1989-90.

Hawkins, Chris & Reeve, George, *Great Eastern Railway Engine Sheds*, Vols. 1 & 2, Wild Swan, Upper Bucklebury, Didcot, 1986-7.

Hawkins, Chris & Reeve, George, *An Illustrated History of Great Western Railway Engine Sheds. 1: London Division*, Wild Swan, Upper Bucklebury, 1987.

Hawkins, Chris & Reeve, George, *LSWR Sheds*, Irwell, Oldham, 1990.

Hendry, R. Preston, & Hendry R. Powell, *An Historical Survey of Selected LMS Stations Vols. 1 & 2*, Oxford Publishing Co, Poole, 1982, 1986.

Hoare, John, *Sussex Railway Architecture*, Harvester Press, Hassocks, 1979.

Hoole, Ken, *Railway Stations of the North East*, David & Charles, Newton Abbot, 1985.

Jackson, Alan A., *London's Termini*. David & Charles, Newton Abbot, 1969.

Johnston, Colin & Hume, John R., *Glasgow Stations*, David & Charles, Newton Abbot, 1979.

Kay, Peter, *Essex Railway Heritage: the county's railway buildings and their history*, Author, Wivenhoe, 2006.

Kay, Peter, *Essex Railway Heritage, Supplement*, Author, Wivenhoe, 2007.

Lawrence, David, *Underground Architecture*, Capital, Harrow Weald, 1994.

Leigh, Chris, *GWR Country Stations*, Ian Allan, Shepperton, 1981.

Leigh, Chris, *GWR Country Stations: 2*, Ian Allan, Shepperton, 1984.

Menear, Lawrence, *London's Underground Stations*, Midas, Tunbridge Wells, 1983.

Miller, R. W., *London & North Western Railway Company Houses*, London & North Western Railway Society, Loughborough, 2004.

Minnis, John, *Southern Country Stations: South Eastern & Chatham Railway*, Ian Allan, Shepperton, 1985.

Minnis, John, 'Goods Lock Ups [of the London Brighton & South Coast Railway]', *The Brighton Circular* Vol. 19 No. 3 (June 1993), 6-64.

Moore, *Leicestershire's Stations, An Historical Perspective*, Laurel House, Narborough, 1998.

Nevell, Michael, 'The Archaeology of the Rural Railway Warehouse in North-West England', *Industrial Archaeology Review*, Vol. XXXII No. 2, November 2010, 103-115.

Peck, Alan S., *The Great Western at Swindon Works*, Oxford Publishing Co, Poole, 1983.

Potts, C.R., *An Historical Survey of Selected Great Western Stations Vol. 4*, Oxford Publishing Co, Poole, 1985.

Pyer, G. A., *A Pictorial Record of Southern Signals*, Oxford Publishing Co, Oxford, 1977.

Pryer, G. & Bowring, G. J., *An Historical Survey of Selected Southern Stations Vol. 1*, Oxford Publishing Co, Oxford, 1980.

Pryer, G. A., *Signal Boxes of the London & South Western Railway: A Study of Architectural Style*, Oakwood Press, Usk, 2000.

Radford, J. B., *Derby Works & Midland Locomotives*, Ian Allan, Shepperton, 1971.

Reed, Brian, *Crewe Locomotive Works and its Men*, David & Charles, Newton Abbot, 1982.

Sheeran, George, *Railway Buildings of West Yorkshire 1812-1920*, Ryburn, Keele, 1994.

Smith, M. D., *Horwich Locomotive Works*, Wyre Publishing, St Michael's on Wyre, 1996.

Vanns, Michael A., *An Illustrated History of Great Northern Railway Signalling*, Ian Allan, Shepperton, 2000.

Vaughan, Adrian, *A Pictorial Record of Great Western Signalling*, Oxford Publishing Co, Oxford, 1973.

Vaughan, Adrian, *A Pictorial Record of Great Western Architecture*, Oxford Publishing Co, Oxford, 1977.

Vaughan, Adrian, *GWR Junction Stations*, Ian Allan, Shepperton, 1988.

Wikeley, Nigel & Middleton, John, *Railway Stations: Southern Region*, Peco, Seaton, 1971.

SPECIFIC STATIONS

Addyman, John & Fawcett, Bill, *The High Level Bridge and Newcastle Central Station: 150 Years across the Tyne*, North Eastern Railway Association, 1999.

Binding, John, *Brunel's Bristol Temple Meads*, Oxford Publishing Co, Shepperton, 2001.

Bradley, Simon, *St Pancras Station*, Profile, London, 2007.

Brindle, Steven, *Paddington Station, its History and Architecture*, English Heritage, Swindon, 2004.

Chivers, Colin & Wood, Philip, *Waterloo circa 1900, an illustrated tour*, South Western Circle, London, 2006.

Ellaway, K. J., *The Great British Railway Station: Euston*, Irwell, Oldham, 1994.

Fitzgerald, R., S., *Liverpool Road Station,*

Manchester, An Historical and Architectural Survey, Manchester University Press, 1980.

Hawkins, Chris, *The Great British Railway Station: King's Cross*, Irwell, Oldham, 1990.

Hunter, Michael & Thorne, Robert, *Change at King's Cross*, Historical Publications, London, 1990.

Simmons, Jack, *St Pancras Station*, Revised Edition with additional chapter by Robert Thorne, Historical Publications, London, 2003.

Smithson, Allison & Peter , *The Euston Arch and the Growth of the London, Midland & Scottish Railway*, Thames & Hudson, London, 1968.

Thorne, Robert, *Liverpool Street Station*, Academy Editions, London, 1978.

Tutton, Michael, *Paddington Station 1833-1854*, Railway & Canal Historical Society, Mold, 1999

Wray, Tom, *Manchester Victoria Station*, Peter Taylor, Hereford, 2004.

BRIDGES, VIADUCTS AND TUNNELS

Binding, John, *Brunel's Cornish Viaducts*, Pendragon, Penryn, 1993.

Blower, Alan, *British Railway Tunnels*, Ian Allan, London,

Hammond, R., *The Forth Bridge and its Builders*, Eyre & Spottiswoode, London, 1964.

Lewis, Brian, *Brunel's Timber Bridges and Viaducts*, Ian Allan, Shepperton, 2007.

Murray, Anthony, *The Forth Railway Bridge: A Celebration*, Mainstream, Edinburgh, 1983.

Smith, Martin, *British Railway Bridges and Viaducts*, Ian Allan, Shepperton, 1994.

Walters, David, *British Railway Bridges*, Ian Allan, London, 1963.

Wood, L. V., *Bridges for Modellers*, Oxford Publishing Co., Poole, 1985.

ACKNOWLEDGEMENTS

In preparing this book, I have had the help of many friends. Firstly, those who have helped with photographs. I am especially grateful to John Alsop who very kindly allowed me to go through his magnificent collection of railway postcards, to Peter Brown and the Railway & Canal Historical Society for giving me access to the photographic collection of the late Jeoffry Spence and to Robert Humm for access to his collection. In addition many others have helped: Jim Connor, Tony Harden, Brian Hart, John Scrace, Ed Bartholomew at the National Railway Museum and Alyson Rogers at the National Monuments Record. Thanks also go to the other copyright holders credited alongside the illustrations for permission to reproduce photographs. Derek Coe has kindly answered many queries about signal boxes. David Lawrence, former BR Property Director, gave me the story from the inside of how the railway approached its legacy of historic buildings.

Although this is a personal project, and, in no sense, an official English Heritage publication, all the views expressed in it being mine alone, I am also indebted to Martin Robertson, formerly of English Heritage, Keith Falconer and Roger Bowdler for their help and to my colleague, Kathryn Morrison, for reading the text.

Finally, my thanks go to Graham Coster, my editor at Aurum, for his enthusiasm and help throughout the project, to Barbara Phelan, Managing Editor, to Ashley Western for his inspired book design, to Tim Peters for additional help with the layout, and to Steve Gove, copy editor.

INDEX